Dishing Dirt in the Digital Age

Toby Miller
General Editor

Vol. 25

The Popular Culture and Everyday Life series
is part of the Peter Lang Media and Communication list.
Every volume is peer reviewed and meets
the highest quality standards for content and production.

PETER LANG
New York • Washington, D.C./Baltimore • Bern
Frankfurt • Berlin • Brussels • Vienna • Oxford

Erin A. Meyers

Dishing Dirt in the Digital Age

CELEBRITY GOSSIP BLOGS AND PARTICIPATORY MEDIA CULTURE

PETER LANG
New York • Washington, D.C./Baltimore • Bern
Frankfurt • Berlin • Brussels • Vienna • Oxford

Library of Congress Cataloging-in-Publication Data

Meyers, Erin A.
Dishing dirt in the digital age: celebrity gossip blogs
and participatory media culture / Erin A. Meyers.
pages cm. — (Popular culture and everyday life; v. 25)
Includes bibliographical references and index.
1. Gossip. 2. Celebrities. 3. Blogs. I. Title.
BJ1535.G6M49 302.23'1—dc23 2012050310
ISBN 978-1-4331-1807-4 (hardcover)
ISBN 978-1-4331-1806-7 (paperback)
ISBN 978-1-4539-1052-8 (e-book)
ISSN 1529-2428

Bibliographic information published by **Die Deutsche Nationalbibliothek.**
Die Deutsche Nationalbibliothek lists this publication in the "Deutsche
Nationalbibliografie"; detailed bibliographic data is available
on the Internet at http://dnb.d-nb.de/.

The paper in this book meets the guidelines for permanence and durability
of the Committee on Production Guidelines for Book Longevity
of the Council of Library Resources.

© 2013 Peter Lang Publishing, Inc., New York
29 Broadway, 18th floor, New York, NY 10006
www.peterlang.com

Printed in the United States of America

To my husband, Michael

Table of Contents

List of Illustrations

Acknowledgments

An earlier version of chapter 3: The New "Professional" Gossip: Celebrity Gossip Bloggers as Media Producers was first published as "'Blogs give regular people the chance to talk back': Rethinking 'Professional' Media Hierarchies in New Media" in *New Media and Society 14*(6), 1022-1038, September 2012.

Introduction

Celebrity Goes Digital

The glossy celebrity-oriented magazines or so-called "tabloids" that line the aisles of grocery store checkouts and newsstand magazine racks have historically drawn millions of readers seeking the latest dish about the ongoing private-life sagas of their favorite stars. Despite their popularity, tabloids have a reputation as as a "guilty pleasure" not only because of their tie to the ephemera of celebrity culture, but because they rely on gossip rather than "fact" as the point of entry into that culture. Typically condemned as the catty province of malicious and mindless women, written and spoken gossip are alternately criticized as insignificant wastes of time and nasty forms of social control that serve to rigidly categorize social norms and to ostracize those who fall short. Yet this myopic view of gossip ignores the vital role this form of communication plays in women's public cultural production. Many scholars have already reclaimed gossip as a potential space of feminist resistance and community-building for women, recognizing how private talk about public figures (like celebrities) connects women to the public sphere and to each other on their own terms (Jones, 1980; Meyer Spacks, 1985; Hermes, 1995; Jaworski & Coupland, 2005). Viewed through this lens, celebrity gossip's focus on the details of the private lives of stars—from the mundane to the scandalous—emphasizes the ways in which celebrities matter as sites of social meaning-making, moving stars off the silver screen and into the cultural processes of everyday life.

We are drawn to stars, as Richard Dyer (1986) claims, not simply because they are talented or beautiful, but because they "represent typical ways of behaving, feeling and thinking in contemporary society, ways that have been socially, culturally, historically constructed" (p. 17). The contemporary celebrity is an ideological symbol that, as P. David Marshall (1997) suggests, "operates at the very center of culture as it resonates with conceptions of individuality that are the ideological ground of Western culture" (p. x). Gossip about celebrities is an interpretive mode of media engagement in which audiences negotiate the tensions between the public and private celebrity self, searching the image for evidence of socially constructed ideals (or, more tellingly, their rejection) defining what it means to be an individual in that particular time and place. Gossip is not just about gaining knowledge or even learning the "truth" about the private individual behind the star façade. Indeed, in the tabloid coverage of

the stars' lives, "real facts" take a back seat to the emotion and interpretation of gossip talk. In a behind-the-scenes look at the tabloid industry in *The Guardian*, an anonymous celebrity weekly editor describes the editorial process as based on a central question: "How can we construct a story around a set of emotions that our readers are going to relate to?" (qtd in Burkeman, 2009, para 9). The pleasures of gossip, as well as its social meaning-making potential, lie in the evaluation of that knowledge and the formation of shared understandings of the world and the gossipers' place within it. Celebrity gossip media, like tabloids, offer audiences the means to participate in the shared negotiation of meaning inherent to gossip and to connect those meanings to their everyday lives. As audience data confirm that young women are the predominant audiences for celebrity gossip media, I argue that these media forms and the gossip talk they inspire shed light on this form of women's cultural production and acknowledge the social power of celebrities, and the audiences who gossip about them, in shaping contemporary culture.

The Changing Celebrity Media Industry

The early 2000s marked the beginning of an important shift in the production and consumption of celebrity gossip media. At a time when the American magazine industry—particularly news magazines—struggled in the face of declining ad sales and circulations, titles focused on celebrity culture and lifestyles were expanding and earning record profits. According to *The New York Times*, the average total sales of popular celebrity glossies *Star*, *People*, *Us Weekly* and *In Touch* combined were up 11.6 percent at the end of 2004, with *Star* and *In Touch* sales each rising about 80 percent from the previous year (Story, 2005, p. C1). Surging subscription and single-issue sales across the genre led to the introduction of new titles, such as *Life & Style Weekly* in 2004 and an American version of British celeb-weekly *OK!* in 2005 eager to tap into this growing market. This expansion of titles and booming sales made the genre a powerful presence on newsstands and in popular culture.

However, after riding high in the early years of the decade, the genre has been in decline since 2005. In 2007, the magazine industry reported an 11 percent drop in sales of all titles on newsstands, the main sales spot for celebrity gossip magazines (Magazine Publishers of America, 2008). Though genre leaders including *People*, *Us Weekly*, and *In Touch* remained in the top ten of overall single-issue circulation and in the top 100 of paid subscriptions, their numbers began to stagnate in 2005. In this year, single-issue sales of former powerhouse titles like *Us Weekly* and *In Touch Weekly* slowed to single digit growth (2.1 and 6.5 percent, respectively) (Magazine Publishers of America, 2006). Once the core sales site of the industry, single-issue sales of tabloids

continued to drop as the decade progressed. *Us Weekly*'s sales declined nearly 16 percent between 2007 and 2008 and *In Touch Weekly*'s numbers fell a staggering 30 percent in the same period (Magazine Publishers of America, 2008). *Us Weekly* did rebound a bit in 2008 with a notable 10 percent increase from its 2006 sales figures, indicating that the decline in magazine sales was not a reflection of a waning public interest in celebrity gossip (Pérez-Peña, 2008). Nevertheless, despite this brief surge, sales of *Us Weekly*, like many other celebrity glossies, continued to fall from the industry peak in 2004. In the first half of 2012, the greatest declines in newsstand sales were in the celebrity genre, with *People* down 18.6 percent, *Us Weekly* down 11.4 percent, *In Touch Weekly* down 13.3 percent and *Star* down 14.2 percent (Haughney, 2012).

The economic downturn that began in the mid-2000s certainly played a role in declining ad sales and reduced circulation, but American audiences had not lost their interest in celebrity culture. As print gossip magazines (and indeed print magazines across the board) were downsizing staff and decreasing page numbers, online sources of gossip were flourishing. Nielsen//NetRatings notes that between February 2006 and February 2007, celebrity gossip websites "have seen significant audience growth," with several of the top sites increasing their audiences by 40 percent (Bausch, 2007). Audiences still wanted the inside scoop on celebrities' private lives, and were increasingly turning to the Internet to get it. In general, the print industry initially viewed the Internet "as a competing medium" that challenged their economic and cultural dominance, and many gossip titles quickly expanded their online presence as their print sales sagged (Jordan, Edmiston Group, 2006, p. 2). For example, genre leader *Us Weekly* launched its online version, usmagazine.com, in the summer of 2006, and in 2012, the site attracts over 8 million unique American visitors per month by offering the latest breaking celebrity gossip to satiate audiences between print issues (Quantcast, 2011). A 2005 financial review of the consumer magazine industry by the Magazine Publishers of America claimed the print magazine industry felt it had solved "the Internet content riddle," by using online platforms to offer content that is "distinctly different...but complementary to...the printed page" (Jordan, Edmiston Group, 2006, p. 2). The goal was to protect the "brand" of the print outlets and their gossip media industry dominance by offering extended content that complemented, but was not intended to replace, the magazines.

However, this rapid growth of online celebrity content included the rise of a new breed of online celebrity gossip that offered something different than print magazines—the celebrity gossip blog. Celebrity gossip blogs take full advantage of the technological and social possibilities of new media and highlight the changing roles of audiences within new media culture. Ostensibly

existing outside of the control of both the media and celebrity industries, gossip blogs offer the latest celebrity dish coated in a thick layer of gossip commentary from a blogger who is, like her readers, an onlooker to celebrity culture. That is, gossip blogs are built around what audiences, including the blogger him/herself, *do* with celebrity content. They offer comments sections and other interactive spaces for audience members to publicly participate in gossip talk as part of their reading practices, a space missing from print media. Ultimately, what makes blogs unique forms of celebrity media are the ways they foreground gossip talk as the primary mode of engagement with celebrity culture and highlight the audience as an active player in the system of celebrity production. Unlike print media forms, gossip blogs embrace new media's immediacy and interactivity to explicitly involve the audience in both the construction and consumption of the celebrity image through gossip talk. Celebrity gossip blogs have transformed the ways audiences get the latest celebrity dish and the ways in which they engage with celebrity culture through gossip talk.

But what exactly is a gossip blog and how do we understand its place within media and celebrity cultures? This book is a critical examination of the impact of the technological and textual shifts engendered by new media on the use of gossip as a form of everyday cultural production. It investigates why celebrities play such an important role in contemporary culture and how gossip blogs, in particular, have intensified this social role. Following Joshua Gamson's (1994) approach to celebrity as a cultural phenomenon, this book breaks down gossip blogs into their main elements—texts, producers and audiences—and examines the interplay between these elements. The focus is on the social use of blogs, in particular how the technological affordances of new media enable the merging of the social practice of gossip with the practice of reading in the creation of a participatory and community-based online culture.

Understanding New Media

Though the catchall phrase "new media" is used to refer to a variety of digital media and communication forms, they are united by an inherent public sociality that was missing from (or at least invisible in) traditional print media. This represents a crucial shift from the one-to-many communication model of traditional mass media to a participatory media culture where the boundaries between producer and consumer are increasingly blurred. Within new media:

> the "audience" member has become a producer of their content. In some instances, that action of producing is quite limited to just moving from website to website in a particularly individual and idiosyncratic way; in other cases, the user is actively transforming the content for redistribution. (Marshall, 2006, p. 638)

The interactive nature of new media, defined by the ability of the audience to produce as well as consume texts as part of the design of the media form, distinguishes it from traditional print media. Though scholars have already documented a range of active audience practices around traditional media forms, the new social web puts these practices at the center of the technological and textual features that define new media. The technological affordances of Web 2.0 wrest control of media content from the traditional media industry producers and destabilize the traditional top-down hierarchy of media production and consumption. The impact of this shift to a participatory media culture was recognized by *Time* magazine when, concomitant with the downturn in the print magazine market, it named "You" as its 2006 Person of the Year. "You," as *Time* points out, are using new media to create and share content foregrounding collaboration and community as key strategies of mainstream media engagement. It is no longer about *what* you read, but *how* you engage with and reshape that text (Grossman, 2006). The key to understanding new media is uncovering how technology is harnessed by users to engender social practices of meaning-making and community-building as part of their media consumption.

While technological changes have profoundly influenced social practices of production, distribution and consumption of contemporary media, they are often too easily valorized as the *cause* of such changes. The connections between technological advances and the social, economic and cultural contexts in which they are created and used are crucial to understanding new media as a cultural phenomenon. Henry Jenkins (2006a) draws a distinction between interactivity and participation that is useful in understanding celebrity gossip blogs through a social, not just a technological, lens. He argues these two terms are related, yet distinct, elements that support the audience's social engagement with new media. Interactivity, he says "refers to the ways that new technologies have been designed to be more responsive to consumer feedback" (p. 133). The degrees to which audiences are able to interact with media are framed by the available technological affordances. In the case of gossip blogs, the blogger decides whether or not to include interactive features and which specific features to add. Each technological choice opens or limits interaction, controlling the ways in which the audience can engage with and through media content. For example, choosing to include a comments section at the end of a post opens space for readers to engage in dialogue within a particular setting. Requiring them to register as members in order to do so is also a technological limit on how they can interact in that space. But such control is not absolute, as offering the audience a prescribed space and/or way to interact with the media content does

not necessarily mean that they will use it in the way the producer intended or even use such features at all.

In a 2003 survey of 53 million American adults, the Pew Internet and American Life Project found that some 44 percent had contributed content to the Internet (Lenhart, Fallows, & Horrigan, 2004, pp. 3–4). Yet their definition of "creating content" was quite broad and included posting photographs to websites and commenting on newsgroups as well as more complex creation acts like maintaining a personal webpage or blog. The numbers of adults creating content in each of these categories decreases as the complexity of the process of creation increases. For example, though 21 percent have posted photographs to a website and 17 percent have posted written comments to a website, only 13 percent maintain their own websites, three percent have uploaded videos to websites, and a mere 2 percent maintain blogs (ibid). Similarly, Hitwise, an Internet tracking company, reports that websites typically heralded for their emphasis on user-created content and interactivity actually show very small numbers of users actively creating content. Just 0.16 percent of YouTube visitors upload video, 0.2 percent of Flickr visitors upload photos, and Wikipedia gets edited or expanded by a mere 4.6 percent of users (Prescott & Hanchard, 2007). The more recent explosion of the user-friendly microblogging platform Twitter has not radically increased content creation either. In a study of over 11.5 million Twitter users, Alex Chang and Mark Evans (2009) found that 85.3% post less than one Tweet per day and 21% of users have never posted a Tweet. It appears that most users of these popular social media sites are reading, watching or listening, not necessarily using the interactive features to create content. In other words, despite *Time*'s claim that an "explosion of productivity and innovation" was rocking media culture to its core, many audiences still used, and continue to use, new media in typically old-media ways (Grossman, 2006).

Instead of valorizing the mere availability of interactive spaces as the key to changes in media culture, Jenkins' (2006a) introduction of the notion of participation to the study of online audiences turns our attention from the technological affordances of new media to the complexities of audience engagement as a driving force behind these cultural shifts. Participation refers to the cultural and social goals and practices that shape how, why, when and where audiences engage with media content, recognizing the agency in such audience practices. Jenkins suggests individual audience members "participate in the production and distribution of cultural goods—on their own terms," rather than assuming such practices are dictated by technology alone (p. 133). These terms may not include the use of prescribed interactive spaces, such as posting comments or emailing bloggers, yet these practices are no less active and

meaningful just because they are invisible or imagined. Similarly, celebrity-watching audiences have always used gossip to actively make and remake the meaning of that image. Both written and spoken gossip allow celebrity-watching audiences to link abstract social ideologies to a "real" person, offering a concrete way to discuss and negotiate social meaning about questions of identity (e.g., what it means to be a "woman" in our society) or proper social behaviors (e.g., how to be a "good mother") within their everyday lives. But some of the most important aspects of that activity, reflecting Jenkins' notion of participation, are not necessarily visible; rather they occur on the level of abstraction.

Since reading remains the primary mode of engagement on celebrity gossip blogs (and one that feeds other more visible public content-creation practices), Jenkins' distinction between interactivity and participation is central to this analysis of celebrity gossip blogs and their audiences because it recognizes the value of such invisible engagements and imagined community-building practices as part of the everyday cultural production of gossip. The negotiation and judgment of social norms characteristic of gossip media texts are meant to draw a reader into a sense of moral community with others. This community is largely imagined, as it is tied together not through face-to-face interaction between members, but through a mental understanding of a broader connection based on shared affinity and world-view. Gossip blogs, in contrast to print magazines, may offer technological space for such meaning-making to become part of the visible content of the blog. Though this does not preclude the continued existence of other forms of solitary meaning-making fed by celebrity media consumption, it does give new visibility and power to audience gossip practices. Celebrity gossip blogs remain grounded in the interpretive and social aims of gossip talk but engage the technological capabilities of new media as the medium through which users connect with the celebrity image and with each other in complex ways.

The Rise of Celebrity Gossip Blogs

It is difficult, if not impossible, to pinpoint the exact moment when blogs became a major force in celebrity gossip media. This book examines blogs and their role in celebrity culture in the late 2000s, a moment when their impact was beginning to be felt across the celebrity media industry. As evidenced by *Time*'s declaration of "You" as the Person of the Year in 2006, the mid-to-late 2000s were a key moment of transition within the media industry when amateur producers and active audiences were redefining media culture (Grossman, 2006). The first free blogging software, Pitas, was released in 1999 and was followed in 2000 by Blogger (which was purchased by Google in 2003). These

and other widely available and user-friendly blogging software products enabled gossip bloggers to create their own sites and define their own voices within celebrity culture outside of traditional media hierarchies. While there is a long history of media audiences creating their own media around their favorite media texts (e.g. Jenkins 1992; 2007), gossip blogs are distinctive for the ways this audience-produced content has intervened into the industry itself. The rapid rise of celebrity gossip online was not simply a result of mainstream print magazines creating online platforms, but of audiences creating their own gossip spaces. For example, Perez Hilton began his eponymous blog in 2005 and by early 2007, it was among the top five most popular celebrity news sites, according to Nielsen//NetRatings, beating out the online sites of magazines like *Us Weekly* and *In Touch* (Bausch, 2007). The site's audience grew a staggering 215 percent between July 2006 and July 2007, landing in the top ten most visited online entertainment (not just celebrity) sites in August of 2007 (Tiffany, 2007). This is not to suggest gossip blogs have completely overthrown the traditional gossip media players in the online realm, as major players like *People* and *E! Online* regularly out rank Perezhilton.com. In May 2008, for example, *People's* online portal drew over 9 million unique visitors to Perezhilton.com's 2.5 million (ComScore, 2009). These numbers still reflect a niche audience, as both sites were attracting less than 1 percent of the overall Internet traffic, according to tracking data from Alexa (2009b). Nevertheless, the fact that a blog started just one year prior by an individual outside of the celebrity industry even competes with traditional industry texts and entered the top ten of overall entertainment sites points to crucial shifts within the media and celebrity industries. In just a few short years, gossip blogs like Perezhilton.com reshaped the gossip media industry in terms of what sort of content is produced, who produces it, under what conditions and how audiences engage with that content. This book seeks to understand the history of the gossip blog through the ascendancy of these blogs during this key moment of transition within media culture.

The ephemeral nature of both celebrity culture and new media technologies present a challenge to the slower work of academic analysis and publishing. Today's biggest star, as well as today's hottest website, can easily disappear or be usurped by another the next, and books move at a much slower pace than either of these objects of analysis. But the constant change that characterizes these new media texts and the celebrities they cover should not preclude the close and in-depth analysis of academic study, as the historical contexts the development and use of new media technologies as means to engage with celebrity are crucial to understanding contemporary trends in popular media culture. The technology of the Internet enables change to happen quickly and often, and continued changes within the genre demand further analysis.

Nevertheless, this book attempts to historicize the celebrity gossip blog and its role in contemporary celebrity culture by identifying broad and significant themes and patterns in the production, circulation and reception of these new media texts. Though the blogs examined here have changed in many technological ways, including format and layout changes or shifts in interactive features, I argue the social practices behind the production and reception of gossip blogs remains rooted in the pleasure and possibilities of gossip talk as a form of cultural meaning-making and the increased public visibility of such audience practices. Looking closely at blogs during this moment of transition provides insight into how and why such changes occurred as well as how this impact continues to be felt within the celebrity and celebrity media industries today.

In order to investigate the ascendancy of this particular form of gossip media, I examine six popular, advertiser-supported and American-based celebrity gossip blogs, Perez Hilton (perezhilton.com), Pink is the New Blog (pinkisthenewblog.com), Pop Sugar (popsugar.com), Jezebel (jezebel.com), What Would Tyler Durden Do? (wwtdd.com) and The Young, Black and Fabulous (theybf.com). Each of these blogs will be discussed in detail throughout the book, beginning with a general introduction in chapter two. Rather than attempting the overwhelming and rationally impossible task of examining every celebrity gossip blog available on the Internet, I instead strategically chose exemplars that demonstrate the range of technological and social attributes that characterize the celebrity gossip blog genre. Each blog I have chosen offers a different perspective on celebrity culture and highlights varied ways of understanding celebrity images through gossip talk. The fact that they are popular enough to garner advertising support is crucial, as the open nature of blogging means that anyone with access to a computer and something to say could, potentially, create a blog. Indeed, a Google search for "celebrity gossip blog" on October 12, 2007 yielded over 5.6 million results, clearly indicating an examination of the genre as a whole would be impossible. But the ability of these few blogs to draw audiences (and advertising dollars) large enough to threaten print magazines' dominance has reconfigured how celebrity gossip is produced and consumed within contemporary celebrity culture. These blogs emerged as commercial archetypes that helped define the category of celebrity gossip blogs as distinct media forms and illustrate the ways in which the gossip genre has adapted, both technologically and socially, to remain popular with audiences. My investigation of these specific blogs will offer an illustrative, but not prescriptive, view of the broader genre of celebrity gossip blogs and their audiences.

Though celebrity gossip blogging is certainly a global media phenomenon, it is hard to separate the influence of celebrity gossip blogs from an American

context. First, despite an increasingly globalized popular culture, celebrity culture itself remains tied to American stars. Given the history of America's global dominance in the entertainment industry and the contemporary fact that a handful of American-owned media corporations control the vast majority of the global entertainment and information industries, it is not particularly surprising that America regularly exports global celebrity but rarely imports it (Artz & Kamalipour 2007). Non-American celebrity cultures certainly exist, for example the robust celebrity culture within the Indian Bollywood film industry, but these celebrities are localized and rarely translate outside of their specific national contexts or appear within mainstream American celebrity culture in the same way American stars regularly cross global borders. As Barry King (2003) points out "'Big in Japan' is not the same semantically as 'Big in America'" (p. 49). The popular American-based celebrity gossip blogs I examine here play an increasingly important role in the global export of American stardom and its attendant social ideologies, but I do not claim they represent a global approach to celebrity culture. Furthermore, though many of the blogs I examine here do draw global audiences, their focus on American celebrity still attracts a predominantly American audience according to web traffic data. Following Dyer's (1986) claim that stars are the historically grounded "embodiments of the social categories in which people are placed and through which they have to make sense of their lives," I argue these American-based celebrity gossip blogs provide further insight into how American audiences use celebrity gossip to negotiate dominant conceptions of identity at this particular moment in American culture (p. 18). Further research on how the technological and social aspects of the celebrity gossip blog have been deployed within non-American celebrity cultures as well as how global audiences read American celebrity gossip blogs are needed, but such analysis falls outside of the scope of this book.

The first part of this book will focus on the role new media technologies play in the production of gossip media texts, investigate the historical role of these texts in defining celebrity culture and explore how gossip blogs have reconfigured audience engagements with celebrity culture with the new media landscape. As with other new media forms, there is a tendency to valorize celebrity gossip blogs as doing something completely "new" through a focus on the genre's technological affordances. However, this technological determinist argument glosses over the fact that gossip blogs are, ultimately, texts. While celebrity gossip blogs certainly offer *something* "new" to the social context of media development and use, particularly in terms of audience interactivity, participation and cultural production, this book begins with a look at their origins within celebrity gossip media and a textual analysis of how they function as gossip media texts. After all, despite all their new media bells and whistles,

blogs remain, like their print tabloid predecessors, text- and image-based media. Understanding the textual similarities between blogs and print media helps reveal how blogs have both embraced and reshaped traditional ways of writing and reading celebrity media.

Chapter one looks at the historical role the celebrity image plays in the creation and circulation of social norms and how a distinct media industry based on celebrity gossip arose to aid in that process. This chapter lays the foundation for understanding how gossip about celebrities has historically functioned as part of media devoted to celebrity culture and the role it plays in the cultural power of celebrity images. Drawing on existing scholarly work, I approach gossip as a mode of cultural production based on shared negotiation and judgment of the social behaviors and values of others. Gossip is not simply about possessing knowledge, but about evaluating that knowledge in order to help structure the gossipers' social network and understanding of the cultural world. It is an informal mode of everyday communication concerned with situating, interpreting and transforming information against the background of one's own social position and interests. Celebrities, as will be discussed in this chapter, are ideal objects of gossip talk because their widely circulated images are easily accessible symbols that anchor such meaning-making practices. The celebrities covered on gossip blogs, as well as the audiences gossiping about them, are overwhelmingly female, making celebrity gossip a key site of women's culture production. That is, I argue that celebrity gossip is not just media *for* women, but also media *about* women and the ways women, their bodies, sexuality and gender roles are represented and policed (often by other women) through gossip. For example, through the consumption and negotiation of celebrity gossip media coverage of Britney Spears' battle for custody of her children amidst rumors of her failing mental health and potential drug use, celebrity-watching audiences used gossip to reach moral consensus about what ought to define motherhood in contemporary culture. In this case, criticizing Britney as a "bad mother" served to set boundaries and determine what a "good mother" ought to be.

Chapter two is a close analysis of the technological affordances that shape celebrity gossip blogs as new media texts and the content that emerges within the constraints (or freedoms) these affordances offer. After defining the genre of celebrity gossip blog in a broad sense, this chapter offers a close textual analysis of what is said on celebrity gossip blogs (and who says it) in order to trace the shifts in celebrity gossip media engendered by new technologies. My intent is to reach an understanding of the social and technological influences on the production of celebrity gossip blogs as unique textual forms and how blog gossip produces and circulates social norms. I began observing these blogs in 2007 and conducted a more intense, five-week online observation from

February through March 2008. During this fieldwork period, I visited each site at least once per day (depending on the blog's posting schedule) and remained on the site for as long as it took to observe and document the available content. My extended and intensive fieldwork offers a holistic investigation of gossip blogs as new media texts and focuses on the blogger and his/her approach to celebrity culture over time rather than through singular or selected texts. Though my discussion does not engage every part of a particular blog, the overall understanding of each blog is advanced by this extended look at these constantly evolving texts. In reproducing examples of these texts within this book, I reformatted for readability (e.g., converting pink fonts to black) and in order to save space (e.g., removing user avatar images). I retained, however, the textual effects (such as capitalized or italicized text) as well as all syntax, spelling and/or grammatical errors as they appeared in all blog posts and reader comments in order to preserve these texts as they appeared at that moment in time. The inclusions of hyperlinks in the original blog post are indicated here by **bold text**. Additionally, several of the images discussed in this chapter are reproduced from the website where they first appeared in order to preserve the blogger's (obvious) manipulation of the image as a form of gossip commentary.

Defining blogs as texts is complicated by their fluid and participatory nature. New media technologies have reshaped practices of production, distribution and consumption of media texts, in part, by blurring the lines of distinction between the role of producer and consumer of media. While this undeniably shifts how we understand the ways in which these blogs are read, it also impacts the ways these texts are produced and who produces them. Chapter three examines the celebrity gossip blogger as a media producer who takes full advantage of the blurring of the producer/consumer divide that characterizes engagement with new media. Unlike online versions of print tabloids, those who author celebrity gossip blogs approach celebrity culture primarily as audience members/fans, not as journalists or publicists. This positions the blogger outside of the category of "professional" celebrity media industry producer. Bloggers are fans, amateur gossip writers who use their own engagement with commercial media to produce and circulate their own gossip texts outside of the traditional circuit of celebrity production. At the same time, the popularity of some blogs—and the attendant ad revenue generated—demands a rethinking of the category of "professional" media producers. Bloggers are both audience members and producers, and this paradoxical position illustrates the ways new media, in both technological and social terms, has destabilized the traditional hierarchies of commercial media production.

As the primary producers of content on their blogs, bloggers provide insight into the process of blogging and the role of the blogger within celebrity

culture. Though blogs are written from the subjective perspective of the blogger, even an extended observation of these texts offers only a partial understanding of the processes and motivations behind blog writing. In order to address this absence as well the shifting locus of cultural production within new media, I conducted oral interviews with five of the six bloggers and, as will be discussed in more detail in chapter three, compiled an archive of popular press interviews with the remaining blogger, Perez Hilton, who declined to be interviewed for this project. These interviews allow the bloggers to define their role in celebrity culture in their own terms, rather than having a prescriptive definition of producer or audience placed on them. In my analysis of these interviews, I not only considered what the bloggers said in the interview but placed this insight in the context of what they say on their gossip blogs, allowing for a more complex look at gossip blogs as new media texts.

The final chapters of this book foreground the ways in which the predominantly female audiences of gossip blogs use gossip talk as an active engagement with celebrity culture that highlights the celebrity image as cultural conduit. Though audience engagement is relevant throughout, I will specifically address the role of gossip as a mode of public cultural production and community-building for audiences of celebrity gossip blogs in chapters four and five. The power of gossip media lies in its ability to disrupt celebrity industry control by promising audiences access to the "unauthorized" and "real" individual behind the constructed façade. This suggests gossip media has always offered audiences some space to resist the dominant meanings forwarded by celebrity culture. At the same time, while I frame gossip as an active engagement with celebrity culture, I do not assume that all meanings made through gossip talk are necessarily transgressive. Gossip talk can work as a mode of social control that upholds oppressive norms, particularly around questions of social identity. These chapters will explore the possibilities and limitations of the multiple forms of gossip talk on celebrity gossip blogs as an active and socially oriented audience practice.

Since reading remains a primary mode of engagement with new media platforms, chapter four begins with a look at a range of often-invisible audience reading practices and how they engender a sense of community among readers within the public space of the blog. While the presence of reader comments on celebrity gossip blogs clearly indicates some sort of engaged audience, this represents only a small percentage of the actual reading audience and conflates interactivity with participation in ways that ignore the range of social contexts audiences bring to their engagement with new media. These contexts can include identity categories like race, class, gender or sexuality as well as conditions of reading (e.g., reading at work or at home) and reading strategies (e.g.,

audience commitment to the practice of commenting vs. reading alone). In order to access these more invisible audience practices and how they contribute to a sense of community (both real and imagined), I conducted an online qualitative reader survey. As with the blog texts, reader responses to the online survey are reproduced with original spelling, grammar and syntax in order to accurately reflect the readers' own words. The analysis of the survey responses paints a portrait of the audiences who consume celebrity gossip blogs and the range of reading strategies that shape their choice of blog(s) to read and their modes of engagement on that blog.

Chapter five looks at the visible community of commenters—those readers who actively contribute to the content of the blog through the comments sections—and the social practices involved in their participation. The technological affordances that shape the comments sections and other interactive spaces make reader engagement publicly visible but impose certain limitations on that visible engagement. But how commenters actually use these spaces and why some readers choose not to participate in the comments sections reveals something about the social dimensions of participation and the strength of the community on a particular blog. Through discursive analysis of the comments sections across the blogs supplemented with additional data from the qualitative reader survey, this chapter examines the social goals and practices that shape the unique forms of community on each of these gossip blogs. Each community unites around gossip and celebrity culture, but negotiate and evaluate the latest celebrity dish in distinct ways that speak to the particular ideological lens offered by the blogger. In this sense, the blogger possesses a great deal of power in defining not only what celebrity content will be covered, but also how it will be covered. This control is never absolute, and the negotiation inherent to gossip talk is central to the community of commenters on a gossip blog. This chapter investigates how bloggers and audiences use celebrities as ideological anchors for discussions of larger questions of social values and norms. It explores the relationship between the technological affordances of the blog and the social practices and goals of the commenter community in order to understand how and why commenters make meaning through gossip about celebrities on blogs and in their everyday lives.

In the concluding chapter, I synthesize the analyses of the gossip blog texts, producers and audiences, as well as discuss technological and social changes that have occurred on these blogs since the time of my fieldwork, in order to understand the broader impact of participatory culture on celebrity and media cultures. Celebrity gossip blogs demonstrate the necessary relationship between technological affordances and social practices in understanding new media cultures and their roles in our everyday communication and connection with

others. Gossip remains a pleasurable mode of engaging with celebrity culture and is a mode of communication well suited to the technological affordances of immediacy and interactivity that shape new media. Within celebrity culture, the rise of this participatory media culture wrests the power of meaning-making away from traditional celebrity producers and highlights the rising influence of audience meaning-making practices, particularly gossip, in shaping the social power of celebrities. Audiences have always used gossip as a key entrance into celebrity culture and a site of social meaning-making, but new media technologies open new public spaces for this talk to occur online. This is at once "new" and "old," as new media take existing audience practices and reconfigure them in a new public online settings that foreground the complexities of audience engagement with celebrity culture. This is an important shift in celebrity culture, one that reaffirms the importance of audiences in the production and circulation of celebrity images and recognizes the value of gossip talk as a means of cultural production.

Chapter 1

The Celebrity Image and Gossip Media

What is a celebrity? In contemporary popular culture, the idea of "celebrity" is so wide and varied that it seems everyone gets his or her proverbial fifteen minutes of fame. How can we understand a category that includes everyone from Oscar-winning actresses to reality television contestants to athletic champions to political mistresses? More importantly, some social critics ask, why is there so much media attention to these individuals and their exploits? Whether we love to hate it or hate to love it, celebrity has infiltrated every part of contemporary popular culture. Like a train wreck—a metaphor tellingly used to describe those celebrities whose excessive behaviors are regularly featured in mainstream media as well as celebrity gossip outlets—it is hard to look away from the ongoing sagas of celebrities as they are exhaustingly documented across the mass media. New media technologies, particularly the Internet, have intensified this constant coverage, documenting the mundane daily activities of the stars as well as breaking details on the latest scandal. Though this coverage appears to some to be a shallow and meaningless distraction, looking closely at celebrity culture reveals a great deal about American culture and social identity. This book is not an attempt to determine who should and should not be included within the ranks of contemporary celebrity culture, or whether or not media attention to them is excessive, unwarranted or even distracting. Instead, this book seeks to understand celebrity as a social phenomenon—how cultural pervasiveness of the celebrity image positions it as a key site for the representation and negotiation of issues of the self and identity within modern American culture.

Generally, though not exclusively, emerging from the entertainment industries, the celebrity, in a basic definition, is a public figure whose image is highly visible across the media. But, as Graeme Turner (2004) points out, the category of celebrity is unique because unlike other public figures, celebrities' "private lives will attract greater public interest than their professional lives" and their "fame does not necessarily depend on the position or achievements that gave them prominence in the first instance" (p. 3). The recognition of talent or skill may bring an individual into the public eye, but the category of "celebrity" extends beyond this professional labor, say as a pop star or an actress, to

encompass every aspect of her persona. Speaking specifically of film stars, Dyer (1986) says the celebrity image:

> consists both of what we normally refer to as his or her "image," made up of screen roles and obviously stage-managed public appearances, and also of images of the manufacture of that "image" and of the real person who is the site or occasion of it. (pp. 7–8)

It is not simply their ubiquity across media that makes celebrities potent ideological symbols, but how these various mediated representations work to "articulate what it is to be a human being in contemporary society" (ibid., p. 8). As an image, the celebrity is socially grounded and contextualized within the historical conditions in which it is produced, expressing contemporary cultural concerns about the self though a widely disseminated and highly identifiable media image. Though a range of media have been involved in the expansion of celebrity culture within American popular culture, this book is focused on the ascendancy of celebrity gossip blogs in the early 2000s as a moment of transition that affected the construction, circulation and consumption of celebrity images. Chris Rojek (2001) points out that "mass-media representation is the key principle in the formation of celebrity culture," and this chapter offers a brief overview of the development and rising influence of the celebrity within American media culture in order to understand the contemporary role of gossip blogs in celebrity culture (p. 13).

Stardom and Celebrity: Understanding the Image

In his 1985 book *Intimate Strangers: The Culture of Celebrity*, Richard Schickel suggests that the history of celebrity in Western culture is closely linked to the history of communication technology, demonstrating the crucial role media play in celebrity culture. As new forms of media develop and older forms find new ways to reach larger audiences more quickly, demand for and availability of information has skyrocketed. Ideally, easing and increasing the flow of information would achieve the democratic ideal of a well-informed public who are astutely tuned in to the world around them. However, Schickel sees the information explosion in modern society as having the opposite effect. As information is spread wider and faster, it necessarily becomes more simplified, relying more heavily on simple symbols "that crystallize and personify an issue, an ideal, a longing" (p. 28). These symbols "help us to resolve ambivalence and ambiguity" not only about wider social issues, but also speak to "private needs and desires," helping audiences to make sense of themselves within an increasingly fragmented modern Western capitalist system (ibid.). Rojek (2001) similarly argues:

To the extent that organized religion has declined in the West, celebrity culture has emerged as one of the replacement strategies that promotes new orders of meaning and solidarity. As such, notwithstanding the role that some celebrities have played in desta-bilizing order, celebrity culture is a significant institution in the normative achievement of social integration. (p. 99)

Such accounts of the social function of the celebrity image recognize that while celebrity remains a commercial process, the image produced, circulated and consumed within that system is "one of the key places where cultural meanings are negotiated and organized" (Turner, 2004, p. 6). That is, the audience's "affective investment" with the celebrity image, the ways in which they use the image to make sense of larger questions of the self in contemporary society, is crucial to the construction and maintenance of celebrity's economic and social power (Marshall, 1997, p. 75).

Schickel (1985) claims that our fascination with celebrities, as well as their power as cultural symbols, is rooted in the "illusion of intimacy" constructed between the audience and the celebrity figure by a range of media forms (p. 4). He suggests a "finely spun media mesh" has ensnared audiences into thinking "we *know* [celebrities], or think we do. To a greater or lesser degree, we have internalized them, unconsciously made them a part of our consciousness, just as if they were, in fact, friends" (ibid.). While the audience may recognize that the star seen on screen or stage is a highly constructed figure, that star is brought close and revealed as a regular person through the (public) media coverage of the details of her private life. These boundary crossings between public and private selves have always been central to the representation of all forms of celebrity within mass media. In contemporary celebrity culture, however, the distinctions between public and private selves are increasingly blurred. A star image may be built on the public display of talent but its cultural reach is expanded through media coverage of the private, such as in the case of actress Angelina Jolie, while other public figures, such as Kim Kardashian or Nicole "Snooki" Polizzi, parlay media attention to their private lives into more legitimate "professional" media appearances. Dyer (1986) argues "the whole media construction of stars encourages us to think in terms of 'really,'" search-ing the mediated image for signs of the authentic and "real" individual beneath the surface (p. 2). This is not to suggest that these private life details are any less constructed than the professional or "public" self. But they *seem* real and authentic *through* the association with the private, and thus "bespeak our society's investment as the private as the real" (ibid., p. 13).

The celebrity, then, is best understood not as a person, but as a representa-tion of a person that helps audiences sort out what it means to be a human being in contemporary society. Though celebrities are real people, our cultural

interactions with them remain at the level of image and signification because, as Dyer (1998) argues, "we never know them directly as real people, only as they are to be found in media texts" (p. 2). In other words, though there is a real person known as Britney Spears, the celebrity known as "Britney Spears" exists only through media representation of her professional and private life. This image appears natural and authentic, but is the product of a system of celebrity production in which various cultural intermediaries participate in and struggle over the publicly circulating image of "Britney Spears" within and through various media forms.

Gamson (1994) suggests these cultural intermediaries fall into three distinct but linked industries responsible for packaging, promoting and distributing the celebrity image to consumers: the independent celebrity producers, the entertainment institutions and the entertainment-news media (pp. 62-63). These are the traditional celebrity production "professionals" who are responsible for crafting and controlling the celebrity's public persona—both her performing self and the glimpses of the private and "real" self. No celebrity can emerge fully formed into the public consciousness without the aid of these workers, whose at times uneasy co-existence is marked by both struggles for control over the image and shared rewards from the work of the others (Rojek, 2001). No one player holds a monopoly as the starting point of fame, though some may play a greater role in maintaining (or changing) the celebrity's image. Understanding the role of each of these cultural intermediaries and the tensions between them reveals a great deal about the how fame is built and managed within contemporary celebrity culture.

According to Gamson, the category of independent celebrity producers includes workers like publicists, agents, managers and other specialists who build up the celebrity's attention-getting power as a means to sell that image to other commercial industries. These workers function as gatekeepers who control the access to the celebrity product, building up the perceived value of the celebrity as a commodity through authorized media appearances that promote name recognition, which are in turn "cashed in…for jobs" with the second category of celebrity industry workers—the "entertainment institutions," such as film studios, television networks, record labels etc. (Gamson, 1994, p. 62–63). Though talent and ability are tied to performance-related jobs, the entertainment industries are ultimately concerned with the celebrity's power to draw an audience, thus closely tying the celebrity with the perpetuation of consumer culture. In addition to drawing audiences to films, television shows, pop music albums or other public performances as well as to ancillary media like tabloids, celebrity images are deployed to promote a range of consumer products. As Schickel (1985) points out, celebrities "can sell us anything, given

the right circumstances" (p. 29). Celebrities do sell us "things," but do so by embodying ideologies of individualism, freedom and authenticity central to Western capitalist culture. That is, these meanings are "expressed in a commodity form" through the celebrity image and negotiated (and consumed) by audiences as a means to make sense of everyday life (Marshall, 1997, p. 18). What draws us to celebrities, and valorizes their economic power, are the social meanings they embody.

The celebrity image is a key site "for the configuration, positioning, and proliferation of certain discourses about the individual and individuality in contemporary culture," making the appeal to the "ordinary" private self a central facet of all celebrities' public presence (Marshall, 1997, p. 72). This economic interest in the attention-getting power of the celebrity as an embodiment of individualism has opened the category to include personalities who become celebrities by simply "being themselves" rather than display any discernable talent. The clearest contemporary example of this category of celebrity is the reality television star. While few would argue that reality television stars like Snooki or Kim Kardashian are celebrities in the same way Angelina Jolie is a celebrity, these public figures are central players in contemporary celebrity culture precisely because of their attention-getting power as representations of the individual in modern society. Turner (2006) labels this the "demotic turn" in media celebrity where "ordinary" people "who have no particular talents which might give them the expectation of work in the entertainment industry" are made famous by just "being themselves" for reality television cameras (and other media platforms) (p. 156). This form of celebrity reinforces the necessity of media representation to the cultural and economic power of celebrity. Thus, both the independent celebrity producers and entertainment institutions rely heavily on the third industry—the entertainment-news media—to circulate their preferred version of the celebrity to audiences.

The entertainment-news media are responsible for publicizing the celebrity image in order to maintain the attention-getting capacity that is key to the celebrity's continued presence in public consciousness and viability as a commodity in all spaces of production. The entertainment-news media are linked with both the independent producers and the entertainment institutions, but this symbiotic relationship is marked by a constant struggle for control over the celebrity image and its cultural meaning. These media institutions must choose sides, "either resisting or giving in to the bids by others to control coverage" in order to continue to function (Gamson, 1994, p. 95). Entertainment-media outlets like *Entertainment Tonight*, *Vanity Fair* or *People* gain a certain level of legitimacy by giving in to such control. In exchange for playing by the rules set out by the independent celebrity producers, for example limiting

interview questions to certain approved topics or allowing the publicist to choose the reporter/interviewer, entertainment-media outlets are given more direct—yet still controlled—access to the celebrity. This is not to suggest these "legitimate" outlets are purely mouthpieces for the other producers. Even when playing by the rules of the system, the entertainment-news media maintain a certain level of power in terms of circulation of the celebrity image. Without these outlets, the specific inflection of the celebrity so carefully crafted by the other workers would lack the necessary public visibility media provide. The entertainment-news media can thus use their own power and aura of legitimacy as leverage for greater flexibility in promoting a particular celebrity image. By working together, these three players attempt to close the system of production in an attempt to secure a unified celebrity image whose ability to draw audiences not only to the commercial products associated with the celebrity but also to a particular set of discourses on the self that benefits all points on the circuit.

However, those who resist, yet still participate in, this system are not without their own power, particularly since audiences' pursuit of who the star "really" is in her unguarded moments prompts them to look for information outside of the professional and controlled discourses available in legitimate sources. Gamson notes "autonomous outliers" like tabloid or gossip magazines such as *Us Weekly* or *Star* may lose direct access to the celebrity by resisting the independent producers' attempts at control, but gain legitimacy because of their exclusive focus on supposedly "true" details of his or her private (read: uncontrolled and unstaged) life. It is precisely the perception of their outsider status that makes tabloids appealing to audiences because it allows them to break down the façade so carefully constructed by the other producers and uncover the "real" individual behind the glamorous star. At the same time, these outlets are still participating in the system, both benefiting from and pushing against the efforts of the other players. By revealing the star in her "unguarded" moments, tabloids demonstrate how media play a central role in producing and circulating the celebrity image as well as supporting the illusion of intimacy and authenticity that defines the celebrity/audience relationship, unifying the economic and social roles of celebrity culture.

Celebrity, Ideology and Media

The increased emphasis on the private individual behind the façade of stardom by both legitimate celebrity producers and the autonomous outliers in entertainment media is a key part of the growth of celebrity culture. Prior to 1910 when Carl Laemmle of the Independent Moving Picture Company first publicized the names of his film actors, fans did not know who even played in their favorite films, let alone the details of their private lives. Increasingly

interested in knowing about the players as real people, not just about the roles they played on screen, fans bombarded studios and fan magazines with letters requesting information about the private lives of their favorite stars. By 1920, movie fan magazines responded to audience demand by shifting focus from the technical and professional aspects of Hollywood to lifestyle stories about stars' "homes, vacations, cars, and in particular, their romances" (Barbas, 2001, p. 28). While early fan magazines, such as *Motion Picture Story Magazine* and *Photoplay*, did provide details of the private lives of stars in response to audience demand, studios carefully controlled and at times even fabricated these private details in order to align the star's "real" self with his or her screen roles. Offering reassurance that stars were, in real life, who they seemed to be on the silver screen, celebrity media (in collusion with the studios and other industry producers) reinforced the values that star represented in popular culture. More crucially, through the focus on the glamorous lifestyles of celebrities, these fan magazines played a key role in shaping celebrity images as sites of economic and social aspiration, selling the dream of middle- and upper-class mobility and tastes to their audiences (Sternheimer, 2011). Celebrities served as symbols of American success, teaching audiences how to look, think, feel and act as individuals within contemporary culture.

This tight control over and regulation of media representations of the stars' private lives began to break down in light of the star scandals of the 1920s, such as the Roscoe "Fatty" Arbuckle rape trial in 1921. In the wake of such scandals, star discourse shifted to emphasize the secretive or hidden self behind the mask of fame. Richard deCordova (1990) says, "the fascination over the players' identities was a fascination with a concealed truth, one that resided behind or beyond the surface of the film…The private finally emerged as the ultimate or most ulterior truth" (p. 140). Star discourse still glorified the glamorous and affluent lifestyles of stars, but also began to tell tales of the moral hazards of fame that brought the star back down to earth. Celebrity media framed celebrities as either deserving or undeserving of the rewards of fame by virtue of how they conducted their private lives more than by their public performances or claims to talent.

Audiences voraciously consumed movie trivia and celebrity news in both fan and mass-market magazines throughout the 1920s and 30s, but became increasingly skeptical of studio and media control over star images offered in these sources, recognizing that the star image is a social construction. Yet such skepticism did not translate into a rejection of the new private life discourse around stars as purely fabricated, but rather it intensified the pursuit of the "real" through gossip. Since the illusion of intimacy central to the star/fan relationship promotes a powerful curiosity about a star's personal life as a

means of authenticating the individual seen on screen, fan magazines shifted from a focus on the professional to the personal in order to profit from these audience desires. Studios capitalized on this, feeding tightly controlled and even staged versions of the star's private life to fan magazines in order to reinforce their preferred meaning of that star's public image. But as fan magazines and tabloids began competing in a race to bring the audience more detailed and potentially sensationalistic stories about the stars' lives, they circumvented studio publicity departments and turned to other "insider" sources for stories. This "Hollywood information war" resulted in the rise of "conflicting, sensationalistic and often highly contested celebrity journalism" that continues to define the celebrity media genre today (Barbas, 2001, p. 108). The seemingly unauthorized glimpse inside the private lives of celebrities, not professional discourses, became the standard of celebrity media and the celebrity images produced within it. Such coverage is grounded in gossip talk, as it seeks to negotiate the tension between the public and private self and between the constructed and the real as a means to make sense of the celebrity as an ideological symbol.

Reading Celebrity in Gossip Media

This shift to gossip about the private lives of stars intensified during the Golden Age of Hollywood as gossip columnists like Walter Winchell, Louella Parsons and Hedda Hopper reframed the ways audiences engaged with celebrity culture. In his biography of Walter Winchell, Neal Gabler (1994) argues:

> in 1925, at a time when the editors of most newspapers were reluctant to publish even something as inoffensive as the notice of an impending birth for fear of crossing the boundaries of good taste, Winchell introduced a revolutionary column that reported who was romancing whom, who was cavorting with gangsters, who was ill or dying, who was suffering financial difficulties, which spouses were having affairs, which couples were about to divorce, and dozens of other secrets, peccadilloes and imbroglios that had previously been concealed from public view. In doing so, he not only broke a long-standing taboo; he suddenly and single-handedly expanded the purview of American journalism forever. (p. xii)

Claiming the title of journalist but rejecting the standing journalistic taboo against exposing the private lives of public figures, Winchell defined the genre of celebrity gossip in the early to mid-twentieth century. His column emphasized the behind-the-scenes lives of the stars in ways that humanized these once untouchable glamorous beings by shifting focus from their on-screen performances (though screen personas continued to be relevant) and inviting the audience into their "real" lives. Likewise, though Parsons was not the first to write about stars, her column's exclusive focus on the lives, both glamorous and

quotidian, of Hollywood stars "pioneered a new journalistic format and started a new chapter in the history of American celebrity" (Barbas, 2005, p. 44). Led by Winchell, Parsons and Hopper, gossip columnists in the Golden Age of Hollywood reshaped the role of the entertainment-news media within the celebrity production circuit and set the stage for the unguarded and unauthorized glimpse at star's lives that characterize contemporary gossip media forms. Their columns altered the balance of power by challenging the independent celebrity producers and entertainment industry workers' efforts to define the celebrity image. Consequently, they took the stars off of the screen and into the everyday lives of audiences through gossip talk.

Though these columnists considered themselves journalists, they frequently editorialized, offering commentary on the story that both subtly and overtly shaped the reader's perspective on the celebrity covered. Furthermore, the "facts" reported did not necessarily have to be verified in order to be printed as true. Rather, items *became* true by virtue of being printed by the columnists. While they certainly made efforts to check sources, a "good" item was not necessarily one that was verifiable but one that was sensational or at least presumed to be of interest to the reader, thus reshaping the type of private information about stars circulating in popular culture. In a 1940 profile of Winchell for *The New Yorker*, St. Clair McKelway says:

> [Winchell] continues to print gossip about the marital relations of people who have not applied for divorce, he does not hesitate to hint at homosexual tendencies in local male residents, and he reports from time to time attempted suicides which otherwise would not be made public. He believes that if a thing is true, or even half true, it is material for his column, no matter how private or personal it may be. (p. 30)

The columnists' journalistic style was rooted in the gossip as a mode of communication in which truth is not absolute, but is made and remade through shared negotiation and judgment of information not through objective analysis of facts. This was most clearly seen in the first-person conversational tone of the columns, which emphasized each columnist's point of view as the authoritative voice. Winchell, Parsons and Hopper openly discussed visiting popular restaurants and nightclubs, attending film and theater premieres and generally existing within the sphere of celebrity culture rather than maintaining a distanced objectivity. Indeed, their insider access was offered as proof of their reliability as a source of the latest celebrity dish, rather than evidence of bias, a standpoint we will see later taken up by some celebrity gossip bloggers.

Though the columnists laid the groundwork for gossip about the private lives of celebrities as an important space of audience engagement with stars, they, like their fan magazine contemporaries, retained close, though often

hidden, ties to the studio system. A positive mention in either column was a boon to a celebrity, and studios worked diligently, typically through the use of press agents, to get their clients' names included. The columnists relied on this steady stream of information, but certainly did not print every item brought to them and had other "inside" sources that helped feed the columns. In fact, as Gabler (1994) notes, the press agents were in constant competition to secure space in the popular columns like Winchell's. This was a delicate balancing act of currying favor by offering "free" items "about people and places they didn't represent" in exchange for plugs for their clients as well as "submitting the same items to another columnist" (ibid., p. 244). But crossing these columnists by offering false information or, even worse, negating their exclusive scoop by allowing the same item to run in two different columns at the same time could do incalculable damage to the press agent's relationship with the columnist and the star's public image.

Not simply mouthpieces for the studios, gossip columnists existed in a state of tension with the other producers and industries and worked to legitimate their role in the production of celebrity culture. They fed the illusion of intimacy by offering audiences insider views that generally supported the studio system's interests, but at the same time exercised a great deal of power over just what views would be exposed to the public. Columnists could make or break a star, but also worked closely with studios to control scandals in exchange for additional access to and loyalty (or fear) from the stars. By positioning them- selves as autonomous outliers who flouted industry control and purported to bring readers an unvarnished truth about the private lives of celebrities yet colluding with studios to control the exposure of the stars' lives, the columnists established themselves (and the gossip-based entertainment-news media) as essential and legitimate components of the celebrity production system. The columnists and their form of entertainment-news media were increasingly necessary to circulate the celebrity image and strengthen its cultural and economic reach. As the studio system crumbled and stars gained more control over their own images, the columnists' power was threatened by a new, more invasive form of celebrity gossip: the tabloid.

Early celebrity tabloids like *Confidential* expanded on this emphasis on the private as the key space of engagement with stars by intensifying the focus on the unguarded and uncontrolled private lives of celebrities through increasingly invasive and unflattering coverage. Sofia Johansson (2006) usefully distinguishes the tabloid or gossip press coverage of celebrity culture from the more "legiti- mate" celebrity media in terms of their reverence, or lack thereof, towards their celebrity subject. Tabloids, she argues, focus "on 'exposés' of details the celebrity would like to remain unknown—something that is often the result of

invasive journalistic methods such as cheque-book journalism and paparazzi coverage" (p. 344). Unlike the fan magazine or columnists' formulaic and often pandering coverage of celebrities that results from various levels of collusion with the studios, tabloids promise to "tell readers the *truth*...[and] uncover what had been hidden about the stars" in these other industry-controlled sources (Desjardins, 2001, p. 214, emphasis in original). Tabloids remain economically tied to the celebrity industry but their interest is in revealing the "truth" found when one looks behind the mask of stardom, not in protecting the carefully constructed image. This "truth" worked, in part, to humanize the stars as "just like us" beneath the façade of stardom and offer audiences a way to identify with some stars as role models. But this unguarded "truth" more commonly was used to reveal that stars were *not* like us at all. Audiences could dis-identify with stars, viewing their lives as cautionary tales of the moral hazards of fame and fortune and/or judge whether or not these stars even deserved fame. These behind-the-scenes revelations about the private lives of stars allowed audiences to use gossip to negotiate these claims of the "true" and "authentic" star in order to affirm or reject the social values that star embodied. In this way, the celebrity becomes an anchor for the negotiation of historically and culturally specific discourses on the self.

Part of this appeal to the truth can be seen in the tabloids' purported use of journalistic techniques and objectivity as well as an increased emphasis on photographs as evidence a means to uncover the truth the industry tries to hide from audiences. Though celebrity tabloids are rarely held up as paragons of journalistic integrity, they do retain a certain adherence to interpretive journalism and its standards of objectivity, particularly through the use of attributed quotes, outside sources and an apparent refusal to kowtow to industry demands in exchange for access to celebrities. However, Elizabeth Bird (1992) points out that tabloids still moralize in their reporting, but such comments are less overt and tend to come from quoted sources rather than the writer him- or herself. Under the standards of journalistic objectivity, a "story is 'accurate' if it faithfully reports what was said or written by sources," thus allowing tabloids to claim what is written as accurate, provided it has a source, without having to take personal responsibility for the content (pp. 92–93). This is distinct from the gossip columnists whose personal opinion more blatantly shaped their reporting of the latest celebrity gossip. Despite the claim that "tabloids are often characterized by distorted quotes, pure fabrication of information and sources, absence of any balancing point of view, and the use of paid tipsters and informants," the process and rhetorical style of reporting is similar to the "mainstream" newspapers (ibid., p. 102). In other words, the moralizing and editorializing is couched within claims to objectivity and interpretive journalism,

allowing the audience to come to their own conclusions based on the brief text and, more significantly, from the photographs that dominate the layout.

Unlike the columnists' emphasis on a colloquial writing style to draw readers in and frame the meaning of a celebrity, the tabloids are built around the visual image as an anchor and catalyst for gossip talk. Paparazzi photographs of celebrities in their unguarded moments are presented to readers as evidence of the real person behind the celebrity façade, or at the very least, the anchor for discussion and/or judgment of that celebrity, adding to and drawing from existing knowledge about his or her image. Su Holmes and Sean Redmond (2006a) argue:

> this constant search for truth—even if it is a search for the "lies" that hide behind the idealized mask of stardom and celebrification—is intensified in an age where new media technologies and new media formats have increased the range and nature of surveillance. Digital audio, video and stills photography, for example, have enabled bugging, filming, capturing the star or celebrity, to escalate to a stage where one can argue that there is no longer a "private" realm that the famous person can retreat to, or a "mask" that cannot be shown to be just that. Alternatively, such panoptic devices can be argued to be the very things that show how "real" the star or celebrity is. (p. 210)

That these photos are (at least ostensibly) unauthorized or "stolen" images, rather than sanctioned promotional photos, adds to their sense of authenticity and truth because they interrupt the circuit of controlled celebrity production. They offer candid moments of public visibility in which the celebrity is "off-guard, unkempt, unready" for the camera, offering the audience a penetrating view into the private side of the star they were not meant to see (Holmes, 2005). In contrast to the columnists who often withheld information in order to bolster their power within the industry, tabloids openly challenge industry control over the celebrity image by offering the audience a different, scandal-oriented point of entry into its production and circulation.

Graeme Turner, Frances Bonner and P. David Marshall (2000) argue the nature of celebrity culture is to valorize the celebrity as special and elite while simultaneously valorizing the "intrinsic ordinariness" of the individual behind the glamorous star (p. 13). The signs are so intertwined that it is nearly impossible to separate the "real" from the constructed image, which encourages audiences to continue the pursuit of the authentic individual by consuming more media about the celebrity. Thus, it is the tension between the two sides of the persona, the larger-than-life and the "real" person, coupled with tension between the possibility and impossibility of knowing the truth about her life which makes celebrities so intriguing to the public and such apt ideological symbols. The ultimate irony of celebrity, of course, is that the fan can never

really know the celebrity through any of these celebrity media texts, as they are just as constructed as a celebrity's public performances.

This is not to say that audiences are simply duped by the preferred ideological meanings attached to the celebrity image circulated by the cultural intermediaries or unable to recognize that the celebrity image available in the extratextual media is not any more "real" than the one on screen. The constructed nature of the celebrity sign allows the audience to derive pleasure from the ability to construct and reconstruct the celebrity's star image from a variety of texts in complex and often contradictory ways. This sort of audience engagement is clearly evident in deconstructive readings of celebrity, such as camp appreciation or queer readings of Hollywood icons like Judy Garland, which work against the meanings intended by the media industries that created these images (Dyer, 1986). The audience is a crucial component of the construction of the social meaning of celebrity images and gossip provides them a means to take the meaning of celebrity image out of the text and into their everyday lives. The very pursuit of the "real" by audiences within celebrity media and public performances encourages audiences to think in terms of truth, bolstering their own feelings of intimacy with a celebrity image which in turn supports the image's cultural meaning. Marshall (1997) suggests that:

> the celebrity is one form of resolution of the role and position of the individual and his or her potential in modern society. The power of the celebrity, then, is to represent the active construction of identity in the social world. (p. xi)

Who we think the star "really" is tells us something about who we are or who we ought to be (or ought *not* to be). The never-ending quest for the "real" celebrity bestows upon her persona a heightened cultural significance that is disseminated through all forms of celebrity media, but is particularly central to the pursuit of the "real" celebrity in gossip media as a way to make sense of everyday life through celebrity culture. That is, gossip itself is a key component of contemporary celebrity culture and a key way for audiences to insert themselves into the circuit of celebrity production.

Celebrity, Gossip and Community

Gossip can best be understood as a mode of social and cultural production based on the processing of social behaviors and shared judgments of those behaviors. In his study of the practice of gossip as a mode of everyday communication, Jörg Bergmann (1993) argues gossip, "draws an essential part of its energy from the tension between what [the subject of the gossip] does publicly and what he or she seeks to keep secret as his or her private affair" (p. 53). As

already discussed, audience interactions with celebrity images in the entertainment-news media and the illusion of intimacy such sources promote are built upon this same tension between the private and public self. Seeking the "real" person behind the glamor and social power afforded by celebrity culture, audiences use gossip to push stars off their pedestals in order to validate or reject the social values they embody. Certainly such talk can become a negative or even vicious means of social control, but all gossip talk is not inherently mean-spirited or even necessarily derogatory towards the subject, despite its reputation. The primary function of gossip talk is to bind individuals together, to create a sense of intimacy and connection within the larger context of modern society.

Bergmann (1993) more specifically defines gossip as an informal mode of talk between two or more individuals about an absent third person who is known, to at least some degree, to all participants. Celebrities are always absent, yet knowledge about their private lives is publicly accessible through the media, making them apt subjects for gossip talk. But while Bergmann suggests that gossipers must necessarily be acquainted with the *subject* of gossip, he never establishes the level of acquaintance necessary *between the gossipers themselves* when discussing what he calls "well-known persons" (p. 51). I suggest the well-knownness of the celebrity works to reduce the intervening social distance between strangers by acting as a social conduit, bringing individuals together around shared knowledge and the creation of shared social values. Furthermore, despite the illusion of intimacy between the celebrity image and the consumer of that image, most people are rationally aware that they are not actually acquainted with the celebrity. This makes gossip about celebrities a "safe" way to judge the values and behaviors of others as a means to work out what those standards ought to be. Marshall (2006) suggests "As audiences, we use celebrities to talk about sometimes very intimate and private issues, but in a very public way" (p. 639). For example, gossiping about your sister-in-law's mothering skills may get you in trouble with other members of the family, but shaming Britney Spears as a bad mother allows you to establish a standard of what it means to be a good mother without threatening your own social relationships. In fact, you may strengthen your relationship with your co-gossiper(s), as you come to a moral consensus about what ought to define motherhood using the celebrity as a social anchor for such meaning-making.

Celebrity gossip media helps promote this sense of connection in multiple ways. Joke Hermes (1995) points out that while reading printed celebrity gossip is a characteristically solitary mode of consumption it still promotes this sense of shared connection because of the community-building characteristics of gossip talk. She says, "written gossip tends to create closeness or familiar faces

in a wider world by helping the reader to bring celebrities into her or his circle of family, friends and acquaintances by inviting readers to share in a moral universe that is at times petty, and at times rich" (p. 121). Both written and spoken gossip, she argues, work to forge communities based on "shared standards of morality (with an imagined community of other gossip readers, or with other readers who are present in the flesh) that alternate between disapproval and understanding" (ibid., p. 132). Hermes explicitly hails Benedict Anderson's (1983) notion of the imagined community as a group tied together not through face-to-face interaction between members, but through a mental understanding of a broader connection based on shared affinity and worldview. Even when reading is done alone, gossip gives one the sense of group membership based on shared interests and judgments. It is a valuable mode of cultural production because it allows participants to link abstract social ideologies to a "real" person, offering a concrete way to discuss and negotiate social meaning about questions of identity (e.g., what it means to be a "woman" in our society) or proper social behaviors (e.g., how to be a "good mother") within their everyday lives.

This claim is central to an understanding of how celebrity gossip blogs emerged as a potential space of community building around a shared topic. First, it assumes the physical space in which gossip occurs is less relevant than the topic and the processes of making meaning around that topic. Just as Hermes envisions the solitary practice of reading a gossip magazine as a space of imagined community, I suggest the text- and image-based gossip available on blogs draws readers into similar sense of imagined community or "an intimate common world in which private standards of morality apply to what is and what is not acceptable behavior" (Hermes, 1995, p. 132). However, online gossip blogs further defy the necessity of physical presence as a prerequisite for community building, as, unlike the solitary reading of a gossip magazine, blog audiences can read the gossip on offer and immediately respond to it through the public online forums and/or comments sections available on most sites, all while sitting alone at a computer. Certainly Hermes' readers used their gossip magazine reading to inform and foster later conversations with others, but part of the appeal of the blog is that one can participate in gossip talk as part of the practice of reading these interactive texts. The virtual public space of the blog and its comments sections are more like face-to-face interaction or actual shared gossip talk, but are unique in that the participant can largely maintain the sense of anonymity that further decreases the social risks of gossip. Participants create usernames and typically have a large degree of control over the amount of personal or identifying information publicly revealed when they engage on a gossip blog. The question remains as to whether or not participants see this as a

space of community and how the computer-mediated nature of such a social network shapes their relationships within it, topics that will be taken up throughout this book.

Celebrity culture and the various media forms devoted to covering it have expanded and changed throughout the course of the twentieth century. The rise of new media technologies in the twenty-first century draw on, and in some ways intensify, their historical predecessors' focus on the private individual behind the larger-than-life star and the use of gossip as a means to humanize, and often chastise, the lives of the rich and famous. This book takes a holistic and historical approach to celebrity gossip blogs that recognizes their ties to early forms of celebrity gossip media as well as the complex interplay between the blogs as texts, the bloggers who produce them and the audiences who consume them in shaping the cultural meaning of a celebrity image through gossip talk. The next chapter will explore the technological and social possibilities of celebrity gossip blogs as unique media texts to see how they draw from and expand these conceptions of the construction and circulation of the celebrity image in gossip media.

Chapter 2

Building the Blog: Celebrity Gossip Blogs as New Media Texts

Media in the twenty-first century are marked by the "breaking down of barriers between traditional media industries and the telecommunications sector...redefining the way music, film, radio, television, newspapers and books are produced, manufactured, distributed and consumed" (Burnett and Marshall, 2003, p. 1). Marshall (2006) suggests celebrity culture is a key space to investigate how the participatory nature of new media culture has disrupted traditional conceptions of media texts, producers and audiences. The expansion of new media, he argues, has destabilized "the symbiotic relationship between media and celebrity" by enabling audiences to intervene in the production and circulation of celebrity images and their cultural meanings in previously unprecedented ways (p. 634). As discussed in the previous chapter, celebrity-watching audiences have always been understood as active, making and remaking the celebrity image through their consumption of and gossip about a variety of textual and extra-textual media sources. But the rise of new online forms of celebrity gossip media texts, with their emphasis on interactivity and participation, foreground audience gossip talk in ways that distinguish these new media texts from traditional print forms and illustrate broader transformations in the relationships between audience and text central to a participatory media culture.

Various online gossip-oriented sites exist, ranging from, but not limited to, online counterparts to traditional print magazines (such as usmagazine.com or people.com), entertainment pages on sites that are not otherwise specifically celebrity-oriented (such as NBC News' entertainment.nbcnews.com or Yahoo's OMG.yahoo.com), official celebrity websites and countless unofficial fan sites. This book centers specifically on celebrity gossip blogs as a specific subgenre of online celebrity gossip. I argue gossip blogs are unique new media texts that are produced outside of the traditional circuit of celebrity production and explicitly aim to promote previously unprecedented forms of audience engagement with and gossip about celebrity images. It is these unique features, I argue, that position gossip blogs as a destabilizing force in celebrity culture, as well as an significant example of broader participatory shifts in contemporary media culture. As a text, the blog provides a technological platform for gossip, but what bloggers and audiences do with and within these textual spaces remains

central to this analysis. Consequently, in order to define the blog as a particular form of new media text, and determine how celebrity gossip fits into this genre, we must look at the interdependent relationship between the structure, content and consumption of blogs.

Defining Celebrity Gossip Blogs

Rooted in the chronological record or "log" of events during a nautical voyage, the earliest weblogs functioned as personal online journals and earned their name from their similar chronological organization of content (Rettberg 2008). From this perspective, a blog is most basically defined as a regularly updated web page consisting of short posts arranged in reverse chronological order with the most recent post appearing at the top of the screen. The "post" is the basic unit of a blog, dividing the site into shorter individual entries. Blog posts share two defining textual features—the (hyper)link and blogger commentary—that distinguish them from traditional texts. Jill Walker Rettberg (2008) suggests blogs "are founded upon the link, building connections between related issues," pointing to the interdependent relationship between the technological and the social in defining blogs (p. 1). The link is a technological affordance that structures the blog as a filter of and a portal to existing web content. The link provides information, but the blog is not merely an information-based text. After all, an online newspaper or a corporate website is certainly informative, but would rarely be mistaken for a blog. What makes blogs distinct is the use of the link as a springboard for the blogger's subjective commentary, connecting the technological and the social into a distinct textual genre shaped by and aimed at audience participation.

The social aspects of blogs make this new media genre a logical fit for celebrity gossip. Gossip is a form of everyday communication rooted not simply in the transmission of information, but in the shared negotiation and judgment of that information. In keeping with the broad definition of blogs, celebrity gossip blogs combine existing content (in the form of links and photos) with blogger commentary. This makes them distinct from other celebrity media forms, as they do not simply report the latest tidbits of celebrity news. Instead, they rely on the blogger's commentary to make that news meaningful and to promote dialogue between blogger and reader and between readers. Blogs are inherently social and participatory media texts rooted in the shared meaning-making of gossip.

Given the wide variety of approaches to celebrity online, this book follows Rettberg's assertion that "the best way of figuring out what a blog is is simply to look at some examples" (p. 4). I examine six different American-based celebrity gossip blogs, reading them over time and with an eye to the relationship

between technological affordances and social practices that make each blog and audience community unique. The fluidity of new media platforms means that a prescriptive definition of blogs in general or celebrity gossip blogs more specifically is impractical. Each blog occupies a point on a continuum of celebrity gossip blogs in terms of structure, layout, content, writing style and participatory potential, mapping the complex relationship between technological affordances and social practices that shape new media culture. As with other new media forms, these blogs are constantly changing in all of these areas; what follows is a snapshot of these blogs as they existed from February to March 2008, a time, as discussed in the introduction, when blogs' popularity and power were on the rise. After a brief description of each blog's approach to gossip and celebrity culture, I offer a more in-depth discussion of the shared technological characteristics—namely the post, the link and the visual image—that characterize the broader genre of celebrity gossip blogs and examine the various social inflections of the content created within and through these technological affordances on each specific blog.

Perez Hilton (http://www.perezhilton.com)

Perez Hilton is arguably the most well-known gossip blogger, and, at the time of my observation, his self-owned site, PerezHilton.com (PerezHilton) was the most popular of all the blogs examined here. Though PerezHilton's popularity has dwindled somewhat in more recent years, a topic that will be explored in the final chapter, this moment represented a pinnacle of this blog's cultural power and set the stage for the increased influence of gossip blogs more broadly. All of the blogs examined here regularly placed in the top 100 celebrity sites, according to web traffic data from Technorati. Given the vast amount of celebrity-oriented sites available on the web, such a ranking does distinguish these blogs as among the most popular within this niche genre. Furthermore, from 2007 to 2008, PerezHilton also regularly placed among the top-ten overall entertainment news sites on the web, drawing an average of 1.7 million unique visitors per month in the United States alone, according to Internet audience tracking firm ComScore Media Metrix (cited in Navarro, 2007, para 12). Though, as previously discussed, these numbers are lower than many mainstream online celebrity news outlets, ComScore also calculates PerezHilton logged more than 48 million page-views per month from American-based audiences in the same period (cited in Shafrir, 2007). The difference between these numbers suggests a higher reader engagement from his audience, as "each visitor would have to be looking at about 26 pages, or, obviously more likely, returning that many times as 'visitors'" (ibid., para 7). The retention and high level of engagement common amongst these gossip blogs are appealing to

advertisers, as the more time an individual spends on a blog, the more opportunities for exposure to advertising. According to Henry Copeland of Blogads.com, PerezHilton "commands as much as $9,000 a week for a single advertisement and $45,000 for the most expensive ad package" (cited in Navarro, para 21). Thus, despite their smaller audience numbers overall, the loyalty of audiences to specific gossip blogs presents a challenge to the celebrity media industry.

PerezHilton, like the other blogs, draws its audience through the use of both technological and social features. This blog is frequently updated with the latest details of breaking celebrity gossip as well as ongoing discussion of the daily minutiae of celebrities' lives. As is typical of gossip blogs in general, PerezHilton relies heavily on images in the form of paparazzi photographs to unmask the private and unguarded celebrity behind the carefully constructed public star image. Born Mario Lavandeira, the blogger known as Perez Hilton made his mark by altering these photos using MS Paint as a way to further break down the celebrity façade. He "scribbles nicknames—or penises, or bodily fluids—all over his blog photos in white ink" as a way to mock celebrity and foreground his own reading of a particular celebrity image, often reshaping the public meaning of that image through his gossip (Stack, 2009, p. 34). Perez's popularity as a blogger and (in)famously sardonic or "snarky" take on celebrity culture has arguably brought celebrity gossip blogs to the attention of mainstream media and the general public, skyrocketing Perez himself to a certain sort of celebrity status that speaks to the increasing relevance of gossip blogs within celebrity culture. Furthermore, this status bestows upon him a sort of "fan insider" position that, like the gossip columnists before him, reinforces his authority to report on the private lives of stars as an outside observer within the inner sanctum of celebrity culture.

Though he claims some insider access, the blog is framed as outside of the control of the "powers that be" in Hollywood. Perez fawns over those select few celebrities he likes and relishes in using gossip talk to expose the "real" selves of celebrities hidden by the machinery of fame. In so doing, he determines those celebrities worthy of our adulation (namely those that are "authentic") and those more deserving of our scorn (those inauthentic "fame whores" who crave attention at any cost). Perez's snarky reading of celebrity culture is firmly rooted in camp readings that find pleasure in dis-identifying with celebrity images. "Snark" is a general term used across the blogosphere to refer to the sarcastic and potentially malicious verbal attacks that permeate blog writing. Snark can be harmless and humorous, but also can serve as biting criticism and derision of an individual or idea. Though Perez often revels in the glamor and spectacle of stardom, he uses snark to reject any hint of industry

manipulation that portrays stars as something they are not, thus privileging authenticity or "just being yourself" as the core of the celebrity image. For example, he is well known for "outing" gay or lesbian celebrities as his way of removing the artifice of Hollywood to find the "real" person. He claims such outing gossip is a challenge to public stigma that surrounds homosexuality and promotes a worldview in which gay or lesbian identity is accepted and celebrated as part of an "authentic"—and therefore worthy—celebrity self. He says, "Some people have this stupid notion in their head that being gay is bad and being gay will hurt your career, and I don't believe that" (qtd. in Lostracco, 2006, para 10). This view, rooted in his open and vocal identification as gay man, provides an important entrance to how the blogger's identity and worldview shapes the content of the blog text and subsequent gossip talk within the audience community.

In addition to outing celebrities under the claim of a pro-gay agenda, Perez harshly judges female celebrities, routinely calling them "bitches" or "sluts" or criticizing physical attributes that fall outside of hegemonic norms of feminine beauty. Interestingly, in contrast to his claim that his outing stories actually help the gay community, he negates the political implications of the policing of femininity by framing it simply as the "fun" of gossip and celebrity culture. He says:

> Do I really think [teenage pop singer] Miley [Cyrus] is a slut? No. But I am going to call her one because it's fun! I don't claim to be objective. I don't really believe everything I write. What I write is an exaggeration of what I believe. It's heightened reality. I write a lot of things just to piss people off or get a laugh. I'm not *The New York Times*. I'm Perez Hilton. (as quoted in Denizet-Lewis, 2009)

Through gossip, Perez, and other bloggers, reinforce the role of the celebrity image as representation of the individual within contemporary culture, while obscuring such ideological work behind a guise of "fun." The fact that hegemonic ideologies routinely surface in PerezHilton's blog posts and, more crucially, circulate and are intensified in the comments sections, points to the function of celebrity gossip as a site of shared social meaning-making that has implications outside of the blog text. That is, to judge Miley Cyrus as a slut reinforces larger cultural norms about acceptable female appearances and behaviors, framing a norm to be followed by *all* young women by showing them what *not* to be. Gossip *may* offer a space of resistance to the industry-control of celebrity culture, but the pleasures of gossip talk may hide more troubling modes of social control that, given the predominantly female audience of this and other gossip blogs, encourages women to participate in their own social subordination.

Pink Is The New Blog (http://www.pinkithenewblog.com)

Pink Is the New Blog (PITNB) is an individually authored blog solely owned by blogger Trent Vanegas, who, like Perez, is an openly gay Latino who uses gossip as an intervention into the artifice of celebrity culture. However, though Trent clearly takes a campy and mocking stance towards celebrity culture, PITNB differs from PerezHilton in both the more sophisticated use of Photoshop to manipulate photographs and in his more loving, though still deconstructive, look at celebrity culture. These two blogs share similar formats and content, but the differences between Trent and Perez's approaches to celebrity content highlight the various ideological frameworks operating in celebrity gossip and the possibilities for resistance in such talk. Trent's approach to his blog is much more personal than any of the other bloggers examined here. He not only puts his own spin on the latest celebrity news, he also regularly shares details about his daily life, relationships and activities in an online journal style. But unlike on PerezHilton, these personal posts do not focus on Trent as a celebrity or a part of the Hollywood scene. In fact, they often reveal his position as a fan, offering information about concerts he attended, television shows he watches or other media he is consuming and enjoying. Though he does acknowledge some inside access, most of which is tied to the increased popularity of his blog, he aligns himself with his audience as an enthusiastic onlooker to celebrity culture.

In addition to this overtly personal tone, PITNB is unique because, in contrast to all the other blogs I observed and indeed most blogs in general, PITNB did not feature comment sections during my observation.[1] Yet Trent's audience is far from invisible. He regularly credits readers for bringing news items or updates to his attention and frequently gives "shout outs" to readers he meets at public events.[2] This raises a question about the necessity of interactive spaces as textual features of gossip blogs and their role in promoting certain ways of reading celebrity on that blog. I will return to the role of the comments section in the textual format of the blog later in this chapter, but the lack of this feature on PITNB positions this blog as a unique point of entry into questions of interactivity in new media texts and the role of the blogger as the primary producer of content within a participatory media culture.

[1] The comment sections were reinstated in June 2008 and I will discuss his reasons for eliminating and then re-instating the comment sections on his blog later in this chapter.

[2] Though Trent does have prominent links to his pages on social networking sites as another way for readers to interact with him, I restrict my analysis to his gossip blog. Other gossip bloggers also have pages on these social networking sites, but these secondary spaces are outside the scope of this project.

Popsugar (http://www.popsugar.com)

Popsugar.com (PS) a provides celebrity gossip blog under the umbrella of the larger network of lifestyle blogs on the Sugar Network, which includes blogs on food, home, fashion, beauty, weddings and other "women-focused" topics. Essentially, PS is like the celebrity gossip section of a women's magazine, though it functions autonomously from the other sections. A reader could conceivably read PS without visiting any of the other blogs in the Sugar Network, though all the Sugar blogs frequently link to each other to encourage audiences to remain within the network. PS adopts the same format as the other gossip blogs, offering individual posts with the latest photos and gossip about celebrities. Two different authors, "Molly" and "PopSugar," write these posts. In my interview with PS blogger Molly Goodson, she said "PopSugar" is a pseudonym used by four different female staff members who help her write and manage the site. Though the Sugar blogs are multi-authored, each one features a cartoonish avatar for each "sugar" that personifies each site. "PopSugar" is depicted as a thin, fashionably dressed (her outfit rotates periodically but is always tied to current fashion trends) white woman with long blonde hair and large sunglasses, clutching a latte and a cell phone. This avatar appears at the top of every page on the site, giving the impression "PopSugar" delivers the latest gossip to the reader, reinforcing the idea of the gossip blog as a conversation with the blogger.

The approach to celebrity on PS is more positive than any of the other blogs in my sample, generally taking a stance of identification with celebrities rather than mocking them and breaking down the façade of fame. This is not to suggest there is no snark or humor on the site. But PS generally speaks about celebrities in a positive tone and, in keeping with its women's-magazine-style approach, puts a great deal of emphasis on covering celebrity fashion as well as celebrating celebrity couples and celebrity babies as a site of aspiration for its largely female audience. This serious reading of celebrity positions stars as ideal embodiments of the self in contemporary culture or as cautionary tales of how *not* to behave. Though not as snarky or mean-spirited as PerezHilton's gossip, this serious approach to celebrity often reinforces dominant ideologies, particularly heterosexist and gendered norms, and, like PerezHilton, engages predominantly female audiences in the social policing of these norms beneath the pleasures of gossip.

What Would Tyler Durden Do (http://www.wwtdd.com/)

Another example of an individually authored blog, though the site itself was sold to entertainment publisher Buzz Media in 2007, What Would Tyler

Durden Do (WWTDD) is relevant to this analysis for several reasons. First, WWTDD's author, Brendon,[3] uses his identity as a heterosexual male to frame a non-traditional approach to celebrity culture. Gossip and celebrity culture are generally considered the domain of women and gay men, so the addition of a straight male gossip blogger challenges this stereotype and points to the broader relevance of celebrity to shaping social life. Brendon foregrounds his position as an "outsider" to both celebrity culture and traditional celebrity-watching audiences by adopting a stance of dis-identification that rejects the value of celebrity culture as a means of justifying his interest in it. Brendon uses his gossip to challenge the cultural value of celebrity and assumptions that stars are somehow "better" than the average person. This is immediately evident in the blog's "About" section, which describes the blog as "focused on bringing you the latest gossip and news about rich and famous celebrities. And then making fun of them. Why? Because fuck them, that's why" (http://www.wwtdd.com/about). The name of the blog, a reference to Brad Pitt's character, Tyler Durden, from the 1999 film *Fight Club*, is meant to reinforce its hyper-masculine and anti-consumerist stance, at least in terms of the cultural value of celebrities as commodities, as the blog itself is advertiser-supported. On WWTDD, celebrities are not individuals to emulate in terms of cultural values, but images to ogle for visual pleasure. Though male celebrities are occasionally featured, the emphasis is on objectifying female bodies and judging their sexual attractiveness as justification for one's interest in them. Celebrities are nothing but image, and claims to authenticity or a "real" celebrity self are often mocked as further evidence of the constructed nature and ultimate moral bankruptcy of the celebrity industry. This approach makes celebrity culture "acceptable" reading for Brendon and his predominantly straight male audiences and allows them to participate in the social meaning-making processes of gossip more typically associated with gay and female audiences without relinquishing the heterosexual male gaze or its attendant social power.

Jezebel (http://www.jezebel.com)

Jezebel.com (Jezebel) is a multi-authored or group blog that is a part of the Gawker Media Group, which produces numerous blogs, including celebrity and popular culture blog Gawker (www.gawker.com), sports news blog Deadspin

[3] "Brendon" is the name the author of this site uses on his blog and he preferred that I use it in my discussion. Though he blogs under this pseudonym, Brendon, like Perez, has constructed a clear persona that is relevant to the blog's approach to celebrity culture. The difference is Brendon uses this persona to separate his blogging life from his "real" life. The issue of the blogger's personal identity and "putting yourself" in the blog will be discussed in more detail in chapter three.

(www.deadspin.com) and technology blog Gizmodo (www.gizmodo.com). Editor-in-chief Anna Holmes, who was brought on by Gawker head Nick Denton specifically to create and oversee Jezebel, heads a five-woman editorial board that take turns writing the posts on this frequently updated site. Jezebel bloggers Tracie Egan and Dodai Stewart most commonly, but not exclusively, cover celebrity and popular culture content for the site. Jezebel's tagline "Celebrity, Sex, Fashion For Women. Without Airbrushing" provides readers with an immediate clue to the perspective it takes on celebrity culture, namely as a feminist intervention that recognizes the pleasures and the problems of celebrity culture. This blog is not entirely devoted to celebrity culture, as it covers a range of political and popular culture through its explicitly feminist lens. However, celebrity content tends to be among the most popular in terms of page views and number of reader comments, suggesting celebrity gossip is a dominant topic and draw for Jezebel audiences.

Jezebel provides a forum for celebrating celebrity culture while simultaneously criticizing it for reifying racist, sexist and homophobic ideologies. In particular, this blog has become known for challenging unreasonable standards of attractiveness and behaviors for women perpetuated by celebrity culture. Regular features like "Midweek Madness," a weekly takedown of celebrity tabloids and their obsession with celebrity couples and pregnancy rumors, use humor and snark as a mode of dis-identification with celebrity culture that distinguishes Jezebel from the women-focused and serious gossip approach of PS. For example, in keeping with this feminist approach, Jezebel mocks celebrities for ridiculous behavior or clothing, but refuses to allow any "body snarking" from bloggers or commenters. Body snarking is a term used by Jezebel bloggers and commenters to refer to the excessive scrutiny and policing of (female) celebrity bodies through malicious mockery common to celebrity gossip blogs. Thus, while critique is central to this blog's approach to celebrity culture, it is meant to challenge hegemonic norms rather than advocate the use of humor and sarcasm to mask adherence to dominant ideologies.

The Young, Black and Fabulous (http://www.theybf.com)

The Young, Black and Fabulous (YBF) was primarily chosen because of its exclusive focus on black celebrity culture. While other blogs in my sample occasionally cover celebrities of color, they usually do so only if that particular celebrity has broken through into the white-dominated "mainstream" of celebrity culture. A major black star such as Will Smith, Beyoncé Knowles, Kanye West or Jennifer Hudson may occasionally be featured on mainstream blogs, but these sites generally reflect, and do not question, the overwhelming whiteness of mainstream celebrity culture. YBF, an individually authored blog

written by an African American woman named Natasha Eubanks, who also owns the blog, provides a forum explicitly focused on the wide range of black and other ethnic minority celebrities ignored by mainstream blogs. This focus means that the content of YBF frequently differs significantly from the other blogs in my sample, as Natasha does not report even the "biggest" celebrity stories if they do not include non-white celebrity. For example, Britney Spears is a staple of gossip media in general and the other blogs in my sample all covered at least major events, if not the minutiae of her daily life. YBF, however, does not feature content on any aspect of Britney's public or private life because she does not fit into the black celebrity focus of the site. By virtue of its focus on black celebrity culture, YBF covers celebrities that are never or very rarely featured on most mainstream blogs, thus broadening the range of celebrity content that informs my analysis.

YBF's ideological perspective and approach to celebrity gossip draws from a larger history of the independent black press as a media source created by and for the black community as an alternative to white "mainstream" media. Though black audiences certainly read mainstream celebrity gossip media and have always been counted amongst the fans of white stars, the role of the black press in creating a uniquely black celebrity culture is an important part of the history of celebrity gossip media. Anna Everett (2001) argues the advent of independent black press and the rise of the African American spectator in the early twentieth century allowed black audiences to reject "discomfited spectatorship generated by the displacement of their visual pleasure onto white cinematic heroes and heroines" and instead "indulge their escapist fantasies and ego gratifications" through a celebrity culture that spoke to their specific cultural experiences as African Americans (p. 110). More importantly, the independent black press used coverage of black celebrity culture as a means to challenge racist imperatives of mainstream popular culture and to envision a uniquely black cultural experience.

From its inception, black celebrity media encouraged identification with black stars whose on- and off-screen personas represented positive aspects of black culture and were individuals "in whom the community can take great pride" (Everett, 2001, p. 164). Everett notes coverage of early black cinema star Edna Morton compared her glamorous and beautiful image to that of [white silent film star] Mary Pickford as a means to "signify the beautiful black female body long hidden from America's general film audiences" but grounded that image in a story of "accessibility" and "dignity" (2001, p. 162). Stars like Morton were celebrated by the black press for their blackness, rather than for their willingness to acquiesce to white standards of beauty or to relegate themselves to stereotypes. At the same time, the black press recognized that black stars

(and black audiences) remained tied to mainstream Hollywood standards that marginalized this positive version of blackness, and often used gossip to reclaim a positive black identity. For example, Lincoln Perry, the actor best known for his "Stepin Fetchit" character that embodied many negative black stereotypes, was portrayed in the early black celebrity press as an intelligent and shrewd businessman whose *performance* as Stepin Fetchit brought him wealth and happiness. Depictions of his private life celebrated the "real" Perry as an honest and virtuous black man who was a positive role model for black audiences, despite his stereotypical character (ibid., p. 163-165). Through gossip, his image was reclaimed by black culture as positive through identification with his off-screen persona.

However, the black celebrity media also encouraged dis-identification with those black stars that did not uphold these goals. For example, Everett details how black actress Louise Beavers was taken to task by the *Pittsburgh Courier* in 1934 as a "racial sellout" who put her "individual interests" above those of the community because she willingly reproduced negative black stereotypes in films that naturalized real-life racism and, more problematically, openly supported the Hollywood studio system that continued to marginalize black actors (2001, pp. 209–210). By moving away from the cultural values and goals of the African American community, Beavers undermined the goal of equality as well as the goal of creating a black culture freed from racist white stereotypes. This stance of celebrating black celebrity culture as well as defining that culture by chastising those who do not uphold its values and goals remains central to the style and content of YBF. Natasha's coverage of black celebrity culture seeks to address the exclusion of black celebrities on the mainstream sites, but, more importantly, also works to define a positive vision of black culture for audiences through identification and dis-identification with black stars. YBF intervenes into mainstream celebrity culture that ignores and/or devalues black stars, but engages in the same discourses and modes of gossip talk that define that mainstream celebrity culture.

Building Blocks: The Post

Gossip blog posts consist of three major elements—links, visual images and commentary—each of which will be discussed in greater detail in order to illustrate how it contributes to the textual, technological and social features of each of these gossip blogs. Most blogs arrange posts in reverse chronological order, with the most recent at the top of the page, thus allowing readers to more readily see what is new on the site. For the celebrity gossip blogs in my sample, the updates occurred primarily between 9am and 8pm (EST) Monday through Friday, with most bloggers not updating much beyond 5pm (EST).

Weekend posts were less frequent, and some, like Jezebel and WWTDD, did not post at all on weekends during my fieldwork, barring some major celebrity event (such as the Oscars) or breaking celebrity news story (such as Britney Spears shaving her head). Molly discusses this as an attempt to meet the needs of the audience rather than a personal preference, saying she and other bloggers post regularly throughout the traditional workday because gossip blog audiences are "people who are bored at work" (Goodson, personal interview, May 27, 2007). The frequent updates are a technological demand of the genre, but one that opens meaning-making potential for audiences interested in the latest celebrity gossip.

Physical and Technological Layout of Posts

Each gossip blog has a distinct "look" and physical layout, but they share key formal similarities that both emulate and move beyond print gossip magazines. Posts are generally focused on one particular topic, mimicking a tabloid-magazine-style format, and feature a main headline followed by more detailed text and images about the particular topic. For example, a PerezHilton post from February 19, 2008, titled "A Process of Healing," features only photos and text regarding a public sighting of a "recovering" Britney Spears in the wake of her well-publicized public meltdown and hospitalization in late January and early February 2008 (Hilton, February 19, 2008). This individual post is part of a larger story about Spears' celebrity, as it reflects existing knowledge about her public and private lives (as discussed on PerezHilton and elsewhere). But it also functions autonomously as an up-to-the-minute update on a particular moment in her public life. Restricting each post to a particular celebrity topic allows the blogger to limit the audiences' engagement to that specific celebrity, as opposed to functioning as a chat room where any celebrity gossip can be brought up. Commenters who go off topic are known as "threadjackers," in that they "hijack" a post about one topic in order to discuss something completely different, and are generally criticized or reprimanded for such behavior across all the blogs in my sample.

PITNB is a more obvious exception to this multiple individual post format. In its original format (and the format for the majority of my fieldwork), PITNB consisted of one long, multi-topic post per day with no space for comments included. Though the various items were clearly separated, often by images acting as sub-headlines within the post, there was generally only one post per day. This post was usually published in the early to mid-afternoon and updated only if new information relevant to the stories covered became available. Readers would scroll down the page through one post rather than having unique tags and URLs for each item. This format is similar to a newspaper

gossip column style in which one column per day covered a range of celebrity gossip items. It is also more reflective of personal-diary style blogs, which is actually the genesis of Trent's blog. In contrast to the other blogs, which were always envisioned as topic-driven blogs exclusively focused on celebrity culture, Trent began his blog as a personal diary project that naturally evolved into the celebrity gossip blog it is today. He says:

> My first blog site was at easyjournal.com, which was a free blog site. And I didn't know how to start, so I just started talking about myself and my life. But because I'm such a huge fan of pop culture, media, movies, TV…I just love all that stuff, it just naturally worked its way into what I was talking about because it's the stuff that I encounter every day…I started talking about all these things, and that's really how it started…[D]id I plan on creating a site where millions of people would read it? Absolutely not. It never even occurred to me that it was a possibility. It felt like a hobby. It felt like something I was doing just for me. (Vanegas, personal interview, August 20, 2008)

On March 3, 2008, Trent launched a new multiple-post design for the site. Trent says this "more traditional" blog format is "more freeing" for him as a writer, though it does "make the day longer" because he must update more frequently throughout the day instead of finishing his day after he published the single, multi-topic post (ibid.). By the end of my fieldwork, all the blogs in my sample followed this "traditional" topic-driven blog format of frequently updated, short, single-topic posts.

The physical layout of the posts speaks to a connection between the technological and the social in new media platforms, as it shapes *how* a reader can engage with the content. Some blogs show the entire text of a post on the main page, while others provide only a few lines or a visual image as a way to introduce the topic of the post to readers who must click on a link that redirects them to a secondary page containing the full content of the post. For example, the main page of YBF typically features truncated posts consisting of a single image and a few lines of text followed by a link to "click to read the rest" that redirects the reader to a new page dedicated to the full text of the post. Jezebel also uses this linked format, with the shortened version on the main page acting as a teaser to draw readers to the full story. PS, WWTDD, PerezHilton, and PITNB (both before and after the redesign) generally display the entire post on the main page, only using the "read more" link if a post is particularly long or as a link to additional images. The use of truncated teaser posts on the main page or other "read more" links allows readers to scroll past items that do not interest them without seeing the entire post and click only on those they want. However, readers on all blogs do have to click on the post in order to view and/or participate in the comments sections. This element of choice is important to understanding blogs as interactive media forms. On one hand, it

offers a participatory space where readers can direct their own reading practices and potentially create, or at least read, content created by other readers. At the same time, the click-through process reifies the blogger as the primary creator of content, as any reader-generated content is not typically visible on the main page of the blog.

This technological control of how readers engage with the site is often tied to the social perspective forwarded by the blogger. For example, Perez occasionally uses the main page headline as a tease for the readers, using a scandalous or salacious claim to prompt further reading, particularly on "blind items" where the celebrity is not (at least initially) named. For example, a post entitled "Pregnant and Boozing!!!!" published on February 27, 2008, featured a photo of a pregnant woman holding a glass of wine with her face blocked out with a white circle. The text below the main page image read:

> Somebody pulled a Gwyneth!!!!
> What actress was spotted drinking the alcoholic beverages at the Oscars on Sunday night????
> **CLICK HERE** to find out!
> We hope she's right and has a good lawyer! (Hilton, February 27, 2008)

Clicking the link takes the reader to the full text of the post that begins with the same image and text, but goes on to include a quote from a *New York Post* gossip column alleging that actress Nicole Kidman, who at the time was rumored to be pregnant, was spotted drinking wine at the 2008 Oscars and displays a picture of Kidman on the red carpet at the event. It is crucial to note that there is no actual photographic evidence of this rumor in this post. The initial image of the pregnant woman on the main page teaser post is clearly not Kidman, nor does Perez claim that it is. In fact, this image is simply a stock image from photo agency Almany that I easily found through a Google image search for "pregnant woman drinking." Furthermore, the image of Kidman that is included in the extended post shows her on the Oscars red carpet, but does not show her drinking. Instead, the juxtaposition of the images serves to visualize the rumor and make it more concrete for readers. The image serves as an anchor for gossip talk and is a necessary element of the layout of the gossip blog post.

The teaser image and text promise juicy gossip as a means to encourage readers to click the link, promoting deeper and prolonged engagement with the site. Though they are interactive, these technological affordances offer a prescribed form of engagement and their mere existence on the post does not address all aspects of social participation or meaning-making on these blogs. These technological features do, however, speak to the economic interests of

these advertiser-supported blogs, as increased page views translates into more advertising revenue. Getting readers to click through to individual posts from the main page increases the overall number of page views for the blogs as well as the amount of time audiences spend the blog, both of which ultimately makes blogs more attractive to advertisers.

Building Blocks: Interactive Links

In keeping with the general definition of blogs as texts that combine links with commentary, celebrity gossip blogs use existing (online) content as a springboard for the blogger's observations and interpretations. Celebrity gossip bloggers, for the most part, are not breaking gossip stories on their blogs; the bloggers in my sample (except Perez, whose claims to exclusivity are infrequent and often challenged) rarely, if ever, make this sort of claim about their posts. Instead, they take existing information from other sources and comment upon it, producing new, publicly available content based on gossip. Though some critics claim blogs are merely repackaging existing content, bloggers generally do not repost entire articles from other places word for word, preferring instead to highlight specific sections as a starting point for gossip that is then connected to the full text of the original source via a link. The link is a technological building block of the blog, offering a starting point for gossip commentary by the blogger and discussion amongst readers in the comments sections.

Links to Outside Sources

Despite claims that new media forms like blogs are destroying traditional news outlets, gossip blogs could not exist in their current form without other sources of celebrity news and gossip as the starting point for blogger commentary. All of the blogs in my sample include links to outside sources for their information in most, if not all, of their posts. These links come from print tabloids and their online counterparts as well as other "legitimate" online news sources, such as CNN.com or MSNBC.com. Occasionally, the blogger will credit a reader or an "inside" source for sending in a tip via email, but citing and linking to existing web or print sources is most common. Bloggers typically do not hide the fact that they are not the originators of the information and focus instead on the unique commentary they bring to the information as the real value of the blog text. Thus, while blogs rely heavily on links to existing media outlets for their content, the gossip-based commentary adds value and creates a new type of gossip media text.

The extensive use of links as a textual feature of gossip blogs explicitly engages the interactive affordances of the web. The presence of a link allows

readers, if they so choose, to instantly check the information sourced to that link as a way to extend their reading or seek additional knowledge. This is particularly useful for short bits of gossip where the information is sparse but the gossip talk may be more complex, because it draws on previous knowledge of the celebrity's public and private life. For example, every morning Jezebel compiles a list of the latest developments in celebrity culture in a regular feature called "Dirt Bag Roundup." Each item is clearly sourced with a link readers can click in order to see an image or read more about the issue. The following is an excerpt from a typical "Dirt Bag Roundup," illustrating the interactive role of the link:

- A source calls Lindsay Lohan's new friends "leeches." Maybe LL is used to that? CoughmommyDinacoughcough? [**Page Six**]
- Dina Lohan on her show, *Living Lohan*, which begins shooting on the 16th and will air around Memorial Day on E!: "Be nice to us." [**Gatecrasher**]
- Yeah, yeah, we know. Patricia Heaton has no belly button. [**TMZ**]
- Blind item! Which 8-year-old son of a daytime TV personality told gossip reporters on the red carpet that he had recently come down from bed to find his famous mom drinking margaritas on the terrace? "She told me she was going to do the dishes, but she lied to me!" the tyke complained earnestly. [**Gatecrasher**] (Stewart, March 11, 2008)

Instead of reposting entire articles, the most interesting bit of information is culled from the original sources and presented to readers couched within brief commentary from the blogger (in this case, Jezebel blogger Dodai Stewart). Readers are given the ability to click the link at the end of each item to read more or see related images, but this is not generally necessary in order to understand the meaning of the item within the framework of the blog. A casual reader may not understand the commentary, and could click on a link as a way to begin to make sense of it and enter into the community of readers of this blog. But since blog reading is a cumulative process, more regular readers actively draw on existing knowledge of the celebrity and how she is discussed on Jezebel in order to grasp the meaning of the short item.

Self-Referential Links

Bloggers frequently use links to refer back to previous discussions of a particular story or celebrity elsewhere within their blogs. This strengthens the authority of the blogger in covering a developing story because it provides background to the current post from within the blogger's perspective. In other words, the reader can verify the story not only through outside sources, but also from the blog itself. PS does this the most frequently of any of the blogs in my sample and provides an excellent example of how this self-referential sourcing reflects

blogging as a cumulative process. A February 19, 2008, post features a paparazzi picture of supermodel and reality television star Heidi Klum, her husband, singer Seal Samuel, and their children wearing face paint and sitting on a curb during a visit to Disneyland. PS blogger Molly contextualizes the photo, saying:

> It's official: The Klum-Samuel family loves face paint more than anyone else. Seriously, though, it seems like every other time **we see them**, at least **one member** is **looking all colorful or catlike**. I'm not complaining though, totally love it. This time the occasion was Seal's 45th birthday, celebrated at Disneyland over the weekend. Little Leni even took it up a notch with her **princess outfit**. Clearly the happiest place on earth is even more so when you've got extra special makeup on. (Goodson, February 19, 2008)

Each link refers back to previous posts on PS about the Klum-Samuel family in which they are similarly framed as adorable and fun-loving, with the final link referring to an additional photograph from this particular family outing on another PS page. As is typical of PS's approach to celebrity, this post and those it links to reinforce the positive sense of identification with celebrities and promote the desire to emulate their lifestyles and the values they embody.

That PS includes these self-referencing links in every post not only solidifies their reading of celebrity culture for readers as the preferred one, it also demonstrates the use of technological affordances to structure audience engagement, in this case to keep the community within PS instead of giving page views to other (competing) gossip blogs or celebrity news sites. PS certainly credits outside sources for content when appropriate, but typically combines that with self-referential links (both in bold), such as in this February 14, 2008, post regarding Britney Spears:

> Beyond her **new hobby as a dance instructor** and finally better-looking hair, things have been pretty quiet with Britney since she was **released from the hospital** last week. Jamie Spears is still in control of Britney's estate at this point, but today there will be a hearing to **determine whether or not his role as conservator will be extended.** So, tell us—do you think Britney's dad should get to stay in control of her life? (PopSugar, February 14, 2008)

The first two links refer back to previous PS stories on Britney, but the last refers to a new People.com report about an ongoing legal battle to determine a conservator for Britney's estate as she recovers from a widely publicized psychological breakdown and involuntary hospitalization (Brueur, 2008). This post combines sourced information about Britney's ongoing mental issues with previous PS posts, thus reaffirming the blogger's authority to speak on this issue by giving details, in the form of self-referential and outside links, to support the particular reading of Spears' image.

Building Blocks: Visual Images

Though a general definition of blogs focuses on the relationship between links and commentary, I contend the visual image is an equally critical building block for the subgenre of celebrity gossip blogs. It is extremely rare to see a celebrity gossip blog post without at least one visual image accompanying the written text. These images are usually, though not exclusively, paparazzi photos of the celebrity in her private and unguarded moments. Most of the blogs begin with an image at the top of the post, using it to draw readers' attention to the commentary below or to encourage readers to click a link to read more about the featured celebrity. The photo acts as evidence, anchoring the gossip talk and supporting the blogger's gossip commentary on the celebrity image.

The primacy of the photo to the gossip blog speaks to the "complex and contradictory" nature of the celebrity image that always already embodies both a public and private self (Dyer, 1986). Audiences use gossip to move between the image of the star-as-performer and the behind-the-scenes individual in the never-ending search for the "authentic" star. While blogs emphasize the private celebrity, they are never completely divorced from the notion of star-as-performer. Blogs regularly include photos of celebrities in obviously stage-managed moments, such as officially sanctioned red carpet or other industry events, as well as video clips or production stills (behind-the-scenes or actual performances) from a celebrity's work, reminding audiences of the celebrity's performing self. For example, YBF and PerezHilton regularly post new music videos from pop stars, and PITNB and Jezebel regularly provide screen captures and discussion of new episodes of television shows such as *The Hills* and *Project Runway*. By promoting the public and professional work of the star, the blogs do, to some degree, serve the promotional needs of the celebrity industry. However, their reliance on paparazzi photographs as the key textual element of the post often works to disrupt that carefully constructed professional image. These photos serve as anchors for commentary about the celebrity and allow the blogger (and audiences) to use gossip as a means to reconcile the public and private selves of the celebrity.

Paparazzi Photos and Gossip Commentary

By providing up-to-the-minute details through near-constant visual surveillance of the celebrity and her daily life, paparazzi photographs act as both catalyst and anchor for gossip talk. They are a catalyst in that they initiate gossip talk by providing the gossipers—the blogger and the audience—with details to discuss and an anchor in that they are always read through existing discourses of the celebrity. Despite being the main focus of a post, these photos do not usually offer any new information and are only made meaningful through the negotia-

tion of existing information and judgment typical of gossip talk. Outside of specific moments of scandal, such as the widely seen paparazzi photo of Britney Spears shaving her head, most of the photos and gossip on blogs work to reveal the quotidian, though at times glamorous, lives of the stars. This can be as innocuous as a sighting of a star in public, with the photo acting as evidence and as a springboard for blogger commentary, a mode seen in the previously discussed PS post about Heidi Klum and her family visiting Disneyland. There is not any sort of scandal revealed by the photograph. Rather, it serves as a visual anchor for further discussion of the couple and their family, a major theme of gossip on PS.[4] It assumes the reader has some sort of familiarity with the celebrity (further bolstered by the linked references to previous posts about Klum and her family in the text) and finds pleasure in seeing the star in an everyday and relatable setting.

Given the primacy of the blogger's commentary to the textual form of the blog, photos rarely speak for themselves. They almost always appear with some sort of caption, manipulation or other form of commentary that helps shape the meaning of the image and tie it back to the blogger's subjective viewpoint. The image, like the link, is used to both catalyze gossip talk by providing new details on an ongoing story and anchor that gossip within the existing framework of the blog. In her analysis of PerezHilton, Anne Helen Petersen (2007) recognizes the power of Perez's blog, saying "Even if a star were not previously in public disfavor, the fact that Perez *reports that she is* effectively morphs rumor into reality" (p. 4, emphasis in original). How Perez uses photos in his posts—where he places them, how he manipulates them, how he captions or comments on them in the text—is essential to the work of morphing "rumor into reality." This is evident in the post, "A Process of Healing," which strengthened Perez's reading of Britney's recovery through the use of paparazzi photos of the star engaged in ordinary and everyday activities, not professional work, as evidence of her progress (Figure 1).

Though he was a big supporter of Britney in her early days, Perez, along with most other bloggers, had become increasingly critical of her public image and gleefully mocked her "train wreck" behavior as evidence of her (deserved) fall from pop stardom, regularly calling her, among other names, "white trash" and "Shitney Spears." However, when widespread speculation began that her bizarre public antics were the result of possible mental illness and/or drug

[4] Klum and Samuel are an interracial couple, but this was not a site of scandal when images and stories about the couple were published during my fieldwork, if it ever was. Not all the blogs featured this couple, as I saw no posts about either Klum or Samuel on WWTDD or YBF, for example. If any sort of derogatory comments were made about the interracial couple or their mixed-race children on any blogs, they were removed before I saw them.

abuse, Perez, and many other gossip media outlets, reframed their gossip about the star in a more positive and supportive way. The text written on the photo in Figure 1 by Perez further reinforces his (newly) positive reading of her image available in the text of the post, thus using the image itself as evidence of this new "truth."

Figure 1: Britney Spears on PerezHilton

Look at her. LOOK at her!

We can just see a very noticeable difference in Britney Spears. She seems calmer, happier and more at peace.

Now that the negative influences have been removed from her life, the once and future pop star's family is ensuring that their beloved daughter gets healthy.

With the chaos gone from her life, a dressed up Brit Brit was subdued and smiling sincerely as she went out to dinner at SHU sushi restaurant in Los Angeles on Monday night with her new bodyguards and assistant.

If Britney keeps things up, hopefully she will be able to see her children soon.

That would be very nice! (Perez Hilton, February 19, 2008)

Perez does not offer links back to previous stories to support this reading or any of the details he offers (such as the claim that "negative influences have been removed from her life"), relying on the regular reader to be aware of these

stories that were part of the scandal surrounding her mental breakdown. But even for the casual reader, his gossip commentary *becomes* truth because the photo of a smiling and seemingly serene Britney appearing in public supports it.

The role of the paparazzi photo in both initiating gossip talk and anchoring it to the particular discourses offered by the blog suggests the cumulative nature of blogs is a formal characteristic of the genre. Readers are better able to interpret the photos offered by the blogger if he or she has a working knowledge of the discourses and practices of the blog. For example, Jezebel has a regular feature (often appearing four or more times per day) called "Snap Judgment." These posts offer only a paparazzi photo and a caption/headline with no additional commentary. The title "Snap Judgment" is an explicit invitation for readers to scrutinize and judge the image presented and offer their own commentary in the comments section. These captions/headlines are generally meant to be humorous and act as a way to get conversations about a specific celebrity started in the comments section, but rely on a cumulative reading of the blog to understand how to interpret this particular moment of the celebrity's life. In a Snap Judgment from March 10, 2008, pregnant rock star and fashion icon Gwen Stefani is caught by paparazzi cameras while walking with her husband, Gavin Rossdale, and first child, Kingston (Figure 2).

Figure 2: Gavin Rossdale and Gwen Stefani on Jezebel's
"Snap Judgment"

Though the headline/caption "Gwen and Gavin's Special Delivery" references her pregnancy, its brevity assumes the reader has prior knowledge of this facet of Stefani's private life that she will bring to her reading of this photo (Holmes, March 10, 2008). Indeed, Stefani had already publicly announced her pregnancy, so this image is not intended to break that news, but simply to follow the progression of her pregnancy, a favorite pastime of the blogs called the "baby bump watch," that itself speaks to the cumulative process of reading blogs. Furthermore, the fact that the caption refers to Gwen and Gavin by first name only also assumes prior knowledge of this celebrity couple. As there is no new information here, the use of paparazzi photos to anchor these posts encourages scrutiny and judgment of the celebrity image through gossip talk. On most blogs, this frequently takes the form of body policing, both in terms of fashion choice and in terms of beauty and sexuality.

On Jezebel, however, such visual policing is regulated by the approach to celebrity defined by the bloggers and also by explicit rules governing the comments section. This is particularly important for Snap Judgments, as the limited framing by the blogger allows the readers to take a larger role in determining the meaning of this image and the celebrity within it. Within the "no body snarking" rules established on Jezebel, a dress may be deemed unflattering or unattractive, but the woman wearing it is not to be called "fat" or "ugly." Jezebel commenters on this Snap Judgment discuss Stefani's dress, whether or not they like the two as a couple, and whether or not they have "real" or a "Hollywood" marriage. The comments are not universally positive, but they are not excessively cruel in their criticisms, as on other blogs. But the photo itself is the catalyst and anchor for continued discussion of this particular celebrity/celebrity couple, prioritizing gossip talk as the main mode of engagement. Snap Judgments are unusual for the small amount of blogger commentary framing the photo, instead allowing readers' talk in the comments sections to provide the majority of the written text for these posts. As will be discussed in chapters four and five, the clear social rules of participation and the formal and informal moderation that characterizes the comment sections on Jezebel enables this sort of reader-led dialogue to emerge yet remain within the ideological framework of the blog.

Even more so than the link, which requires the user to click away from the current page and, perhaps, even the blog itself, photos are key building blocks of the blog because they are tied directly to the subjective viewpoint of the blogger. By using photos to make a joke or to further a previous discussion of a particular celebrity within existing discourses, celebrity gossip blogs reinforce particular social ideologies through engagement with celebrity culture. WWTDD regularly features paparazzi photos of female celebrities in swimsuits

or other skimpy outfits, which fits with the blog's emphasis on objectifying female celebrities in order to police the boundaries of acceptable femininity and female sexuality through gossip talk. On March 7, 2008, Brendon posted a paparazzi picture of singer Melissa Etheridge and two of her children playing on a beach. This image of a fully clothed, older and publicly out lesbian with her children does not seem to fit with the blog's usual approach to celebrity culture (Figure 3).

Figure 3: Melissa Etheridge on WWTDD

However, the presence of a celebrity in this mostly banal photo means it can be used to anchor commentary that reinforces the typical viewpoint of the blog. Within the framework of WWTDD, the gossip talk is not really about Etheridge or her role as a professional singer, but about what her image means within contemporary culture as defined by the blog:

> Between **yesterday** and today, I'm starting to get the suspicion that porn movies lied to me about the secret life of lesbians. Where are the co-eds who can't afford to repair their car? Where are the cheerleaders helping their team celebrate the big win? Where are the co-ed cheerleaders who can't afford to repair their car after the big win? I was led to believe lesbians led secret lives of sexy passion, where looks of desire turned to an exotic journey of the flesh. Not...**this**.

> They say lesbian parents are no more likely to raise gay kids than traditional parents, but if all these boys know about vagina is that it looks like Melissa Etherdige and her (kill me) lover, that kid is full blown gay. Like how when kids get bit by a dog as a baby and then they hate dogs all their life. This is like that, except that I'd rather have my dick in the mean bitey dog. (Brendon, March 7, 2008, hyperlinks in bold)

Again, there is no new information or even any discussion of any gossip stories related to Etheridge in this post, rather the image is used to make a joke and to offer an anchor for commenters to similarly police social standards of feminine bodies and lesbian sexuality through the mocking of celebrity culture.

The comment section of this post definitely reinforced Brendon's reading, evident in the following comments, representative of the type of gossip talk that followed the original post:

> Al Gore: More proof lesbians are just uglsy that couldnt get cock. God hates ugly lesbians, only loves the hot ones

> StinkyChalupa: …instead of posting shit like this post something that will give me a boner

> Purplemonkeydishwasher: Yeah, I'd hit that…with a hammer until it stopped breathing (comments on ibid.)

As will be discussed in more detail in chapter five, the comment sections on WWTDD often go way beyond the ironic and snarky humor offered by Brendon in the initial post. He describes his own approach to celebrity as rooted in comedy, likening it to television shows like *Jimmy Kimmel Live* or *South Park* that use satire and irony to mock social norms and taboos. Brendon says, "I'm not homophobic. I'm not racist. And I don't want the page to seem like it is. But if it's a joke, if it's clearly a joke, yeah, I have no problem making it" (Brendon, personal interview, July 22, 2008). Many commenters on his site, however, do not seem to make the same distinctions or are less skilled in negotiating the boundaries of taboo humor. But as it does uphold the preferred reading originally offered by Brendon, such audience-created content remains consistent with the rest of the blog, offering it as a space where such heterosexist ideologies are not only tolerated, they are actively promoted. Furthermore, as will be discussed in detail in chapter five, these participants gain social capital within the community of WWTDD by making such comments, further validating this as an acceptable worldview both within and outside of celebrity culture.

Manipulation of Images as Commentary

As with links, all of the blogs in my sample rely on other sources for their images. These are typically photos found in web searches, purchased directly from photo agencies, such as WENN, Splash or X-17 or, more rarely, sent in by readers. As with the use of textual content culled from other sources, most gossip bloggers do not claim to have taken the photos of celebrities that appear

on their sites. However, the interactive nature of new media allows the bloggers to choose how to present these images in the service of their preferred reading of the celebrity. Though all use captions and clever juxtapositions as an attempt to limit the meaning of a photo, Trent and Perez are unique amongst the bloggers in that they manipulate these photos as a way to comment upon the celebrity gossip story. Their manipulations are obvious and played for humor value, and are not intended to mislead the reader or verify a false story with photographic evidence. Trent is the most adept at this form of visual commentary. He regularly uses Photoshop in creative and skillful ways to poke fun at celebrity culture in ways that resonate with the tone of his blog. He suggests this is a hallmark of his blog and part of what makes it stand out from the competition:

> I feel like my strength is more the photos, like trying to be funny…and that's something only I could do. I think only I could do! The writing on the pictures is something I did before anyone else did. (Vanegas, personal interview, August 20, 2008)

Though his manipulated images are always contextualized within a post, his use of manipulated images can stand alone as humorous gossip-based commentary.

Figure four is a good example of this sort of image manipulation. The image celebrates the birth of singer/actress Jennifer Lopez's twins by depicting two babies exploding from Lopez's pregnant body.

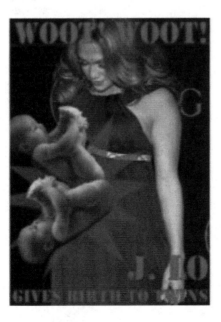

Figure 4: Jennifer Lopez on PITNB

Since the public did not know Lopez's due date, Trent had been speculating that she would "pop" any day for several weeks leading up to the birth of her twins in 2008, using paparazzi photos of Lopez appearing in public during the late stages of pregnancy as evidence of her imminent labor. Celebrity audiences certainly could have found the news of the birth on any number of sites after the official announcement was made, but Trent brought the news to his readers in his own unique way through this photo manipulation. It is extremely unlikely that audiences would think this was an actual photo of Lopez giving birth or that the babies pictured bursting from her stomach are even her actual children because the manipulation is so obvious and reflects back on his playful assertion that she is going to pop. It is a humorous but not cruel reading of the media frenzy surrounding celebrity babies that easily fits into PITNB's overall approach to celebrity culture (Vanegas, 2008, February 22).

Perez Hilton has also made photo manipulation an important form of gossip commentary on his blog. His judgment of celebrity is sometimes conveyed through intentionally juxtaposed, but otherwise untouched, images. On March 11, 2008, Perez published a post headlined "Separated By Plastic" and tagged as part of a regular photo series on his blog called, "Separated at Birth" (Figure 5). By posting an image of Madonna from the 2008 Rock and Roll Hall of Fame induction ceremony next to an image of the demonic doll The Bride of Chucky from the horror film of the same name, Perez playfully mocks Madonna's hair and makeup choices as well as calling up existing knowledge of her rumored plastic surgeries in the caption "Separated By Plastic." The juxtaposition of these photos does the work of deconstructing the celebrity image without any additional text in the blog post. Though Perez usually frames gossip about Madonna in a somewhat positive light, as he is quite vocal about his own love for her and her music, her lack of authenticity is called out here in ways consistent with his overall approach to celebrity culture.

This body snarking is not surprising, considering he frequently criticizes female celebrities for falling outside of rigidly defined boundaries of female beauty by being too fat or too thin or not dressing appropriately. Here, when a female celebrity attempts to hold on to the socially acceptable beauty that is part of her continued fame, she is ruled inauthentic and just as worthy of our scorn as a woman who "lets herself go." Furthermore, the juxtaposition of these two photos implies that the aging female, particularly one who has plastic surgery to attempt to hold on to her youth, is like a monster. Ultimately, the female celebrity is caught in a double bind. Refusing plastic surgery will brand her as "ugly" and unworthy, but having it makes her inauthentic and monstrous.

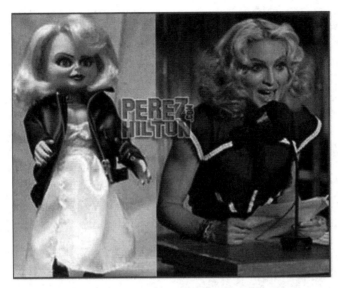

Figure 5: "Separated by plastic" on PerezHilton

Perez is perhaps best known for his use of Microsoft Paint to manipulate images as a form of visual commentary. This manipulation is much less technologically sophisticated than Trent's use of Photoshop, but serves a similar purpose of framing the meaning of an image through visual commentary. Using white "ink," Perez writes directly on photos, draws penises on celebrities' faces and bodies, places stick figure babies over the stomachs of supposedly pregnant celebrities and/or dots under the noses of those he alleges are using drugs. These simplistic deconstructions of celebrity's image are then echoed in the text of the post, though, again, the manipulated images typically need no additional commentary in order to be understood. This remains rooted in the negotiation and judgment that characterizes gossip talk, but, in accordance with Perez's overall approach to celebrity culture, is much more malicious and cruel in its mocking. Perez's obvious manipulation of images (see Figure 6 for examples) serves to strengthen his own reading of that celebrity as the preferred one for the audience.

These manipulations are used for humor, but a closer reading of a specific instance illustrates how these simple manipulations reinforce some of the larger ideological discourses that permeate his blog. On February 21, 2008, Perez published a new "Headline of the ~~Week~~ Weak," a semi-regular feature where he posts non-celebrity news headlines/items. These stories appear to be only tenuously related to his blog's celebrity focus, but through his deliberate manipulation of images, are given a different meaning. The post on the main page featured no image, only the headline "Israeli PM blames gays for quakes"

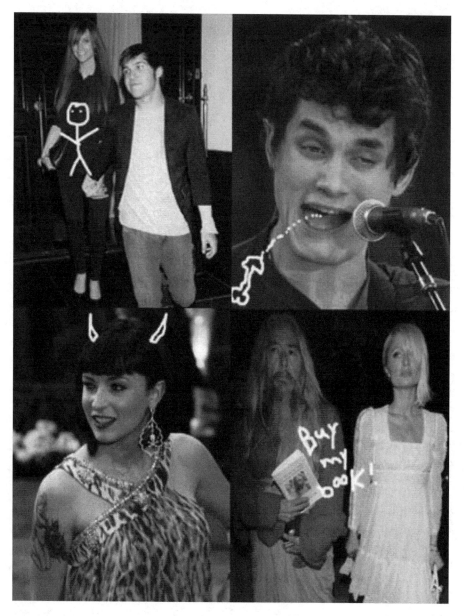

Figure 6: PerezHilton images (clockwise from top left: Ashlee Simpson in "More Baby News" (Hilton, April 14, 2008); John Mayer in "What's He Smoking???" (Hilton, March 27, 2008); Paris Hilton in "Is This A Publicity Stunt???" (Hilton, March 2, 2008); Diablo Cody in "The Stripper Strikes Again" (Hilton, February 28, 2008)

and Perez's entreaty to click the link to "read the incredulous article accompanying this headline" (Hilton, February 21, 2008). This is the only direct textual commentary by Perez, as the full text post that appears after clicking the link is the full text of a BBC news report in which the Israeli Prime Minister "blamed Parliament's tolerance of gays for earthquakes that have rocked the Holy Land recently" (ibid.). Given Perez's openly gay identity and vocal support for gay equality issues on his blog, this post could be read as a way to draw attention to homophobia as an ongoing social and political problem and as a call for an end to such discrimination.

However, the meaning of this post is complicated by Perez's manipulation of the image in the full text post that not only re-emphasizes the celebrity focus of the blog but also potentially undercuts the post's potential challenge to homophobia. No image appears on the short teaser post on the main page, but when the reader clicks to read the full text, she is presented with a photo of pop singer and *American Idol* season two runner-up Clay Aiken followed by the full text of the BBC report about the Prime Minister's comments. The image of Aiken is manipulated by Perez to make it appear that he has a white substance dripping from his mouth in a simulation of semen, a common form of image manipulation used by Perez that signifies homosexuality for men or excessive sexuality for women (Figure 7). On the surface, the image and the text seem unconnected. However, the juxtaposition is played for humor, and the "joke" here is that the manipulated photo of Aiken is used with an article dealing with a gay issue. This relies somewhat on readers' previous knowledge of Perez's ridicule of Clay as a closeted gay man, most evident in the fact that Perez commonly refers to him as "Gay Aiken," or familiarity with Perez's other photo manipulations.[5] But the juxtaposition of the manipulated image and the news story about gays also speaks for itself.

This example reveals the complicated ideological stances that permeate Perez's blog and indeed other celebrity gossip blogs. Like Brendon, Perez claims he is simply making a joke or deliberately trying to generate controversy as part of his deconstructive approach to celebrity culture. As previously mentioned, Perez is well known for "outing," or attempting to out, gay and lesbian celebrities who have not discussed their sexuality in public. Beginning in September 2005, Perez famously began speculating about the sexuality of former N*Sync member Lance Bass after paparazzi photos surfaced of him with Reichen Lehmkuhl, the winner of the reality show *The Amazing Race*. Perez continued to feature stories and pictures of Bass and Lehmkuhl as a way of outing Bass in a

[5] Aiken did not come out publicly until September 2008 and, at the time of this post, continued to deny reports that he was gay (Caplan, 2008).

public forum. Bass publicly came out in July 2006, in part, he claimed, because of media rumors perpetuated by sites like PerezHilton (Huang, 2006). Perez re-

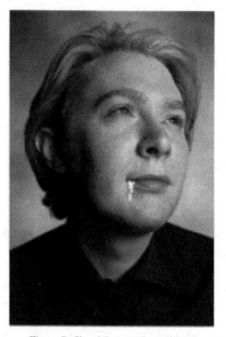

Figure 7: Clay Aiken on PerezHilton

cognizes the power of his blog to shape cultural attitudes more broadly and sees this outing as an important and positive project for the gay community. He says, "The only way we're gonna have change is with visibility. And if I have to drag some people screaming out of the closet, then I will. I think that lots of celebrities have an archaic fear that being gay will hurt their career but look at Rosie [O'Donnell]. Look at Ellen [DeGeneres]" (as quoted in Access Hollywood, 2006). From this perspective, using the photo of Aiken with this post illustrates that homophobia is a widespread problem, and the views of people like the Israeli Prime Minister keep gay people from revealing their true selves and achieving social and political equality. By raising this issue on his widely read site, Perez claims to be promoting dialogue about political and social issues using celebrity culture as an entry point.

Yet the mean-spirited way in which Perez outs potentially gay celebrities, such as the semen on mouth manipulation, speaks more to the reasons why celebrities might choose to remain closeted. Indeed, the few commenters who actually take up the issue of this juxtaposition (as opposed to simply talking about the BBC story itself or threadjacking by posting something unrelated to

either, which happens frequently on his unmoderated comment sections), mostly take the opportunity to mock Aiken's sexuality along with Perez. Vanessa says, "Can I please tell you how funny it is you chose Gay Aiken as your picture for this post? I'm cracking up" (comment on Hilton, February 21, 2008). Perez's readers seem more interested in the "fun" of his attempts to out Aiken rather than using gossip talk to challenge homophobia within and outside of celebrity culture. Furthermore, his unmoderated comments sections are routinely filled with homophobic slurs, many of which are directed at Perez himself. This would seem to further undercut his political project of challenging gay stereotypes because his comments sections do little to support dialogue and instead offer a forum for the same sort of hateful speech and attitudes he claims to fight against.

Many in the gay community have suggested this approach does not help the movement for gay rights or public perception of gay identities. Kim Ficera, contributing writer for AfterEllen.com, a lesbian-oriented entertainment blog, says, "although Hilton talks a good game, saying that closeted Hollywood celebrities are hypocrites who, as public figures, deserve to be exposed, his delivery sucks. Why sabotage the validity of his argument by being mean and immature?"(qutoed in Raezler, 2009). Similarly, Trent from PITNB suggests the public nature of blogging provides bloggers a powerful voice in culture, but one that comes with responsibility. He says:

> I don't do outing stories because I feel like for me, it wasn't like that huge of a deal, but I know that being gay, depending on where you live, can be a life or death situation, whether it's with your family or with your community. And everyone's struggle is their own struggle, so I would never ever want to impose any sort of undue hurt on some-one who's going through that. So I don't do that sort of thing. (Vanegas, personal interview, August 20, 2008)

Trent does post photos of gay celebrity couples and families alongside straight to support his view that gay families are just as normal as straight families, but he will only discuss a celebrity as gay or lesbian if he or she is already publicly out. Additionally, unlike PerezHilton's unregulated comments sections, Trent moderates his (reinstated) comments sections. He actively removes comments and bans users who use such defamatory language, particu-larly homophobic slurs, thus using the technological affordances of his blog to support his social goals. Such efforts recognize that what audiences do on gossip blogs has resonance outside of these technological spaces. That is, celebrity gossip is not just "fun" but functions as a source of social knowledge where audiences make sense of larger questions of the self and identity in culture. Perez has changed his approach in more recent years, as will be

discussed in the final chapter, but it is nevertheless relevant to understand the type of gossip upon which his blog was built and first drew audiences.

Building Blocks: Reader Comments as Textual Content

The final structural component of the post, the comments section, is also the clearest illustration of the intertwined nature of the technological affordances and the social practices of engagement on gossip blogs. The complexities of reader engagements will be explored more thoroughly in chapters four and five, but I mention them here as part of the format and layout of the blog as a textual form as well as a site for the social construction of meaning through gossip talk. Always appearing at the bottom of the full text post page and constantly updated as new reader comments are published, the comments sections are immediate and interactive technological affordances that enable readers to instantly engage in gossip talk with the blogger (who may or may not respond in these sections) and each other. This participatory space was simply not present for readers of tabloid or other print gossip media. Using the initial post as an anchor, commenters contribute content to the blog, shaping the social meaning of a celebrity through their gossip talk. As comments are visible only after the blogger's initial post and not on the main page of the site, this technological affordance supports the blogger's subjective viewpoint as the preferred reading of the celebrity. Not all readers choose to use this interactive feature to participate in the gossip community, but the comments sections are critical to the overall negotiation of meaning on the blog, as it provides a space for readers to voice their agreement or disagreement with the blogger's ideological standpoint and to engage in dialogue with each other within the social protocols established by the blogger and the other commenters.

Bloggers may be the primary producers of content and have greater control over the technological affordances that shape how readers engage in the comments sections, but the social practices of commenting are not necessarily as easily controlled. For example, the removal of comments sections on PITNB was a technological solution to a social problem on the site. In its original incarnation, PITNB did include comments sections, but Trent took them down in the summer of 2005 because they no longer fit with what he perceived as the tone of his blog. That summer, he and a friend had witnessed a hit and run accident in which a young woman was killed. Trent recalls:

> the next day, there was no way I could talk about anything funny or anything snarky. I just didn't want to deal with anything. I was like, you know what? I can't do [celebrity gossip] today. I put up all this information about what we saw and who to call [if a reader had additional information] because it was a hit and run…I filed a police report and that sort of thing…and the first comment someone left was "oh get over it, give us

the gossip" or something like that. And it just occurred to me that what if [the victim's] friends read that or what if [the victim's] family read these? It's fairly sensitive. And it's so easy for people online to be hateful or as hurtful as they want to be because it's faceless, it's anonymous, you leave a message and no one knows who you are. And at that moment, I took the comment section down and I left it off. (Vanegas, personal interview, August 20, 2008)

While Trent's decision to remove the comments sections because of the negativity is a radical move to control it, as blogs are defined, in part, by their interactive spaces, all of the bloggers impose various technological and social protocols to moderate the content added to the blog by the readers. In this case, Trent decided that the sensitivity of the topic and the fact that some of the commenters refused to treat it respectfully, a hallmark of his approach to celebrity culture, meant that he could not include any sort of dialogue. As the primary producer of the site, the blogger can exert this sort of explicit and technological control over the content created by readers in the comments sections. More commonly, as will be explored in the chapters on audience practices, it is the textual content created by the blogger and the ideological norms it reinforces, rather than technological controls, that shape audience meaning-making practices.

As texts, celebrity gossip blogs share common technological features that help define the genre. Yet it is not simply the presence of links and visual images that define the celebrity gossip blog, but how those features enable the social practice of gossip talk on and through the blog. Gossip has historically played a key role in celebrity culture, allowing audiences to find pleasure in the pursuit of the "real" person behind the façade of the celebrity image and to use that individual as a way to negotiate larger questions of social identity and culture. Celebrity gossip blogs remain rooted in this form of engagement with celebrity culture and make it central to the textual content of the genre. Gossip blogs do not report celebrity news, they report about it. They use gossip talk to promote dialogue and connection between blogger and reader and between readers as the key feature of the genre. The blogger's subjective commentary is catalyzed and anchored by the structural features of the link and the visual image, opening space for meaning-making through gossip talk. Defining celebrity gossip blogs as textual forms is a key point of entry to understanding how celebrity gossip blogs have reconfigured celebrity culture, but this impact comes more from what people do with these texts.

Chapter 3

The New "Professional" Gossip: Celebrity Gossip Bloggers as Media Producers

The celebrity gossip blog is an inherently interactive media text, one built on "the social, technological, and economic environment of user-led content" engendered by new media technologies (Bruns, 2008, p. 2). As new media texts, blogs highlight audience production practices in ways that, according to Jenkins (2007), "transform[s] the relationship between media producers and consumers" by allowing "average consumers of brands and branded entertainment" to play "a more active role in shaping the flow of media throughout our culture" (p. 357). While new interactive technological platforms like the Internet did not create the active audience, as scholarly work recognizing a wide range of active audience practices predates such technological shifts, they have made these practices visible and vital in ways that reconfigure audiences' role in media culture.

In contrast to the traditional top-down hierarchy of commercial media in which professional producers or "cultural elites" create and circulate content (and cultural meaning) for mass consumption by (passive) audiences, new media technologies have made visible an "audience/producer" or what Axel Bruns (2008) calls a "produser" that exists outside this traditional professional media producer class and threatens its commercial and cultural dominance. The audience/producer engages in media production as part of the pleasures of consumption, thus blurring the distinctions between audience and producer as a means to create a distinct form of textual production that draws on both roles. Blogs certainly illustrate the ways in which produsers have impacted traditional media cultures, but this shift from audience to producer is a complex one. Bloggers began as audiences of celebrity culture, and retain that tie in their production of their gossip texts through the use of pre-existing, commercially produced media content as a springboard for their subjective commentary, continuously blurring the line between producer and audience. Here, I explore how the production and consumption of these texts disrupt the traditional models of media production and consumption through an appeal to active audiences and participatory culture.

Framing the Active Audience

The notion that audiences do more than simply receive/consume mass media is not itself a new concept, as the category of the "active audience" has been central to much contemporary cultural and media studies scholarship (Ang, 1985; Biocca, 1988; de Certeau, 1984; Jenkins, 1992; Morley, 1980, 1992; Radway, 1984). Rejecting a monolithic notion of the audience as a passive mass who simply consume and accept the bourgeois ideologies transmitted by commercial media, these and other scholars acknowledge audiences are "being active in all kinds of ways" when they engage with mass media (Morely, 1992). Though the range of what counts as "active" consumption and has been and continues to be called into question by cultural and media scholars, the concept of the "active audience" remains crucial to studying media because it recognizes that meaning is never completely fixed by the producer and arises from the socially situated relationship between text and reader. This acknowledges that audiences can resist the hegemonic closure of the text through active and critical consumption (Hall, 1980). This shift made audiences central to any media system by offering insight into how audiences produce cultural meaning through everyday media consumption. Put another way, audiences never "just" consumed media texts, but always made them a part of their lives in complex and rich, though not always publicly visible, ways.

Fans and fan cultures, as Jenkins (2006a) argues, provide useful models for understanding a range of active audience practices as well as the push for public visibility of those practices as part of the system of media production. Fans, he says, have always been "the most active segment of the media audience, one that refuses to simply accept what they are given, but rather insists on the right to become full participants" (p. 131). Fans are not simply consumers of texts; rather they use their consumption as a springboard for their own cultural production, creating a range of texts that enhance and extend their pleasure in the original text. These fan-created texts not only challenge prescriptive definitions of audiences as passive consumers, but also explicitly challenge the authority of official producers to act as the sole producers of texts. Prior to the advent of the Internet, this sort of audience production typically remained on the margins, offering a supplemental mode/site of engagement that generally had only a small and often localized circulation. However, as Jenkins points out, the rise of new media technologies made fan-produced texts increasingly visible and viable by "provid[ing] a new distribution channel for amateur production" that ruptured traditional media production hierarchies and increased the reach and relevance of fan-produced texts (ibid.). New media technologies not only enable audience members to more easily produce their own media texts and circulate them alongside (or at least in public conversation with) the original

commercial media text, but many new media texts, including blogs, are explicitly built on these audience practices. This has extended the sort of active engagement and forms of cultural production typically associated with fandom into the broader definition of new media audiences.

Framing the audience as active is important to understanding the diversity of meanings that may be gleaned from media texts as well as how social contexts shape practices of consumption and production. However, it is equally important to recognize the potential limitations of such celebratory views of the active audience, particularly within the new media landscape. First, not all audiences engage in visible or production-oriented activities as part of their active engagement with media texts. Bird (2011) argues that to equate every form of active audience practice with this type of production-oriented activity fails to recognize the complexity of audience activity both within and outside of interactive technologies. She says, "It is very clear that the majority of people, whether by choice or access to time and resources, are not producers" (p. 504). The distinction between interactivity and participation laid out earlier in this book remains relevant here as a means to disentangle the idea of active audience engagement from the mere existence of interactive technologies, recognizing a range of social choices and practices that shape audience engagements within the new media landscape. Bruns' (2008) concept of produsage similarly distinguishes between traditional modes of industry production and alternative models of audience production that address "the emerging context of the information age," as well as recognizing the role of technology in promoting a wide range of new forms of social engagements amongst audiences (p. 2). Though he celebrates the transformative possibilities of produsage, this model does acknowledge that an audience's activity is not defined by the technological platforms alone, but is rooted in social practices of creativity and collaboration as the key challenge to the dominance of the traditional top-down hierarchy. Produsage offers a useful framework for understanding how celebrity gossip blogs make active audience practices of production visible through the social use of these technological platforms as well as the potential for this production to disrupt traditional hierarchies of media production. However, as will be evident in the next chapter on audience reading practices, I do not assume all audiences become producers in the same way.

Relatedly, though the recognition of active audiences presents an important grassroots challenge to the commercial media industry, it does not entirely strip that industry of its power. David Morley (1992) argues, "The power of viewers to reinterpret meanings is hardly equivalent to the discursive power of centralized media institutions to construct the texts which the viewer then interprets" (pp. 29-30). Because they begin as audience consumers, produsers remain tied

to commercial media texts in many ways. Blogs, in particular, rely heavily on existing commercial media outlets for their content. Thus even within new media, commercial media outlets retain a great deal of power in shaping the landscape of meaning. Furthermore, as initially amateur or grassroots sites like celebrity gossip blogs begin to gain traction within the professional media culture, their style and approach are often co-opted or copied by mainstream media industries as a means to undercut their threat to the system, an issue that will be more fully addressed in the conclusion. As a model of audience partici-pation, produsage does offer useful insight into the potential of new media users to disrupt traditional hierarchies and reshape media culture based on active engagement, but must be approached with some caution. As Bird (2011) points out, "Convergent media can and have transformed the traditional 'audience' experience," but understanding the complexity of this experience and its relationship to both production and consumption must be placed within broader conceptions of active audience practices (p. 510).

Audiences and/as Producers

Closely tied to the technological affordances of immediacy and interactivity offered by new media, produsers are re-imagining the top-down hierarchy of commercial media production through a user-led model of participatory media culture that blurs the once clear-cut boundaries of industrial production processes. Just as commercial culture borrowed from traditional folk culture in the creation of mass media, produsers are not re-inventing the media system, but borrowing from and intervening into it in creative ways that highlight audience meaning-making practices over commercially controlled texts. Digital technologies have placed the tools of professional-level media production and distribution in the hands of audiences, enabling them to rework existing content as part of their practices as audiences without, necessarily, becoming a part of the category of professional producer (Jenkins, 2006b, p. 136). For example, Jenkins (2006b) points to "game modders, who build on code and design tools created for commercial games as a foundation for amateur game production" as examples of this sort of participatory practice that builds upon an engagement with commercial media as a means of active audience production that remains (at least initially) on the outside of the professional hierarchies of production (p. 137). These audience/producers present a unique form of cultural production that remains tied to both the consumption of mainstream media and produc-tion of new texts based on that consumption.

Bruns' (2008) claim that such produsage practices inherently "stand in di-rect contrast to traditional modes of industrial production" is therefore rooted in the idea that the audience/producer cannot be fully separated from either

position (p. 9). Audience/producers are not simply consumers of texts; rather they use their consumption as a springboard for their own cultural production. They rework and remix existing content to create a range of new auxiliary texts that enhance and extend their pleasure in the original text while remaining in dialogue with it. Jenkins (2006b) suggests the public circulation of these fan-produced texts presents "a viable, public threat to the absolute control the culture industries asserted over their intellectual property" (p. 137). Blogs are an increasingly legitimate part of the commercial media system, but one that emerged from, and retains ties to, an audience/producer position. Though Jenkins suggests the new visibility of these audience/producers means such practices "have been pulled more and more into mainstream [media production] practice," the linking of production to active audience consumption practices suggest a new position of "professional" audience/producer that rethinks both categories (p. 132).

Celebrity culture makes a useful testing ground for the technological and social possibilities of new media because the traditional circuit of celebrity production is a system of production already marked by tensions and ruptures as multiple professional producers engage in a constant struggle over the meaning of the celebrity image. This system is further destabilized by the intervention of autonomous outliers such as tabloid magazines whose "unauthorized" access promises the truth about the "real" celebrity, often in direct contrast to the efforts of the other professional producers. Despite these struggles, all these players remain tied to traditional hierarchical modes of media production in which the professional producers at the top create and circulate content for consumption by audiences. But these audiences were never simply passive consumers who accepted what the circuit of celebrity production provided. The role of gossip in making celebrity images meaningful in everyday life meant the system always relied on various forms of audience participation. Even in the often solitary practice of reading a celebrity gossip magazine, audiences are invited to use the codes of gossip talk to negotiate and judge the information presented in the magazine in an active process of meaning-making (Hermes, 1995). Historically, these practices remained on the margins, as the producers of the magazines structured the limits of such meaning-making activities and there was no clear public space for readers to engage in such cultural production outside of their own personal spheres. That is, gossip readers produced meaning but did not typically produce their own publicly available texts.

The rise of new media platforms shifted where and how audiences consumed the latest gossip, opening new spaces for audiences to create and circulate media texts outside of the traditional circuit of celebrity production

and for the rise of the "professional" audience/producer in the form of the celebrity gossip blogger. Rooted in gossip talk, blogs privilege the unauthorized details of the celebrity's private life over a discussion of public performances. Like the tabloids, blogs threaten the controlled construction of the star image through their emphasis on the uncontrolled and private self, while simultaneously increasing the visibility of the star to an ever-expanding online audience. But celebrity gossip blogs go even further into the realm of the autonomous outlier by distancing themselves not only from the celebrity industry but also from the professional media industry more generally by highlighting their amateur status. Bloggers approach celebrity from the audience/fan perspective that favors gossip commentary and personal thoughts about a particular celebrity over a more distanced and objective reporting of news about that celebrity. This blurring of the line between producer and audience is central to bloggers' intervention into the traditional celebrity media industry and the creation of a unique position as a professional producer within the new media landscape.

Celebrity Gossip Bloggers as Audience/Producers

The gossip blogger is a unique player within the system of celebrity production who is simultaneously a consumer and creator of content. The category of "blogger" initially emerged outside of traditional conceptions of the "professional" media industry producer, as one needs no specific expertise or industry affiliation to gain entrance to the blogosphere. As amateur producers, bloggers' creative practices exist outside the boundaries and control of this system, but are having an increasingly profound impact on the way it operates. As with any blog genre, not all bloggers who write about celebrity culture have achieved commercial success or widespread impact on celebrity culture. Yet in the mid-2000s, a few gossip bloggers clearly crossed over into the realm of "professional" producers because their blogs were able to draw large enough audiences to attract the same sort of advertising revenue that supports the commercial gossip media industry.

Using the Internet, gossip bloggers have created a new professional class of media producers whose existence outside of the traditional entertainment-media industry hierarchy destabilizes the way gossip and media are created and circulated in contemporary celebrity culture. This legitimizes the audience/producer as its own category of professional media producer that is distinct from, yet increasingly competitive with, mainstream commercial media professionals. Like other commercially supported media forms, the bloggers must be able to draw audiences to maintain their positions as professional producers. All the sites examined in this book, even more niche-market sites

like black celebrity gossip blog YBF, log thousands of pageviews per day, regularly appear in web traffic tracker Technorati's list of Top 100 celebrity and entertainment blogs and frequently place among top entertainment sites overall. Though celebrity gossip blogs, in general, attract a niche audience, these sites are at the top of that niche in terms of popularity. Only a few gossip bloggers have crossed over into the realm of "professional" producers because their blogs are able to draw large enough audiences to attract the same sort of advertising that supports the commercial gossip media industry, it is notable that they did so based on their ability to "archive, annotate, appropriate and recirculate [existing] media content" as active audiences rather than through traditional media industry channels (Jenkins, 2006b: 136). Gossip bloggers begin as amateurs, but I consider these bloggers as "professional" because they work full time on their blogs and earn most, if not all, of their personal income from that work. At the time of the interviews, several of the bloggers (Natasha, Trent and Perez) owned their blogs outright, and the remaining bloggers earned salaries as writers for blogs under the umbrella of larger online media networks, but retained creative control over the direction of the site. As a case study, how blogs and bloggers impact the celebrity gossip media industry offers insight into larger questions about the shifting roles of audiences and producers within the broader new media landscape.

Gossip Blogs and Celebrity Journalism

Celebrity gossip blogs reconfigure, rather than completely reinvent, existing forms of entertainment-news and gossip media that shape the traditional circuit of celebrity production. Gossip bloggers are doing what fans do best—take existing media content and rework and remix it, carving out their own self-defined space as audience/producers within (and enabled by) new media. This is not to suggest that bloggers are directly and consciously mimicking the gossip columnists or tabloid magazines, but that the audience/producer position is always influenced by existing media forms because of its tie to audience consumption practices as a starting point for production. Important distinctions in the production and consumption of these textual forms do exist, but blogs remain indebted to the entertainment-news media and tabloid magazines in multiple ways.

At a basic level, blogs remain tied to existing forms because they draw their content from them, positioning the blogger initially as an audience member. Though blogs present a challenge to the traditional celebrity media industry, they simply could not exist in their current form without other traditional sources of celebrity news and gossip. This ties them to the industry as audiences who consume and negotiate these texts. In order to produce their blogs, the

blogger initially engages with celebrity culture as an audience member by consuming what the traditional celebrity media industry makes available and then producing their own texts based upon their reading of the latest celebrity news. In his discussion of how he gets information for his blog, Brendon from WWTDD addresses the primacy of existing sources to blogs in general, saying:

> me and everyone else [who blogs about celebrities] just has Google alerts set up for every celebrity you can imagine…I have about, say, 25 things that I check all day, every day. Like *People* and *Us* and *OK* and the English tabloids and the New York tabloids and of course TMZ and all that stuff. And whatever's interesting, I try [to incorporate in my posts]. (Brendon, July 22, 2008, personal interview)

This practice stems from traditional newsgathering practices of tracking developing stories on news subscription services like The Associated Press, but bloggers generally link to their mainstream media sources without permission or subscription. New media technologies enable the blogger's access to the information, but bloggers typically do not simply repost the stories gathered from other sources. As gossip-based sites, they use the information gathered as a springboard for the production of their own unique online texts that draw from, but extend, the content of these sources. It is this value-added content that takes the gossip blogger from audience to producer while retaining ties to both positions.

Gossip blogs are also tied to celebrity tabloids through their position in the circuit of celebrity production as autonomous outliers who remain economically tied to celebrity culture, yet refuse to fully submit to the control of the traditional celebrity industry. Tabloids have long traded on this outsider nature as a source of power within celebrity culture. By existing outside of the control of the other industry workers, tabloids offer audiences a seemingly unauthorized glimpse of celebrity culture that is at once "paradoxically not above a lie and yet somehow 'closer to the truth' than other journalism" (Brauer & Shields, 1999, p. 8). Despite this paradox and outsider status, tabloids are still tied to journalistic practices that shape the traditional media system. Bird (1992) suggests, "the history of tabloids is one strand in the broader history of journalism" and these media must be recognized as part of that framework (p. 9). They may push at the limits, but print tabloids remain rooted in conventional journalistic practices of newsgathering and reporting. In particular, though tabloids moralize and sensationalize their subjects, their reporting style remains tied to the journalistic concept of objectivity in which "the facts speak for themselves, whether the facts are observed by a reporter or quotes from sources" (Bird, 1992, p. 17). Tabloid journalists distance themselves from the story and allow the readers to draw their own conclusions based on the facts, however dubious their provenance, presented. Bloggers create their unique professional position by explicitly

distancing themselves from these practices through a more explicit focus on gossip. By approaching celebrity as an audience/producer who consumes and comments on the celebrity image with no attempt to be neutral or objective, bloggers adopt a standpoint of commentator instead of journalist. Molly of PS makes a distinction between the work of blogging and tabloid journalism:

> [Tabloids] definitely have to watch what they write and who they write about. That's part of the game… Which is just not something that, at this point, most blogs deal with [because] they're just, you know, commentary. [Bloggers] are not really making the stories. But they're reporting *about* stories that are in [tabloid outlets like] *Page Six*… I'm definitely more about commenting on photos or commenting on stories that are first hand reported elsewhere. (Goodson, May 26, 2007, personal interview, emphasis mine)

Bloggers are not journalists in pursuit of a story, tracking down and vetting original sources or dealing with independent producers for legitimate access to the star. Nor are they concerned with adhering to the journalistic standards of distanced objectivity and fact checking that characterize the writing style of news media, including most celebrity tabloids. Instead, they take already published information from other sources and comment upon it, providing a link back to the original story or using a photograph as a springboard for their discussion of and, importantly, gossip about the latest information for their readers. Bloggers begin with the gossip-oriented practices of reading that highlight negotiation and judgment of information and use that to create new texts.

The bloggers' ability to produce gossip texts begins with consumption of traditional celebrity media, but is not meant to directly mimic or reproduce the style or approach of those sources they consult. Trent of PITNB suggests retaining his role as an audience member is central to creating content for his blog because it allows him to emphasize his own viewpoints:

> I don't consider myself to be an originator of information…I'm more of a commenta-tor or a watcher…I have a group of sites that…you know, news sites and gossipy sites and message boards where people are talking about stuff. And I'll just say this is where the story comes from and I'll post a site if I use it. And then I just give my two cents. (Vanegas, August 20, 2008, personal interview)

In fact, all of the bloggers in my sample frame their work in this way, emphati-cally stating that the work they do is *not* journalism because they react to and talk *about* celebrity stories rather than break or even simply report them. Even though they are doing professional work, and, some may argue, a form of journalism in their editorializing, these bloggers simply do not see their work as connected to any sort of traditional journalistic practice. They see their media production as outside the boundaries of professional journalism because they

are tied to the pleasures of gossip they experience as audience members. At the same time, the blogger is not a typical audience member. He or she occupies a privileged position in terms of shaping the meaning of the celebrity covered because of the public platform offered by the blog and the size of the audience he or she draws. In this sense, the blogger acts as a mouthpiece for larger audience segments that read celebrity through a similar ideological lens, making audience meanings a part of the public circulation of the celebrity image.

That these bloggers do not see themselves as journalists is not surprising, as few had any experience working within any facet of the professional media industry before starting their blogs. The only bloggers from my sample with any prior journalistic experience are Anna, who worked for print media outlets *Star* and *InStyle* before becoming the editor-in-chief for Jezebel (a role she left in 2010 to pursue other writing projects) and Perez, who worked at *Star* at the same time he started an early version of his gossip blog, called PageSixSixSix.com (Holmes, 2008, personal interview; Denizet-Lewis, 2009). Despite her journalistic background, Anna still makes a distinction between the two forms, seeing blogs as platforms for:

> what the writer is personally feeling. Like if they have a very, very strong opinion about something, they're going to insert themselves and their opinion much more than if they were just, you know, announcing that something had happened. (Holmes, August 9, 2008, personal interview)

As editor-in-chief of Jezebel, she assigns stories to certain writers because a strong connection to a topic or celebrity, not the distanced objectivity characteristic of traditional journalism, will make a better blog post. Bloggers reject the label of journalist in part because it frees them from the more rigid standards of writing and fact-checking such a label implies and allows them to emphasize their own voice in a more conversational and gossip-oriented style not available in traditional media forms. Natasha from YBF sees this as an important difference between bloggers and traditional celebrity journalists:

> I'm well aware of journalistic standards and the journalistic integrity and ethics standards that a journalist has to take. None of us in the blog world do that and so we don't really have the right to call ourselves journalists...So I think that's the main difference between us and the gossip tabloids. They're more journalists. I'm more saying what I feel like saying. We still need to have responsibility for what we say. But [even] if we didn't, we're not typically gonna get sued for it. (Eubanks, July 23, 2008, personal interview)

Unlike print tabloid reporters, bloggers are not expected to be objective and neutral in their engagement with celebrity culture. The blogger explicitly uses first-person gossip, a form of engagement more associated with celebrity

audience reading practices, to create media texts that reflect his or her ideological perspective. The Internet provides the tools to create and circulate this content, and by finding an audience and earning commercial support, these popular bloggers have entered the realm of professional celebrity media producers on their own terms. By elevating audience practices as a space of production, these bloggers challenge the notion that only official professional celebrity industry producers control the public meaning of celebrity culture.

Gossip, Technology and Content Creation

The bloggers' perceived distance from professional journalistic practices is related to their use of the Internet to create and circulate their texts, making new media technologies and the attendant affordances of immediacy and interactivity key to the public emergence of these audience-based production practices. First, the immediacy of the Internet enables information to be accessed and spread instantly. This means bloggers have the ability to consume a wide range of content to feed their own commentary. At the same time, bloggers must quickly comment upon the latest developments in order to retain their positions as producers. Thus, behind the blog's frequent updates and up-to-the-minute photos and details is a blogger whose workday is not defined by weekly publication deadlines in the way print magazines are. Brendon says:

> If I go three hours without checking my email I start freaking out. Because you never know what's going to happen. I remember the day that Britney [Spears] shaved her head. My girlfriend and I took [a night off]. Got home at like 11 at night, you know, and I had thousands of emails just saying "Britney shaved her head! Britney shaved her head!" And so you don't ever want to miss…you don't ever want to be last. I mean…if something big happens…you just have to be on it all the time. And, you know, on a lot of days when I don't feel like writing, like I'm not in a funny mood, or I had a fight with my girlfriend or whatever, I don't want to do this. No one cares. No one cares if it's a holiday. No one cares if I'm depressed. They just want the website. And I'm the only one here. It's just me. (Brendon, July 22, 2008, personal interview)

This perspective, echoed in similar ways by the other bloggers, reveals that the blog's audience is not necessarily relying on it solely for the latest information. Indeed, in Brendon's anecdote, his audience *already knew* the latest information about the star, but wanted to read what Brendon had to say about it, highlighting his role as a commentator, not a journalist breaking exclusive news, as the reason audiences visit his site. The immediacy of blogs is also relevant to their power to disrupt the traditional circuit of celebrity production. Perez acknowledges that the ability to update in such a frequent and timely matter is key to his success because it means he "can react more quickly than print media…It also means that publicists have less leverage because they have

less time to control a negative story" (Day, 2007, para 19). The immediacy of the blog format means he can offer the latest gossip faster and, he claims, with more accuracy than print outlets that must adhere to journalistic codes and print publishing schedules. Using new media technologies to change when and how audiences engage with celebrity culture, blogs quickly established themselves as a strong force within celebrity culture.

In addition to shaping the content, the immediacy of the Internet also shapes how and where bloggers do their work in ways that further distance them from the traditional professional celebrity media workers and the definitions of professional celebrity journalism. Since the Internet can be accessed anywhere in the world, the reliance on online sources as starting points for their commentary means that gossip bloggers can keep their fingers on the pulse from anywhere and do not need the more direct access to celebrities that historically shaped the relationships between the independent producers and entertainment-news media. Unlike traditional celebrity media workers who rely on contacts with other players, bloggers do not have to be located in Los Angeles or New York City—the two centers of American celebrity culture—in order to have access to celebrity news and events. All the bloggers I interviewed are based in urban centers, but this was largely unrelated to their ability to access and comment on the latest celebrity gossip. In fact, several are located in areas not typically considered hubs of celebrity culture, namely San Francisco, Atlanta, and Alexandria, Virginia. Trent began PITNB in Detroit, Michigan, hardly a capital of celebrity culture, but was able to make it a success by commenting on information he found as a reader on the Internet, not through journalistic investigation. Speaking of the early days of his blog, Trent recognizes that:

> because I lived in Detroit…I didn't have access to these parties, I didn't go to these premieres. So what I did was I basically ingested everything that was happening and I kind of put my spin on it…And that's the only way I know how to do what I do is [through] my voice. (Vanegas, August 20, 2008, personal interview)

He has since moved to Los Angeles, but insists the move was for personal reasons and not motivated by his work for the blog. It was the success of his blog that enabled him to afford the move, but he does not see it as changing the way in which he writes his blog or gathers his information. He still relies primarily on other online sources rather than cultivating relationships with publicists, mainstream entertainment-media sources or other players on the traditional circuit of celebrity production. The active audience practices that are at the heart of the blogger's professional work can be done from anywhere and do not rely on the interplay between producers that define the traditional circuit of celebrity production.

Gossip and "Putting Yourself" in the Blog

By distancing themselves from the journalistic constraints of traditional celebrity media and highlighting their roles as both audience members and producers, gossip bloggers build their content around the meaning-making possibilities of gossip talk. Celebrity gossip blogs are not simply compendiums of gossip items taken from other, more journalistic, sources, but a gossip talk style of conversation about celebrity culture that foregrounds the blogger's voice in ways that create a sense of connection between blogger and reader. The importance of personal voice or "putting yourself" in your blog is echoed by several of the bloggers, who each stated that they write as if they were talking with their friends about celebrity culture instead of using the more distanced and neutral tone characteristic of other celebrity media. This again highlights the notion that they draw on their position as audience members/fans as well as producers in ways that celebrity journalists do not. According to Molly:

> that's what makes blogs fun, and that's what makes people loyal to certain blogs and certain bloggers because you feel like you want to know what Molly feels about that or what Bill from Egotastic feels about that. So you actually feel like you know the person instead of just dry [reporting]. (Goodson, May 26, 2007, personal interview)

This allows the blogger to inject his or her individual identity and worldview into the blog not only as a way to define the approach to celebrity culture, but also to make it more relatable and entertaining.

Brendon, like the other bloggers, points out that unlike journalistic approaches to celebrity, humor is central to gossip blogging. He says:

> I don't pretend to be a reporter or anything like that. I don't pretend to have sources or like any of this is like I'm breaking some story. I'm just trying to write something funny and try to be entertaining and the stories are just the springboard, you know, something to base a joke on. (Brendon, July 22, 2008, personal interview)

However, he also blogs under a pseudonym and though he tries to write what he thinks is funny, he says, "I don't want the page to be about me…The page isn't me. The page isn't supposed to be about me. It's supposed to be about celebrities and jokes and pictures" (ibid.). This is very different from the other bloggers in my sample, who see their blog as an extension of themselves, but still prioritizes commentary over reporting. His blogging persona may not be "him," but it maintains the consistent voice and style typical of the gossip bloggers as opposed to distanced objectivity. Brendon writes in conversational and humorous style that foregrounds a mocking perspective on celebrity culture that permeates all aspects of his blog and draws in audiences who seek that sort of perspective on celebrity culture. The distance he cultivates is a personal, not

an objective, one. He still draws on his position as an audience member, not a celebrity insider, as a starting point for the creation of content on his blog.

This outsider status is important to the blogger's position within the system of celebrity production. By being both fans/audiences *and* professional producers, bloggers offer a unique perspective on celebrity culture that has resonance with readers and with the industry. Trent claims:

> In the 80s when the *National Enquirer* was the go-to tabloid for gossip, there was no feedback from the people. It was just fed to us. We heard from the *Enquirer* that Michael Jackson wanted to buy the Elephant Man's bones, and that was the end of it. And I'm thinking, why? Why would he ever want to do that? If I had a blog back then, I would have been like this is the stupidest thing I've ever heard! Like why would he ever want that? I feel like blogs give regular people the chance to talk back. And it's the talking back that [audiences] respond to. Because I'm not the only one who's thinking that, other people are thinking that as well. I feel like that's really where blogs fit in. It takes the tabloid journalism a step further…when MTV is reading what people say about *The Hills*, do they care what *Us Weekly* says? No, because there are publicists to tell them what's going on, this is when the show is about…Do they care about what a blogger would say? Absolutely. Because bloggers are their fans, their audience who is watching the show. (Vanegas, August 20, 2008, personal interview)

Bloggers act as mouthpieces for larger segments of the celebrity-watching audience, providing public visibility of the range of meanings that circulate around a celebrity's image. Audience practices, while always a part of the circuit of celebrity production, are made increasingly important to the cultural meaning of celebrity in contemporary culture through celebrity gossip blogs.

As audience/producers, bloggers can also shed light on the needs of audiences that are typically ignored by mainstream celebrity media. For example, Natasha's decision to start YBF was a direct response to a lack of minority representation within mainstream media and, in fact, on other gossip blogs. She points out that:

> The only reason I started this was because I saw a need. Because I knew that if I'm craving it, there have to be a few other black chicks who crave it. At least a few. My job is not to do what I do to please mainstream media. (Eubanks, July 23, 2008, personal interview)

YBF exclusively covers black celebrity culture, including celebrities from film, television, music and sports. This market niche may not be large enough for mass market print tabloids like *Us Weekly* to seriously pursue, but Natasha built a popular and profitable blog based on addressing her own desires as an active audience member. She clearly recognizes that a move to producing texts was the best way to make sure she (and others like her) could have texts they wanted to read:

I'm obsessed with celebrity gossip already and after a few months [of reading main-stream blogs] I just got annoyed that they very rarely featured black people on it, other than Beyoncé, Jay-Z, you know? And after asking [those bloggers] to feature more black people, and they of course ignored me, I just decided to do it myself. (ibid.)

This is an explicit move to increase the visibility of black celebrity culture, which she felt was being left out of "mainstream" gossip media and, more importantly, to do so in a positive and affirming way. Just as Jenkins' (2006) fans "refuse to simply accept what they are given" by mainstream media, gossip bloggers like Natasha move from audience to producer in order to reshape mainstream media in ways that are more pleasurable and speak more directly to their needs (p. 131). Her role as an audience member, then, directly influences her position as a producer of celebrity gossip texts.

Like YBF, Jezebel defines itself against the hegemonic norms that permeate both the mainstream gossip media and mainstream gossip blogs. Anna says:

When I was thinking of what the site should be, and what I saw being marketed to young women, I wanted us to weigh in or at least acknowledge there is a large interest in celebrity stuff, but that it's often presented in a very sexist and misogynistic way on what I would call the gossip sites, whether that be Perez Hilton or any other number of popular ones. So the only way we would differentiate ourselves…we would certainly weigh in on celebrity stuff and talk about it, but not by scrawling nasty things on pictures or making fun of the way a female celebrity looks in terms of her body. (Holmes, August 9, 2008, personal interview)

Jezebel provides readers with the latest in celebrity news and gossip, but uses humor and mocking of celebrity culture to make larger arguments about the treatment of women in media and culture. The bloggers of Jezebel and YBF explicitly position themselves as alternatives to what they see as the problematic nature of mainstream gossip blogs and their influence on women's everyday lives. That is, they recognize that the attitudes and identities forwarded in celebrity culture (and in media in general) play a role in how people understand themselves in culture. Their work as professional producers is explicitly tied to their experiences as audience members and what kind of celebrity media they wanted to read. The other bloggers, though not as focused on addressing absences in mainstream celebrity media, also foreground their roles as fans/audiences through their use of gossip, maintaining ties to that position as a key component of their role as a producer within the system of celebrity gossip media.

Towards a "Professional" Audience/Producer

The widespread availability of new media technologies and the ease of their use aided the rise of the "professional" celebrity gossip blogger by giving visibility to their practices as audiences. The reach and impact of their blogs has disrupt-

ed the traditional circuit of celebrity production in unprecedented ways by allowing individuals who began as audience members to participate in the public construction and circulation of celebrity images and redefine the role of "professional" gossip media producer. That is, bloggers are not journalists nor do they work for any traditional commercial celebrity media outlet. Instead, they simply utilized the Internet to start writing about celebrities and celebrity culture from their perspective as an audience of that culture. Furthermore, since bloggers cull their content from existing online sources rather than doing journalistic investigations themselves, they believe they are not beholden to any industry controls or journalistic standards. They approach celebrity culture from the position of a fan/audience member and have created a new category of celebrity media texts and professional producers based not on traditional access to celebrities but on gossip-oriented commentary drawn from this position.

Even in the Internet's more open system of production, not all audience voices have the same authority, and the intervention of celebrity gossip bloggers does not herald the rise of an entirely new media system created by audiences. It is clear that not all audiences engage in this form of cultural production online. Bloggers, in general, represent a very small percentage of celebrity media audiences, as consumption (though itself an active process) remains the predominant mode of audience engagement with celebrity media. This range of forms of participation will be discussed in the next two chapters, and I do not intend to lump audience production practices into the production of the gossip blogger. The next two chapters will focus on a wider range of more "traditional" audience practices.

Furthermore, bloggers who find success on a "professional" level are an even more rarified group, particularly after the genre's expansion in the late 2000s. Trent recognizes that timing played a key role in his success:

> It's harder now because it's so saturated. It's harder for up-and-comers. If I was starting now, even if I was doing exactly what I'm doing right this second, but I was starting now, I'm pretty convinced I would have nowhere near the success I've had. Because it was right moment, right time for me back then. And I'm able to continue doing it now because I've been doing it for so long. But the market is saturated. (Vanegas, August 20, 2008, personal interview)

Of these early successful bloggers, most did not get into blogging as an intentional career move, either as a way to get into celebrity media or to become a celebrity themselves. Employed at the time as a high school history teacher, Trent began his blog as a graduate school creative writing project that transformed into an online journal. A self-described "huge fan of pop culture, media [and] movies," he used using his writing as a creative outlet to extend his engagement with these media forms, not as a means to break into the media

industry (ibid.). Similarly, Natasha was enrolled in law school when she began her blog as a space to discuss black celebrity culture with her friends because they lacked other outlets for this engagement. As with Trent's creative outlet, this highlights the audience position as the point of entry into the cultural production of gossip blogging. Though this was not her original goal, Natasha has since made the blog her full-time profession and intends to build the blog's success into "my own media empire." (Natasha, July 23, 2008, personal interview). She explains:

> That includes not just blogging…I'm just very big on business growing and doing things for ourselves, not banking on mainstream media to do things for us. So I want every aspect of the media…whether it's who's taking the pictures, who's posting the pictures, who's producing a movie, who's the PR people for this, this, and this. Everything that goes on inside of entertainment and even outside of entertainment, I want a piece of for myself. (ibid.)

The ways in which these bloggers turned audience practices into professional careers through the use of new media technologies points to the ability of produsage to reshape media systems. Without the public visibility provided by the Internet, Natasha and Trent's cultural production would have remained on the margins of popular and celebrity culture. Though these are likely still pleasurable ways for them to engage with celebrity culture as fans, the fact that they were able to transform these practices into professional careers reveals the power of produsage as a challenge to traditional media production hierarchies.

Perez is by far the most successful blogger in terms of parlaying his professional blogger status into a lucrative career that includes an expansion of the "Perez" blog brand to include blogs on fashion (CocoPerez), fitness (FitPerez), parenting (Perezitos), and pets (TeddyHilton), all with a celebrity twist. In addition to appearing on numerous talk shows to discuss celebrity gossip and culture, he has also appeared, as himself, on television programs such as *90210* (2011), *The Bad Girls Club* (2009) and *The Hills* (2009), and judged reality competition shows including *American Idol* and *America's Next Top Model* (both in 2010) and the 2009 *Miss America* pageant. Perez created a record imprint with Warner Brothers, has published two books based on his blog and, in 2011, published a children's book called *The Boy with the Pink Hair*. He could not have anticipated this trajectory when he first launched his blog in 2004, but the increasing popularity and legitimization of celebrity gossip blogging as part of the celebrity media industry has enabled him to enter other realms of professional media production. At this point, Perez functions more as a brand than as an individual blogger, a shift that points to the increasing importance of bloggers to celebrity culture and blogging as a point of entry into the traditional media industries. Though his site continues to offer posts attributed to Perez,

the blog is reportedly now written by several uncredited staff members who maintain his voice as a means to maintain the brand at the center of his growing media empire (Tate, 2009). Nevertheless, it was Perez's initial produsage practices that allowed him to both challenge the dominance of the existing media industry and gain entrance to it. This also points to the potential for the traditional media system to recuperate these outsiders into its own service, reshaping mainstream media in ways that co-opt the participatory and resistant possibilities of produsage.

The rise of individual bloggers as professional media producers also legitimized and professionalized the notion of blogging as a part of the larger media system, evidenced by the fact that some bloggers, like Molly and Anna, did not begin their blogs as individually authored sites but within a larger blog network. Molly says:

> I was really bored [at my non-profit job] and sort of blogging on my own. Then [I] sort of started interning for [now defunct gossip blog] Jossip…[and] the gentleman who owns Jossip and Queerty, which is their gay lifestyle blog…came to me and he said "do you want to start a celebrity blog for me?" And I said, sure. So Mollygood [her first blog] was always intended about being about celebrities, and then I moved over to PopSugar in January [2007]. (Goodson, May 26, 2007, personal interview)

Blogging for PS, Molly has creative control over the content on the site, but does not own it outright the way others do. Similarly, WWTDD's Brendon sold the ownership of his site to blog network BuzzMedia, though still retains creative control over its content. Both are more clearly "professional" bloggers now that larger online media networks employ them. These networks are new forms of online publishing that draw on the audience for creative production and potentially recuperate it back into a closed commercial media system in which the owners, not the bloggers who create the content, control the profits. Granted, this is still an expanded media system in some ways, shared by both traditional media outlets venturing online and upstarts which would not find a foothold into the commercial media industry without the Internet as a distribution channel. As will be explored in the concluding chapter, not only have the number of blogs exploded since the mid-2000s, the style and tone that characterize blogs, and that tie them to their audience roots, have been co-opted and replicated by traditional celebrity gossip media outlets.

Those bloggers who have achieved widespread success in no way represent the full range of possible interpretations of celebrity culture, and many have built their success on the reproduction of the hegemonic values embodied by other forms of celebrity media. These blogs may challenge who can produce media texts, but use that intervention to reproduce the same dominant ideologies available across mass media forms. Nevertheless, as previously discussed,

there is evidence that successful bloggers act as a public mouthpiece for certain audience segments and can use this as a challenge to hegemonic ideologies within celebrity culture, which remains an important intervention into mainstream media. The notion of the "audience" and indeed of active audience practices remains central to understanding the impact of gossip blogs on celebrity and media cultures.

Chapter 4

Reading Practices and Audience Communities on Celebrity Gossip Blogs

As traditional print gossip magazines began to decline in the early 2000s, celebrity-watching audiences increasingly turned to online sources to get the latest dish. By the mid-2000s, entertainment news sites were among the fastest growing categories of online content, and gossip blogs were a key part of that growth (ComScore, 2008). Understanding such shifts in where, how and why audiences engage with celebrity gossip online is important to recognizing the impact of celebrity gossip blogs on celebrity culture and celebrity media. Page views and other web-traffic tracking data offer one clue to understanding the online engagements of celebrity-watching audiences. However, in addition to the previously discussed ways in which traffic numbers can be manipulated and misrepresented, relying on traffic statistics to define celebrity gossip blog audiences offers little insight into the social practices of gossip that draw audiences to these blogs and potentially creates a sense of connection within them. Other than potentially revealing how long audiences spend on a blog or how many pages they view within the site, these data do little to describe what audiences do when they visit the site and the specific cultural contexts and identities that shape their various reading practices.

Understanding more complex audience practices on celebrity gossip blogs is particularly crucial because, as with other forms of interactive online media, blogs rely on audiences not just as readers but also as content creators. Indeed, gossip blogs not only tolerate active audience participation, they explicitly encourage it (to varying degrees). As discussed in chapter two, features like comments sections and reader polls make the audience publicly visible and allow them to create content as part of the practice of reading gossip blogs. However, relying only on the data gleaned from the visible forms of engagement on blogs excludes certain segments of the blog audience and fails to directly address a range of less visible community-building practices tied to gossip. After all, blog audiences are always readers, a clear tie to the solitary reading practices of magazine readers discussed by Hermes. In fact, the two most popular blogs in my sample in terms of audience size, PerezHilton and

PITNB, were able to attract large audiences despite their minimal spaces for interactive engagements. This suggests that reading texts remains a key feature of audience engagements with gossip blogs and that content creation is not the primary activity, or even primary draw, for many audiences. To classify these "invisible" audiences as passive receivers of information belies the complexity of their gossip-oriented reading practices and the ways these practices unite readers and create a sense of community on the blog.

In order to offer a more complex view of gossip blog audiences and the spaces of community offered to them on gossip blogs, I begin my analysis by framing them as readers before moving to their more visible forms of active engagement as content creators. My access to this level of audience engagement is drawn primarily from an online survey I conducted from November 2008 through February 2009. Through the survey, which will be discussed in more detail below, I aim to address the invisible audience of readers on gossip blogs, commonly referred to as "lurkers," who read but do not engage in the interactive features on gossip blogs. Their practices reveal a broader definition of audience activity on gossip blogs and illustrate a range of community-building practices that circumvent the technological affordances offered by the blog.

New Media and the Metaphor of Community

It should come as no surprise that academic and popular interest in new media includes the discussion of the practices of online audiences as spaces of community. Nancy Baym (1998) notes that "social relationships thrive on-line and have since the beginning of interactive computing," leading many observers to intuitively adopt the label of "community" to describe the "sense of interpersonal connection as well as internal organization" that characterizes online interactions (p. 35). The intuitive tendency to ascribe the label of community to online groups makes some scholars uneasy, as, they argue, it disregards the potential physical and political limitations of such a conception of community in favor of a romanticized version of a virtual democratic space. At the heart of these debates is the question of how exactly community is to be defined and, thereby, manifest within a virtual setting in which many participants rarely, if ever, meet face-to-face. Jan Fernback (1997) offers a broader understanding of community, suggesting it:

> is a term which seems readily identifiable to the general public but is infinitely complex and amorphous in academic discourse. It has descriptive, normative, and ideological connotations. A community is a bounded territory of sorts (whether physical or ideological), but it can also refer to a sense of common character, identity, or interests as with the "gay community" or "virtual community." Thus, the term "community" encompasses both material and symbolic dimensions. (p. 39)

Here, community is understood both as a feeling or sense of belonging and as a means of materially experiencing the self as part of a group (e.g., a gay man who is part of the larger "gay community") and as part of the larger society. This diminishes the need for physical proximity in order to form community—an important move for understanding virtual community—and rethinks the category in terms of social practice and identification amongst members. Thus, as Rhiannon Bury (2005) claims, the substance of a community is seen in the repetition of various yet distinct "communal practices" by a majority of its members, foregrounding shared social practices and identifications that bind groups together (p. 14).

Placing social practices at the heart of any definition of community is not unique to the online setting, as it builds on the notions of imagined communities already recognized as key to understanding media audiences who may or may not share physical proximity. Mary Chayko (2002) reminds us that even when community members share the same physical space, social connectedness remains "rooted in the mind," through our use of cognitive processes to both understand the world around us and communicate that understanding to others (p. 19). She says, "People are not (usually!) physically connected, bound or tied together; rather we call them 'connected,' 'bonded,' or 'tied' when we intuit that their relationship is sufficiently strong to warrant the metaphor" (ibid.). The focus is on shared engagement or what participants do as part of their ordinary engagements that provides a "workable core" for understanding community. By removing the need for a clearly stated emotional core, this practice approach to community recognizes that individuals need not be strongly connected to feel a sense of community, either in the "real" or virtual worlds.

While some suggest the mediating force of technology separates individuals and impedes a true sense of connection, Barry Wellman and Milena Guilia (1999) point out that many technological advances, including cars, planes and telephones as well as the Internet, allow people to maintain strong ties despite a lack of physical proximity. Technology changes *how* and *where* we engage with others, but the social goals of connection or what we *do* to build and strengthen our connections with others remains central to defining community. As Katie Ward (1999) notes, people are members of many different communities, "each serving a purpose and fulfilling a specific need in that individual's life" and that technology may enable "people [to] drift in and out of numerous different virtual communities staying only as long as the virtual community is providing a solution or fulfilling a need in their life," but does not diminish the social experience of being a part of a group (p. 103). The idea of individual choice in developing and maintaining multiple and varying relations as a form of community are relevant to both on- and off-line communities, but is particularly tied

to the often transitory nature of online engagements. Nessim Watson (1999) suggests that the lack of physical proximity actually increases our ability to form meaningful social connections because it highlights our ability to *choose* how and with whom to form community, reinforcing the importance of social practices to draw members together into shared online spaces.

Though I claim various forms of community do exist on celebrity gossip blogs, my focus on social practices is not meant to idealize these spaces or ignore the potential pitfalls of online sociability. Simplistic definitions of community disregard the ways actual Internet users understand their online engagements, which may or may not include a sense of community or goal of making meaningful social connections. Lack of attention to the features of the online community under analysis, Baym (2006) suggests, "implies that any group involved in social discussion is necessarily a community" and dilutes the metaphor's strength as an analytic approach (p. 45). Many scholars, including Baym, want to retain the community metaphor, but argue for a more rigorous use that recognizes the differences between online groups in terms of structure, content and commitment, and draws attention to the multiple modes of social interaction that occur within these groups. I argue that addressing the various audience practices on gossip blogs, as well as how audience members describe their own engagement on and sense of connection through blogs, reveals the complexity and range of communities that emerge in these specific online settings. Furthermore, it recognizes that these community spaces may not be liberatory, dialogic or supportive spaces of online engagement. The goal is not to define a prescriptive or normative definition of online community but to examine the social possibilities of engagement on celebrity gossip blogs.

Reading Gossip, Creating Community

Gossip is, I have argued, a way to evaluate and negotiate the social meanings of celebrity images, and in so doing, build social connections with others based on shared meanings. By participating in the interpretive strategies of gossip unique to a particular blog community, one indicates belonging to that group. Thus, even the choice to read one blog over another is itself a way to define a community, as it aligns the individual with a certain set of interpretive strategies for reading celebrity culture that reflect a particular set of social values. By judging others through these shared standards, gossipers on celebrity gossip blogs form a relational attachment that speaks to the idea of online communities as interpretive communities bound not by proximity but by shared meaning. Hermes' (1995) research on gossip magazine readers relates the seemingly

solitary practice of reading to this sense of shared connection, as readers are drawn into relationships both imagined and real through gossip talk.[1] She says:

> by either reading gossip or talking about what they have read with friends they appeal to and thus construe shared standards of morality (with an imagined community of other gossip readers, or with other readers who are present in the flesh) that alternate between disapproval and understanding. Gossip brings together by creating an intimate common world in which private standards of morality apply to what is and what is not acceptable behavior. It is about basic human values and emotions, about the fact that, in the end, all human beings are equal, whether they are rich or poor, whether they live in the glittery world of showbusiness or whether they only read about it. (Hermes, 1995, p. 132)

Reading gossip blogs promotes a similar sense of imagined community because such shared interpretation and judgment of information remains central to their textual content.

One blog reader describes a basic sense of connection that arises from consuming the same text by saying "there is high traffic to the blogs, so we must be somewhat on the same wavelength." This shared "wavelength," I argue, goes beyond a common interest in celebrity culture. That readers specifically seek out blogs with a certain perspective on celebrity culture suggests they see this shared meaning as important to their connection with the blog and other readers. Other readers similarly described the shared interests and values promoted on a gossip blog as a space of connection:

> When you read that people have the same opinion that you do about something, it makes you feel connected to them.

> It's almost like a club and the meetings are held everyday and you go over the latest news and keep up with stuff together. A whole lot of people are looking at the same thing you are, it's cool.

> Only a select set of people read blogs, so i feel I have something in common with the other readers that is out of the ordinary.

> I feel like it's a giant community of people just like myself who are interested in this stuff.

[1] I use the term "real" to refer to traditional, off-line face-to-face communities. I do not wish to imply that imagined or virtual/online communities are not "real" or actual communities. My use of the term is simply to distinguish the site and form of interaction that characterizes each community.

These readers do not necessarily engage with others through interactive features, yet still recognize that seeking out blogs that share their own values and judgments about celebrity culture draws them into a common community with others who read the same blog.

While practices of reading gossip blogs are in many ways similar to reading print gossip magazines, these online texts differ from traditional print media in important ways that intensify their potential as spaces of community. The technological affordances of gossip blogs would seem to open more possibilities for readers to engage and connect with each other as part of their reading practices. Interactive features, like comments sections, offer the reader a more public and direct space of connection with the blogger and other readers. But how these features actually connect readers is not merely a question of the availability, as research shows only a small percentage of users across the Internet actually use available interactive features. My own survey of gossip blog readers reflects this finding, as only 2.7% indicated they regularly post comments and 29.2% occasionally post comments compared to 68.1% who say they never post comments. When the occasional commenters are included, audience participation numbers amongst this cross-section of readers are relatively high compared to the rest of the Internet. On one hand, this is not particularly surprising given that gossip lies at the heart of these online texts. The interactive features of gossip blogs have simply made the social practices of gossip an easier and more visible part of consuming celebrity gossip media, transitioning from an imagined community to one facilitated by interactive spaces. However, the number of readers who also comment still represents less than half of the total number of readers surveyed, suggesting that the pleasures of gossip media, even when consumed online, remain tied to solitary reading practices.

Understanding the role of interactivity in shaping reading practices and promoting community is more complex, as the technological usability of interactive features promotes sociability or participation, but does not guarantee nor completely control its form. Keeping with Jenkins' (2006a) distinction between interactivity and participation, Jenny Preece (2000) suggests technological affordances must promote "good usability so that people can interact and perform their tasks intuitively and easily," but must also be tied to the social goals of the group (p. 26). The relatively high level of audience participation evident amongst my survey respondents is, in part, related to the this technological usability, as the interactive features offered on blogs are quite simple to use and do not require much time or technical savvy from the user. Writing a comment on a website, the most common interactive affordance on blogs other than the hyperlink, is much easier than creating and uploading a video on YouTube or editing content on Wikipedia. This suggests that gossip blog

audiences may appear to be more active than general Internet audiences, because the technological affordances are generally limited to those that even the most casual user could easily engage. But, as I will illustrate throughout this chapter, social dimensions of participation are important to shaping the actual use of these technological features and more importantly, to how audiences understand such engagements as ways to connect to others. Though the gossip orientation of these sites points to the possibility that stronger and more traditional sorts of community can exist within the comments sections of gossip blogs, an issue which will be more fully explored in the next chapter, I am here concerned with identifying the more invisible and imagined communities experienced by gossip blog readers, particularly those who choose not to participate in the interactive features of the site.

Defining Celebrity Gossip Blog Audiences

In order to address the range of audience engagements occurring on gossip blogs, I conducted an online survey of blog audiences' reading and content creation practices, and asked if and how readers saw these practices as fostering a sense of community with others. Every effort was made to include readers from all the blogs in my sample, and I asked each blogger if he or she would post a link to my survey on his or her blog. Though all the bloggers initially agreed during our interview, several later declined or did not respond to follow up emails regarding my survey. In the end, only Trent Vanegas from PITNB posted the link to my survey as part of in his daily news link roundup post on November 19, 2008 (Vanegas, November 19, 2008). In an effort to include a wider range of readers in my survey, particularly since PITNB did not include a comments section during most of my fieldwork, I approached the bloggers who author Buttercup Punch (buttercuppunch.wordpress.com) about posting a link to my survey. Buttercup Punch was founded by a small group of active com-menters on Jezebel who, during a period of upheaval in the Jezebel community, which will be discussed in more detail in the next chapter, decided to create a separate forum outside of Jezebel that retained the feminist approach to celebrity and popular culture but featured a more open commenting structure. The founders and readers of Buttercup Punch were (and many remained) active commenters in the Jezebel community, thus were also targeted as a group that perhaps had more experience using the interactive features as part of their reading practices. A post broadly describing my study with a link to the survey was posted on Buttercup Punch on February 25, 2009 (Kadinsky, February 25, 2009).

As I had no other means to directly access readers from YBF, WWTDD, PS or PerezHilton, short of breaking the sites' rules and posting the link in a

comment, I was unable to specifically survey the readers of these blogs. However, the responses I did collect reveal that most respondents are aware of and/or read blogs beyond the one where they found the link to my survey. Therefore, even though my sample appears limited, it actually includes readers of multiple blogs and a range of reader positions, including lurkers and frequent commenters. Between these two sites, I was able to collect 260 completed surveys by American adults (over the age of 18) for analysis. I deemed a survey complete if the respondent went through all the questions, even if a few individual questions within the survey itself were skipped. This was not common, as most respondents answered every question. However, I have indicated the rare occurrence when the total number of respondents changes for a particular question, and even this change is typically less than five respondents.

As I expected, based on existing data on audiences of the celebrity gossip blogs in my sample, my respondents are overwhelmingly white, heterosexual women. Nearly 95.8% (248) of the respondents are women, 84.6% (219) are white, 90.8% (236) identify as heterosexual.[2] Existing research also indicates that the readers of gossip blogs are primarily *young* women. This was supported in my survey data, as 71% (185) are under the age of 30. As a result of the overall youth of my sample, most of the respondents (146) are current college students or have earned a college degree as their highest level of education and 27.9% (72) of respondents have at least some graduate school or have earned some sort of advanced degree.[3] This is consistent with Alexa's (2009a-f) tracking data, which suggests that younger (under 35) and college-educated audiences tend to be over-represented on all the celebrity gossip blogs in my sample, except for WWTDD, which skewed more male than female in its overall audience given its "guy gossip" focus (2009e).

In addition to students, some of whom indicated they worked part-time retail jobs, most respondents indicated they were employed in some sort of office job that reflected their higher levels of education. This included clerical workers (such as executive assistants or billing coordinators) as well as attorneys, office managers, business managers and accountants. Having access to a computer at work, as most office workers do, enables audience members to read blogs throughout the day. Indeed, several of the bloggers characterized their audience as people who are "bored… working at a job they don't necessarily like and spend more time [reading blogs] than actually being productive"

[2] One respondent declined to identify gender and a different respondent declined to identify a racial identity, thus the total N for these two categories is 259.

[3] The total number of respondents for the question on educational level is 258.

(Goodson, personal interview, May 27, 2007). This perception was, in part, supported by my survey data, as readers overwhelmingly indicated they read gossip blogs as a distraction or break from work or as way to alleviate boredom at their jobs. However, the actual workplace is clearly not the only location where audiences use gossip blogs as a break or distraction. Interestingly, most gossip blog reading occurred at home, with 211 of 256 respondents indicating they typically read blogs at home compared to 126 who read at work and 30 who read at school. Many read in multiple places, with 83 respondents indicating they read at work and home and 27 read at home and at school.

These gossip blog reading habits fit with overall Internet traffic patterns in North America. According to Craig Labovitz (2009), while overall Internet usage remains high during the business hours and drops somewhat between 5pm and 8pm (EST), the daily peak of usage is actually at 11pm and remains fairly high through 3am (EST). Though he suggests this 11pm peak is in large part due to online gaming and video streaming, it does indicate that Americans are using the Internet in high numbers after business hours, presumably at home (ibid.). Though blogs are not generally updated after 6pm, the number of readers who identify home as a reading location may simply be catching up on the latest gossip as a form of entertainment at the end of the day. Furthermore, as I did not ask readers what specific time of day they read blogs, those reading from home may include students or others who work at home and/or have their home computer as their primary point of Internet access. They may also have used smart phones, such as the iPhone or Blackberry, as a point of access, but I did not directly ask what sort of device was most commonly used to access the sites. Smart phones with fast data connections were not widespread at this time and several of the blogs had not yet adapted for mobile reading, so this technological distinction and its impact on reading practices are not reflected in my data, but offer a clear site for future research on gossip blogs and their audiences.

Given that this sample was largely drawn from readers of PITNB and Jezebel/Buttercup Punch, the fact that they are so overwhelmingly white was somewhat unexpected. PITNB blogger Trent Vanegas is a Latino male and Jezebel is written by a racially diverse group of women, and I thought this might increase the number of non-white readers. However, the celebrities that are covered on those sites are predominantly white, reflecting the "mainstream" celebrity focus of those blogs as well as the general audience for celebrity gossip. I do not have my own survey data on YBF readers, but blogger Natasha Eubanks indicated that she believes her audience to be predominantly people of color because she covers black celebrity culture (Eubanks, personal interview, July 23, 2008). Quantcast tracking data supports this belief, as it indicates that

43% of YBF.com's audience is African American, which is larger than the African American audiences reported for the other blogs in my sample (Quantcast, 2010). If I had been able to post my survey on her site, I believe that while white audience numbers would remain high overall, there would be more evidence of non-white readers of celebrity gossip amongst my respondents. I was also somewhat surprised by the lack of gay male representation in my sample, particularly since both Trent Vanegas and Perez Hilton openly identify as gay and foreground a gay perspective on celebrity culture on their blogs. However, the low representation of gay men appears to be a result of the low numbers of male readers overall, as only 11 respondents identified as male. Even given the small number of male readers, it is notable that 9 of them identified as gay. While I cannot make a generalization about the gay audience from this small number of respondents, it seems that gay men are more likely than heterosexual men to read celebrity gossip blogs. But it is clear that gossip blogs are a media genre consumed by young, white heterosexual women who, based on education and employment data, are predominantly middle or upper-middle class.

What draws these young white women to celebrity gossip blogs, particularly since, as I have demonstrated in earlier chapters, many of the blogs reinforce oppressive norms of femininity as a key feature of the gossip? On the most basic level, blogs offer pleasurable and fun escape, not only from daily tasks but also, as one reader put it, "distraction from the doldrums of my everyday life." Another reader suggests she reads blogs because of "the fun factor. For just a few minutes you can laugh, ogle, or swoon and it has nothing to do with your life, it's just an escape." Gossip blogs, like their print magazine predecessors, work well as distractions because they are easy to skim through and put down at a moment's notice. In fact, most readers do not spend a great deal of time reading blogs. The average amount of time my respondents spent reading blogs was just over one hour per day (61.2 minutes). Fifteen (5.9%) of the 254 respondents to this question were very heavy users who indicated they spent three to five hours reading per day, but most readers (142 or 56.3%) reported they read less than an hour per day. But blogs are about more than just distraction, as the range of reader engagements demonstrate. Through the survey data, I examine what draws readers to these sites as a form of entertainment and what they do on the sites once they are there that speaks to the negotiation of social and cultural ideologies through the pleasures of gossip talk.

Reading Practices and the Technological Features of Blogs

Each individual blog has its own distinctive relationship to technology, both in how it is used by the blogger and how the audience uses it. The basic techno-

logical affordances of immediacy and interactivity are apparent across all the blogs in my sample, but the degree to which they are used in a social sense speaks to the unique community-building possibilities of the each blog. Thus, while I attempt to make some generalizations about blogs as new media forms, I also will draw comparisons between individual blogs in order illustrate the different ways technology impacts the writing and reading of blogs and its implications for community-building amongst audiences.

Immediacy

Regardless of which blog or blogs audiences regularly read, my survey indicates that celebrity gossip blogs, like other online media, are drawing readers away from traditional print formats. Just over half of the respondents (53%) indicated they never or rarely read print gossip magazines. The popularity of print sources of gossip has not been completely erased by the rise of gossip blogs, as 16.5% of respondents indicated they still read print magazines at least three times per month in addition to reading blogs. Given that most gossip magazines are published weekly, a reader who reads just three times per month may still be reading multiple issues of a particular title. Frequent reading of magazines did not deter them from reading blogs, as this group, on average, reported spending over an hour a day reading gossip blogs (69.4 minutes), which is slightly higher than the average for all my respondents (61.2 minutes). These readers appear to have a strong interest in celebrity gossip and use blogs to supplement, rather than replace, their reading of celebrity gossip magazines. But most respondents consider magazines sources of "old news" that simply rehash the same stories and images already seen on blogs. One reader says, "Celebrity gossip blogs…are updated many times throughout the day. You can read about it as it happens, as with other news. You have to wait for the new issue of the print magazine." As new media platforms, blogs offer audiences up-to-the-minute access to the latest breaking celebrity gossip that simply cannot be matched by the print magazines. Thus, the technological affordance of immediacy is a primary draw for gossip blog audiences.

The appeal of immediacy is described by respondents through two dimensions, the ability of the reader to access the information on his or her own schedule and the frequent rate at which the information on the blog is updated. Blog reading, for most readers, appears to be a momentary pleasurable distraction that helps break up their day. Most readers (89.3%) indicated they read only when bored or have free time.[4] That gossip blogs are easily and quickly

[4] The total number of responses for this question on when they read blogs (Q8) was 252.

accessed from readers' computers, whether at work or at home, makes them appealing for this purpose. Relatedly, many readers also stated their preference for blogs comes from the fact that they are free to access,[5] thus further increasing the ease with which the latest celebrity gossip can be consumed. Overall, the sense that celebrity gossip is fun and frivolous is a primary part of the appeal because it disengages the reader from the seriousness of work or life for a moment. Hermes (1995) found that gossip magazine readers valued the pleasant and undemanding distraction these print texts provide. Gossip blogs serve a similar function with the added benefit of easy access that allows readers to pursue this pleasure whenever they choose and the frequent updating that means there is almost always something new to read. Many respondents said they return to the blogs several times a day to pursue this pleasurable distraction, breaking up the total amount of time spent on blogs into a series of shorter engagements rather than reading in one extended session.

The immediate access to the latest celebrity gossip and other pop culture developments is a major reason why they read celebrity gossip blogs because it helps them stay "current" with an ever-changing celebrity culture. Readers like the fact that blogs offer the latest news about a celebrity's professional projects (including details about upcoming films, albums, television shows and other public performances as well as red carpet and other "official" or promotional appearances) as well as the latest dish about his or her private life. Access to a range of information or, as one respondent put it, the ability to "know what's going on, who is married to whom, who is pregnant, who is giving birth. Just general knowledge" makes blogs appealing entry points to celebrity culture where readers blur the distinction between the private and public in pursuit of the "real" star. Another insists that keeping current on celebrity gossip is key to understanding popular culture more broadly:

> Because the connection between celebs' personal lives and their work is so fluid these days, I find that reading about celeb gossip gives one a good idea of what's going on in the film & music industries. Like, the best way to get a scoop about a film or TV show I'm curious about is to read the gossip rather that the trade blogs.

Even though 50.8% of my respondents suggested there are specific celebrities they like to read about on blogs, most of this group listed several celebrities and/or topics they enjoyed, indicating blog readers are interested in the range of celebrity gossip and culture news more so than using blogs to follow one specific celebrity. Either way, the immediacy of new media certainly plays a key

[5] Though readers do not have to pay any fees in order to view a blog, all the blogs in my sample are commercially supported and prominently display multiple and frequently changing advertisements on their sites.

role in the popularity of celebrity gossip blogs, as the speed and ease of access to the most up-to-date information about popular culture draws these readers to gossip blogs over magazines.

Immediacy as Reading Strategy: Believers and Nonbelievers

Immediacy is a technological affordance but has important implications for the social dimensions of how audiences read blogs. While respondents clearly value the frequent updates available on gossip blogs, they are less confident that what they read is accurate or true, and this sense of belief shapes their reading practices. Though 63.1% say the accuracy of celebrity stories is important to their enjoyment of the blog, 76.9% recognize that blogs only sometimes report the truth about celebrities' lives. One reader maintains, "I believe online blogs are more subject to out-of-the-blue rumors being spread quickly, not based on a grain of truth. I feel SOME print magazines may be more 'legit' in their information." Another acknowledges, "I think it is easier to edit material [on blogs] on a constant basis which leads to stories that may not be as well researched being posted and then removed more frequently." Blogs can post anything and easily retract or remove it, another nod to the role of immediacy in shaping blog content, but perhaps one that more easily allows innuendo and rumor to circulate as truth.

This is not to suggest that readers believe magazines are always telling the truth, as they generally recognize that similar information appears in both sources. But several readers believe the editorial process that shapes print magazine writing means there are more checks on the veracity of content even if it slows down access. One respondent asserts, "We might believe something to be true because there are pictures on a blog, but if it's in print, we KNOW it's true" (emphasis in original). This more rigid view that print guarantees truth is uncommon amongst the respondents, as even those who suggest magazines may have greater access to verifiable stories still think there is fabricated information in magazines. However, the immediacy of blogs allows information to be spread as soon as possible without checking facts, thus must be taken with a grain of salt. This does not diminish the pleasure of reading blogs, and, in many cases, determining what is real and what is rumor is part of the pleasure.

Many other readers, however, see the immediacy of blogs as a feature that makes them more reliable than magazines precisely because they provide instant access to the latest developments. One reader claims, "I think I trust [blogs] more because of their currency. At this point, celebrity 'news' happens every day, and I feel the print format just can't keep up." More importantly, because bloggers do not have to answer to editors, publishers or, indeed, the celebrities themselves when writing their posts, some readers see them as more truthful

than magazines. One respondent points out that blogs "are far less likely to face serious professional repercussions for their work, whereas print gossip rags have to maintain both advertiser relations and source relations with the studios/PR agencies/subjects themselves." For these readers, the blogger's outsider status provides privileged access to the truth because blogs are "uncensored" and more "free" in their discussion of celebrity culture. Bloggers are reporting the latest rumor and scandal as it happens and before these more legitimate celebrity producers can intervene and kill a potentially damaging story. This makes readers feel like they have access to the real celebrity, not the stage-managed version. One reader says:

> I like the genuinely nice items that aren't obviously handed out by publicists. I [also] loved [that blogs posted] the Christian Bale freakout[6] because it was real and not carefully plotted out shenanigans to keep the publicist's client in the public eye.

Another argues blogs are a better source for the real celebrity because they feature "celebrities in photos that aren't so carefully managed, [and allow audiences] to hear them say things that their publicists haven't approved. It's like peering behind the curtain." The immediate access to information is interpreted by these readers as unfiltered and, therefore, more reliable. Blogs give readers a different view of celebrity culture that print tabloids, despite their own autonomous outlier status, cannot provide because they retain closer ties to the circuit of celebrity production than bloggers do.

The technological affordance of immediacy influences the different strategies of interpreting truth and accuracy within celebrity culture. Gamson (1994) describes a range of celebrity-watching audience positions that are ultimately rooted in the audience member's "awareness of celebrity-production activities" and "belief in the veracity or realism of texts" (p. 148). Some audiences, Gamson calls them "traditionals," find pleasure in "believ[ing] that what they read is a realistic representation of the celebrity" and will "ignore or resist" knowledge that suggests otherwise (ibid.). These readers align with Hermes' (1995) serious gossipers in that the pleasure of consuming celebrity gossip comes from a developing sense of intimacy and identification with the celebrity. Reading the details of a star's private life makes these readers feel connected to the celebrity, and their pleasure is rooted in discovering the authentic celebrity through the details of her private life revealed through celebrity media. On the other extreme is a "postmodern audience, opposing the possibility of arriving at truth as hopelessly naïve, reading the celebrity text as a fictional one, undis-

[6] This reader is referring to an audio recording of actor Christian Bale berating a member of the film crew in an explicative-laden rant during the filming of *Terminator: Salvation* that was leaked to the Internet in early February 2009. (Christian Bale rant, 2009)

turbed by evidence of manipulation" (Gamson, 1994, p. 148). These audience members read the celebrity image as nothing but artifice and their pleasure is rooted in exposing the processes of production at work in the creation of that image. Thus, whether or not a piece of gossip is true is irrelevant to their enjoyment of celebrity culture. Gamson notes these are extreme ends of the spectrum of celebrity-watching positions and most audiences fall somewhere between the two and, in fact, "actively travel the axis of belief and disbelief in their everyday celebrity-watching activities" (p. 149).

As Gamson's spectrum of celebrity-watching positions demonstrates, it is impossible to arrive at one definitive classification of the celebrity gossip blog audience precisely because it is an inherently fluid category defined by a range of individual practices. Readers are drawn to gossip blogs, and indeed celebrity culture itself, for very different reasons that cannot be encompassed by a singular notion of audience activity. All seek a form of pleasure through their reading practices, but what constitutes that pleasure is actually quite different. The pleasures sought by traditionals, who value the authenticity and coherent nature of the celebrity image, are in fact opposite those sought by the post-moderns, who engage with celebrity culture in order to break down the celebrity as artifice. As the above discussion of the role of truth in influencing audiences' reading practices illustrates, my survey respondents are aware of the production processes behind celebrity images, but vary in terms of their beliefs on how pervasive such production actually is and whether or not artifice matters to their enjoyment. That both believers and nonbelievers read the same celebrity gossip blogs indicates a range of pleasures are on offer within these texts. Furthermore, the blogs themselves move back and forth between belief and disbelief. This fluid movement between truth and artifice contributes to the game playing aspect of gossip in which new information is placed into the context of existing information in order to make it meaningful. It is this game playing that seems to be the primary pleasure for gossip blog audiences, regardless of whether they the fall more into the category of believer or nonbeliever.

Though the particular perspective of the blog may speak to one type of audience over another, both believers and nonbelievers can, and do, read and participate on celebrity gossip blogs. Readers with a high level of belief tend to question what they read in terms of whether or not it is accurately reported rather than sensationalized:

> I don't want to read about events that didn't occur on a blog about real people; that's why I read novels!

> …otherwise it is really just a waste of time you dont want to think something about a person if it isn't true…we base our opinions of these people on the gossip we read.

> I read perezhilton.com 5 out of 7 days a week but I don't agree with some of the things he does to his posts. I feel that I can read these posts and take from it what I want to see as truth and what I chose not to believe. I mean even the bloggers aren't sure what they're printing is God's honest truth. That's evident in how many "updates" they do to correct their misinformation.

A different sort of truth is important for the pleasure of the nonbelievers. Instead of searching the stories for what is accurate and "real," these readers are more concerned with enjoying the artifice constructed on top of reality to create the fun of celebrity culture:

> It's like storytelling for me. It's all fiction. It's not about whether or not the actual story is true, and I don't believe a quarter of the things reported…it's how the stories are written that interests me.

> [Truth] doesn't matter because the sense of voyeurism that leads me to read celebrity gossip lends itself to the more outrageous, and less accurate stories, which I find most entertaining, regardless of truth value.

The immediacy of new media is central to promoting the gossip game on blogs, as it allows readers to quickly and continuously participate as new information arises. As part of their textual layout, blogs include links to sources, in part, to establish the credibility of the information for the reader and to offer a basic form of interactivity on the blog. The readers (may) engage with this content by clicking a link, and easily and instantly verifying the blogger's claims, something they cannot do with print gossip. As one reader puts it, "online blogs can reference other sites so you get multiple sources so you aren't believing one person." This is an active engagement with the text that is invisible on the site itself but is nevertheless enabled by the immediacy of celebrity gossip blogs.

Interactivity and Participation

The concept of immediacy helps explain the overall shift away from print magazines, but it does not fully explain why readers, given the range of perspectives they offer, are drawn to certain blogs over others. Readers' knowledge of multiple blogs indicates they are aware of a range of sites that offer immediate access to the latest celebrity dish. Eighty-five percent of my respondents indicated they had heard of at least three of the six blogs in my sample and over half (51.9%) indicated they had heard of at least four. PerezHilton, PITNB, and PS maintained the highest levels of awareness across the readers, reflecting these blogs' status as more "mainstream" blogs. Jezebel, WWTDD, and YBF, likely as a result of their more specialized focus, were less widely known amongst readers surveyed, though as the total number of blogs a reader had heard of increased, so did awareness of these less mainstream blogs. YBF had

the least amount of recognition amongst my readers no matter how many blogs they knew, suggesting it speaks to a niche audience that I was unable to access with my survey. YBF does not cover mainstream celebrity culture and, as a result, is not often linked to on other mainstream blogs. It is likely that only those readers interested in black celebrity culture, a smaller segment of the already small general gossip blog audience, would be aware of this site. But, as these gossip blogs share the use of frequent updates to keep abreast of celebrity news, immediacy alone cannot explain the popularity of certain gossip blogs over others.

My survey shows that most (42.2%) of the 258 respondents to this question indicated they regularly read only one blog.[7] Seventy-four respondents (28.6%) indicated they regularly read two blogs and 47 (18.2%) read three. Though there were a few heavy users who indicated they read six or more blogs regularly, they represented only 3.5% of the respondents. These numbers suggest that while readers want instant access to a variety of information about celebrities and celebrity gossip, they turn to a specific blog or blogs to get it. Given the extraordinary number of online sources for celebrity news and gossip, the blogger's style plays an important role in helping readers narrow their choices. One reader points out, "You can pick a blogger who is interested in the same topics you are and most of what you read is interesting to you. You don't have to sift through as much junk." Just as with political blog readers, who Jenkins (2006a) suggests already share the point of view of their preferred blogger, celebrity gossip blog readers view their blog reading as a means to strengthen, rather than challenge, their existing ideas and perspectives on celebrity culture. One survey respondent said, "I only read Jezebel, and I read [it] because it aggregates all the gossip out there while simultaneously viewing it through a feminist lens." Both YBF and Jezebel make their political perspective obvious in their coverage of celebrity gossip and attract, for the most part, like-minded audiences. Readers want to keep current with celebrity gossip, but filtered through a particular lens that adds value to the reading experience by speaking

[7] As readers were given the opportunity to list blogs other than the ones on my sample in this question, these numbers reflect any website the reader defined as a celebrity gossip blog. This includes a few mentions of sites like TMZ.com, x17online.com, and bestweekever.tv that do not fit my basic definition of celebrity gossip blogs, described in chapter two, as well as numerous mentions of other examples of sites that do, such as Dlisted.com or gofugyourself.com. For this analysis, I argue it is more important to recognize what the reader seeks out as a gossip blog rather than count only those I use in my sample. Though the blogs in my sample are among the most popular, a point which was reflected in readers' response to this question, they are certainly not the only gossip blogs or news sites readers visit regularly. I intend these numbers to reflect the general online gossip reading habits, which appear to favor blogs over official entertainment-news sites.

to their existing social values. As one reader succinctly described her reading preferences, "[The blogs I read] tend to…mimic my own thoughts about celebrity." This choice is a form of participation shaped by social preferences, not technological affordances. Furthermore, this shared perspective also helps explain why many gossip blogs are able to draw a young female audience despite implicitly and explicitly promoting sexist or misogynistic readings of celebrity culture because they reinforce dominant ideologies that already shape the audiences' social world. That is, blogs did not create these hegemonic ideologies; rather, they are one of many cultural forms that uphold and reinforce them, often by using humor to deflect underlying meanings.

These findings point to the importance of interactivity and immediacy in shaping the content on gossip blogs as well as the audience's participation or ways in which readers actually access or engage with that content. Audiences are generally limited to reading as the primary mode of engagement, as the blogger maintains a position as the primary content creator for the site. For example, at the time of my fieldwork, none of the blogs featured ways for readers to post videos or images (other than avatar icons) within the comments sections, and YBF even went so far as to specifically ban the inclusion of any outside links in reader comments. Readers' visible contribution to content is thus generally limited to posting text-based comments to individual posts. This suggests a hierarchy within blog communities in which the blogger, as the primary author of the site, is also the primary participant in interactive features and shaper of the social meaning on the site. This is not, however, necessarily a problem for audiences. Though some of the respondents to my survey cited their own use of interactive features as important to their enjoyment of the blog, most are primarily drawn to it as readers, not content creators. Engaging with celebrity gossip blogs, for most audiences, is thus a social practice of participation enhanced by the immediacy and interactivity of new media, but firmly rooted in the shared social meaning-making of gossip.

Online Connections and Community

In order to better understand what sorts of connections readers do (or do not) feel as part of reading gossip blogs, they were asked to rank their feeling of connection with others, including the blogger, commenters and other readers. Though 113 (43.7%) of 258 respondents claimed they felt little or no connection to others when they read celebrity gossip blogs, I argue that the fact that a majority of readers (145 or 56.2%) reported they felt some connection or stronger, combined with the overwhelming evidence that readers choose specific gossip blogs because of the perspective on celebrity culture, points to

the existence of at least an imagined interpretive community amongst blog readers.

It is important to note that this particular survey question addresses *reading* practices, not the use of other interactive features on the blogs. Reading blogs remains a solitary practice, and many respondents do not directly connect it to any sense of community, real or imagined. Since these readers value blogs for entertainment and distraction, it may be that tying their reading to any level of community takes the practice too seriously. As this respondent suggests, entertainment, not community, is the primary source of pleasure:

> I never read comments from other people reading the blogs or anything. I am just checking the stories or videos on the certain celebrity I'm looking up and that is all. It is a few minutes of entertainment and that is it.

Though this reader seems to recognize a shared interest in a particular celebrity draws her to the blog, the actual process of reading is not aimed at making connections with others. Finally, the weak sense of connection felt by many readers appears to be associated with the level of negativity they see in the comments section, indicating that a certain type of supportive and dialogue-based community may be desired by readers but not available on certain gossip blogs. The content of the comments sections and the ways in which comment-ers build community (or not) will be more fully explored in chapter five.

When readers moved from reading to a more visible form of participation in the comments sections, the feelings of connection increased. Readers who reported they at least occasionally posted comments were asked to report the strength of connection they felt when posting comments. The overall number of readers who post comments was low (83 or 31.9% reported posting at least occasionally), and only 81 respondents rated the level of connection felt with others when posting on blogs. However, 53 (65.4%) of these 81 respondents reported connections ranging from some to very strong, demonstrating that some of the pleasures of gossip blogs for these readers involves connecting with others through the interactive features:

> Because you can start having really deep conversations with someone just by having a comment out there they read and respond to.

> Others are able to learn your thoughts on the matter and can reply, which can start a dialogue.

> I think reading blog comments that reflect my own opinions, beliefs, pop culture expe-riences, or sense of humor help me to feel connected to others. I also like blog com-ments that present different viewpoints for me to consider, much like one would get from interacting with people in the real world.

These feelings are similar to those engendered by reading alone, but have a more concrete expression because readers can actually participate in conversation through the comments section.

Many of the survey respondents who felt a sense of community in reading or posting comments on blogs pointed to the role of dialogue and discussion in connecting them to others. For these audience members, comments sections offer a space to connect with others and gain new insight through negotiation of celebrity gossip. The possibility of building a real or imagined community on blogs is thus tied to the way gossip talk builds community in the real world. Readers come to gossip blogs with a sense of shared knowledge about celebrity culture, but expand and, more importantly, judge that knowledge through discussion and negotiation of the latest dish. They feel connected when someone, such as the blogger or a fellow commenter, shares a similar opinion or when that individual's opinion makes the reader think about the meaning of a story in a different way.

The social practices of participation influence how readers engage with each other in ways not tied to the specific technological affordances of the blog. For example, it is clear that some respondents do not see reading or posting comments on gossip blogs as a meaningful way to connect with others precisely because such interactions occur online. As one respondent put it, "it doesnt really create a feeling of being connected to others because it is an online thing where you dont know these people or anything else about them, especially intellectually." For readers like this one, even though blogs offer interactive ways for readers to create content or engage in other ways, the fact that such interactions do not occur face-to-face or between individuals who know each other offline means that any sense of connection is not real or meaningful. Though readers are drawn to a blog for its particular perspective and may feel a sense of connection to the blogger, such a sense of connection does not necessarily translate to the community of commenters/readers.

Furthermore, many respondents see the comments sections not as a place of dialogue and mutual understanding, but as a place too rife with negativity and mean-spiritedness to promote any meaningful sense of connection or community:

> If I don't read the comments, I can generally continue to believe humanity isn't over-run with hateful morons.

> I read The Superficial only thru RSS, as the commenters on that site are generally mean-spirited, unclever, and I don't want to waste my time reading those comments.

> The commenters tend to freak me out with their A) illiteracy, B) stalkerishness, or C) need to be first.

I find that usually [the comments section] ends off topic and someone is saying nasty/ wrong/inappropiate things about stuff that may or may not be what the orignal story is about.

These readers recognize that some sort of more active audience community exists on celebrity gossip blogs, but simply want no part of it. This is not to suggest they do not use their reading practices to build connections in other ways, both online and offline, but they do not see the participatory possibilities offered by gossip blogs as a meaningful place to build community and are content to engage in the more solitary, yet still socially connected, practice of reading.

Offline or "Real-Life" Connections and Community

Though I am primarily concerned with online communities that emerge from celebrity gossip blogs, there are ways that the technological and social affordances of blogs work to promote a sense of community between readers offline. As with gossip magazine readers, shared knowledge about celebrities gleaned from blog reading can help build real-life connections between people who are not already intimately connected. One reader describes the shared knowledge gleaned from reading blogs as:

a connecting factor as many people know the same "facts" you do- you can talk about these strangers and their strange lives with nearly anyone (i work retail & sometimes end up doing this with customers).

For this reader, celebrity gossip provides an easy way to have conversations with strangers by finding a momentary connection through the sharing and evaluating of knowledge about celebrities. Another reader says, "I feel like it keeps me...able to keep up with the pop cultural moment. You can't always be talking about Iraq and politics over the water cooler; everyone would think you're a downer!" Celebrities and celebrity gossip offer, as another respondent claims, "an easy topic of conversation" in most social settings. Their pleasure comes not from the knowledge itself, but using that knowledge to forge connections, however fleeting, with others in their everyday lives. The blogs are a source of information that supports participation in such communities, but not the site of those community interactions.

Beyond offering a way to discuss what one reader describes as "light current events," the evaluative and moral dimensions of celebrity gossip talk can help establish or maintain deeper connections. In fact, most readers who felt real-life connections because of their blog reading pointed to celebrity gossip as a topic they regularly discuss with co-workers, friends and/or family, thus using gossip to further strengthen ties within existing relationships. One survey

respondent clearly separates online and offline life, saying, "it is the Internet...connection is divorced from reality...I do however feel a kinship with those people I KNOW in real-life who read the same blogs as me. We have a shared knowledge base." Keeping current is important to strengthening these relationships through gossip talk because the reader needs new information to bring to the conversation. Another reader states, "If I find a piece of gossip amusing and worth further discussion, I'll discuss it with my best friend." Another reader specifically describes her blog reading as a way to connect with real-life friends, saying, "my girl friends read the same ones so we talk about what 'holly' said or what 'trent' is doing." In this case, these real-life friends have included a virtual friend—the blogger—in their circle, thus blurring the boundaries between real and imagined communities. Similarly, as several readers specifically indicated they talk about celebrity gossip with co-workers, it seems the distraction element remains important, as they use celebrity gossip as a way to take a break from work. In other words, beyond just reading gossip as a distraction, they use the latest knowledge gained from blogs to connect with colleagues on a topic other than work. These readers have already established connections with others and use shared interest in celebrity gossip to strengthen those ties.

There is some evidence of these offline communities visible on some blogs. Both Perez and Trent regularly post pictures sent in by readers identifying themselves as fans of the blog, clearly indicating the existence of a community of readers outside of the comments sections. Figure 8 provides representative examples of these reader-generated images from PITNB from February 16, 2008, and February 23, 2008. Readers create this content using various levels of technological expertise, indicating a range of technological protocols that support this social dimension of participation. Some use Photoshop to caption or manipulate their photos, mimicking Trent's photo manipulations, while others simply hold hand-written signs in digital photos. All of the images express their love for the blog through the use of the "Pink is the New _____" phrase and, typically, pink fonts that mimic Trent's style. These images carve out a space for the individual within the larger audience, but also illustrate their

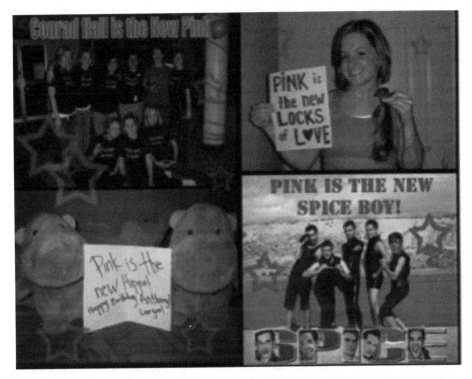

Figure 8: PITNB readers (Vanegas, February 16, 2008 (left), and February 23, 2008 (right))

allegiance to the particular blog and a sense of connection between the reader and the blogger. They are social protocols of participation, determined and controlled by the readers, not by Trent as the producer. In my interview with Trent, he pointed to his own perceived connection with his blog's audience as central to PITNB's success. He said:

> I only know how to do my perspective…[and] I really do think that's what people re-spond to…a huge segment of…people will send me photos. Like women who give birth and within hours send me a photo of their child because they want to share. That is something that you wouldn't necessarily want to send to Sam Donaldson or Ander-son Cooper or someone who does the news. It's more of a friend thing. And I'm so flattered and so thankful and I'm very happy that people want to share that with me and I'm happy to share that with everyone else. (Vanegas, personal interview, August 20, 2008)

That Trent posts these images on his blog as part of a weekly feature strength-ens the imagined community of readers, as those who read the blog recognize that there are others who do as well, even if they never meet face-to-face.

Occasionally, members of these online communities build offline relationships with those they meet through the sites. One survey respondent stated, "I am an active Gawker/Jezebel commenter and I've actually made many friends in real life with other commenters," suggesting that participation on the blog can translate into real-life connections. Jezebel allows, if not actively encourages, readers to use the site to promote regional offline meet-ups. Though announcements of such meet-ups are posted on the blog (as opposed to simply mentioned by readers in comments sections), they not officially organized or sponsored by Jezebel. During my online fieldwork, there were two announcements for reader/commenter meet-ups at local bars in Los Angeles (February 15 and March 7) and one in New York City (February 29). These public meet-ups give audiences a chance to meet others who share their interests, by virtue of being Jezebel readers, and create and/or maintain connections and communities offline. Readers/commenters from other blogs may make connections with each other that translate into offline relationships, but they are not visible on the site, nor did respondents reveal them in the survey. For example, private messaging capabilities available to registered PS users allow readers to communicate directly with each other outside of the public forums and may be used to announce meet-ups or organize other face-to-face encounters. But these and other forms of private engagement amongst users are not publicly visible on the sites, nor were they discussed on my survey. Nevertheless, it is clear that real-life or offline communities can be created and strengthened by gossip blog reading practices.

The interactive features and participatory possibilities of celebrity gossip blogs leads to an easy assumption that people use these sites, as with other online activities, to connect with others. Yet my survey data demonstrates that most readers do not see community building the primary goal of their blog reading practices. It may be because the community is imagined or virtual, rather than traditional face-to-face, that some audience members do not identify a strong sense of connection even as they seek out a shared perspective on a gossip blog. Despite the resistance to the label of community, many of the survey respondents did identify some type of connection with the blogger and/or other readers that speaks to the need for a flexible definition of community within virtual settings. These connections are not necessarily strong, but readers recognize that engaging with others through gossip talk is an important part of their enjoyment of celebrity gossip blogs. Of course, there is also a great deal of evidence on the gossip blogs that readers *do* explicitly seek and find connection with others as a part of their reading practices. In the next chapter, I explore the different types of community evident in reader engagement with and through celebrity gossip blogs.

Chapter 5

Creating Content, Creating Connections: Visible Communities on Celebrity Gossip Blogs

Whether they label it as community or not, celebrity gossip blog audiences are united at a basic level by their shared interest in celebrity culture and gossip. On one hand, this sense of connection around celebrity culture is not new. Though they engage in a new digital space, gossip blog audiences draw on the same sorts of reading practices as gossip magazine readers, using celebrities as cultural conduits standing in for larger definitions of the self in contemporary social life. Like print gossip readers, these blog audiences remain largely invisible, as most are content to remain readers, thus promoting a sense of imagined community in which the readers are drawn to the particular ideological perspective of the blogger and use gossip to reinforce those worldviews. At the same time, the interactive features of gossip blogs do open spaces for audiences to become visible creators of content and cultural meaning in ways that are not offered to magazine readers, necessarily shifting the understanding of the processes of community and meaning-making on these sites. Interactive spaces, particularly comments sections, provide a means of connecting the once solely imagined community of like-minded readers to each other through shared and publicly visible gossip talk. But the possibilities of these technological spaces remain tied to existing social contexts and shared practices of reading that have always shaped audience engagements with celebrity culture. Thus, it is not simply that audiences *can* participate in the construction of social meaning through celebrity gossip but *how* and *why* they do that defines the potential of these online communities.

The unique nature of these online communities and the boundaries that define each one are the result of complex relationships between technological affordances and communal practices on a particular blog. The visibility of the comments sections to all readers is itself a technological feature that, by allowing audience the virtual space to connect with the blogger and/or with other readers, offers them a sense of community despite the lack of physical proximity. At the very least, these spaces make the once imagined audience community more "real" by making their voices a part of the text itself. Yet how

readers actually use this space, as well as why some readers choose not to participate in the comments sections, reveals something about the social dimensions of participation and the form, strength and quality of the commenter community on that blog. Ultimately, even though building community may not be the primary motivation for engaging with celebrity gossip blogs, the negotiation of shared meaning central to gossip talk and the interactive space in which to do this negotiation promotes a sense of community in multiple and constantly evolving ways.

From Reader to Producer: Commenter Communities

Though the technological affordances that govern online interactions limit the types and strength of connections between readers on gossip blogs, these spaces are intended to serve a social function by bringing audiences together into a community of commenters. I here offer an analysis of the various communal practices that shape the commenter communities on five of the six blogs in my sample. PITNB is not included since, as discussed in the previous chapter, that blog did not have any comments sections at the time of my observation. I do not intend this to be an exhaustive account of everything that goes on in the community of commenters on these gossip blogs. Instead, I offer a discussion of how various technological affordances structure and promote specific social practices on each blog with attention to what makes each community unique and the types of social meanings and practices that bind these communities together through the shared use of these spaces. While the nature of each community is particular to the blog from which it emerges, I identify some common practices that speak to an overall sense of how gossip blogs are tied to a larger practice of making sense of celebrity culture in everyday life.

PerezHilton.com

PerezHilton's ranking as one of the most widely read gossip sites on the Internet would seem to position it as a promising place for reader communities to emerge (Alexa, 2009b). The low level of technological moderation that makes it easy for anyone to post comments combined with the high reader traffic on the site certainly makes PerezHilton's comments sections by far the largest in terms of number of comments/participants. It is not uncommon for the total number of comments on a single post to quickly exceed 100, and for especially juicy items, one can expect to see an even greater number.

For example, when a series of "tasteful" nude photos (a *New York* magazine recreation of the final photo shoot of Hollywood icon Marilyn Monroe) of actress and tabloid mainstay Lindsay Lohan were leaked online in February

2008, PerezHilton was one of the first gossip blogs to post the images. His initial post containing the photos was published at 9:20am on February 18. Over 300 comments were posted within the first hour and nearly 2,000 reader comments were posted within the first 24 hours of the original publication of the post (Hilton, February 18, 2008). These high numbers might suggest a robust online community of commenters, as online community "members' frequency of interaction with others is a major determinant of the extent to which they build relationships with one other" (Yuqing, Kraut & Kiesler, 2007, p. 387). However, in the case of PerezHilton's comments sections, the large number of comments belies the strength of the community, as there is little sense of interaction or dialogue *between* the commenters. Participation in these comments section is more of a race to be the first and/or the "loudest" commenter rather creating a space for dialogue, debate or social bonding with others. A typical PerezHilton comments section includes multiple comments that simply say "first!" reflecting the race to have one's comment at the top of the page. The immediacy of online engagement structures these practices, as it seems commenters are simply trying to demonstrate they were the first to read, or at least click, on the post on this frequently updated site. Given the high number of comments (and readers), it seems the position of "first" is one with a degree of social capital because it makes visible the reader's frequent and immediate engagement with the site by the presence of their name at the top of the list of comments. Of course, as the reader must refresh the page in order to see any newly posted comments, "first!" comments can and do appear any-where on the comments section, demonstrating the technological limitations of immediacy in promoting social goals of a community.

These "first!" comments provide the most basic illustration of the individu-alized and highly repetitive comments that define the social practice of com-menting on PerezHilton. By individualized, I mean comments which are simply statements of a reader's opinion without any connection to other comments. This gossip is simply "idle talk" that Patricia Meyer Spacks (1985) argues does not connect gossipers on a deeper level. She describes it as "derive[ing] from unconsidered desire to say something without having to ponder too deeply. Without purposeful intent, gossipers bandy words and anecdotes about other people, thus protecting themselves from serious engagement with one another" (p. 4). Those readers simply interested in a momentary escape or mode of entertainment from the blog may not want in any deeper level of connection. Furthermore, the repetitive nature of the comments suggests a more imagined moral community where audiences use comments to indicate their point of view, which generally falls in line with Perez's mean-spirited dis-identification with celebrity culture. The same ideas and sentiments, and indeed often even

the same phrasing, appear throughout the comments sections, but their highly individualized nature suggests commenters are not using this interactive feature of the blog to create dialogue with each other in pursuit of a stronger sense of community based on negotiation of those meanings.

The large number of comments on PerezHilton and the related weaker and more imagined sense of community are tied to the loose technological affordances that allow anyone to post under any username rather than requiring commenters to register with the site. Ren Yuqing et al. (2007) point out that online communities that use technological protocols to "carefully screen and admit new members" exhibit "much better quality participation in…discussion" than those sites "that have no screening" mechanisms (p. 397). The first ten comments from the aforementioned Lindsay Lohan post serves as a representative example of the types of individualized and highly repetitive comments that fall short of this "quality participation":

#1 - *carly* says – **reply to this**
lohan sucks:)

#2 - *tom* says – **reply to this**
fuh dis ho

#3 - *sick* says – **reply to this**
sick

#4 - *audrey* says – **reply to this**
she's put on a few pounds

#5 - *first* says – **reply to this**
that doesnt even look like her!!!

#6 - *randi* says – **reply to this**
what'd she do to her lips? :/

#7 - *zara* says – **reply to this**
FIRST!!!!

#8 - *sarahcg* says – **reply to this**
obviously not her

#9 - *beautyfulfrenchdemoiselle* says – **reply to this**
firsssssst!

#10 - *chrisTineG* says – **reply to this**
I feel sorry for Marilyn :-((comments on Hilton, February 18, 2008)

Readers jockey to be the at the top of the comments section, dashing off at most a short sentence expressing their opinion on the post, resulting in a large number of comments but little sense of connection between commenters. Interestingly, this high volume of comments itself may work against the development of a stronger sense of community. Yuqing et al. (2007) observe that frequent interactions in a large online community can actually be a detriment to building strong connections because the high volume of communication can overwhelm individual members and inhibit potential interactions between members. On PerezHilton, those rare comments that are more thoughtful and engaged are typically drowned out by the cacophony of individualized comments.

The range and implementation of specific technological affordances on gossip blogs offers one level of insight into the development of online community. These affordances are largely in the hands of the blogger who designs the site and decides which sorts of interactive features to include. This sets the conditions of interactive engagement, but cannot actually determine how or why readers engage with and through these spaces. One particularly striking example of how technological features shape reader engagements is the placement of the comments field on PerezHilton blog posts, a technological protocol entirely in the control of the producer (Perez). The fields for user name and comments appear directly under the initial post (occasionally separated by an advertisement) and *before* the reader comments that have already been posted. Thus, readers do not even have to scroll past other comments, let alone actually read them, in order to contribute their own. PerezHilton does include a technological attempt to promote dialogue by offering a "reply to this" link in existing comment fields that enables a reader to speak back to a specific comment (clicking "reply to this" automatically places a link to the original comment in the new comment text so other readers may click to follow the conversation). In my observation, commenters do not typically use this feature, and when they do, it even more rarely results in an ongoing discussion between two or more commenters. This is more of a social choice based on the high volume of comments, as readers who are just interested in a fun moment of distraction are not going to wade through all those comments to find ways to engage with others who may not even return to read subsequent comments. But this social choice is certainly influenced by technological protocols that promote a quick and shallow engagement.

The weak sense of community on PerezHilton is not entirely tied to the interactive features, as such engagements are also shaped by the social protocols of participation or the culture of commenting promoted on the site by the blogger and the other users. The nature of the comments sections on PerezHil-

ton is clearly shaped by Perez's serious yet mean-spirited reading of celebrity in which readers are encouraged to dis-identify with the celebrity and revel in pointing out her private foibles as evidence of her undeserved fame. As with all gossip, PerezHilton has the potential to challenge the cultural power of celebrities, but the malicious tone of the blog often reinforces dominant moral and cultural norms as the preferred means to critique celebrity culture. Instead of using gossip to challenge the celebrity industry and its commodification of our desires, Perez and these gossipers challenge the value of a specific celebrity based on her adherence to hegemonic norms about race, class, gender and sexuality.

In the Lohan photo example, Perez first challenges Lohan's hubris for even attempting to recreate these iconic photos without the same sort of talent as Marilyn Monroe to back up her celebrity. He points out that "She has no movie coming out. That new album won't be released for a while. Lindsay has NOTHING to promote, other than herself. Lohan is addicted to fame!" (Hilton, February 18, 2008). His critique of Lohan's undeserved fame in this post is tied to the fact that she drawing attention to herself by putting her body, rather than her talent, on display. Thus, this post, read within the framework of the typical approach to female celebrities seen on PerezHilton, works to police Lohan's body for acceptable standards of beauty and sexuality as evidence of her worth as a celebrity. That is, Lohan is "bad" because she is an inauthentic celebrity who uses her body for fame, and *at the same time*, we are invited to judge that body as falling outside of "acceptable" standards of female beauty as evidence of her undeserved fame and lack of social value. This policing occurs much more forcefully in the comments section, demonstrating how the "habitualized ways of acting" that shape a community at the social level are tied to the blogger's ideological framing of celebrity culture more so than technological affordances (Baym 2000, p. 4).

#108 *lisa p* says – **reply to this**
drag queen, hairy pits, saggy tittie balls, nasty nasty nasty

#250 *Not Even Close!!!!!!!!!!!!* says – **reply to this**
She couldn't be a zit on Monroe's Ass!!!!!!!!!!!! Skank needs attention as usual. Besides the fake breasts she has nooooooooooooooooooooooothin. Go OD or have a drink and drive. Put a fork in that freckled waste. Goodbye.......

#1045 *HOLY CRAP!* says – **reply to this**
LOOK AT ALL THOSE NASTY FRECKLES....that just repulses me. She is just about the skankiest thing in Hollywood..and every guy makes fun of her. Firecrotch has been around the block waaaay too many times (comments on Hilton, February 18, 2008)

This ratcheting up of the judgmental tone may be an attempt by the commenter to make his or her voice heard in this large community even after many other similar comments have already been made. If one cannot be first, then one can attract attention by making the most inflammatory or "loudest" comment.

The social goal of making the "loudest" and/or most malicious comment exemplifies the complex relationship between technological affordances and social practices in shaping gossip blog communities. At this time, PerezHilton commenters were not required to register an account in order to post a comment. This means there was no technological way for a reader to track regular commenters nor could a commenter establish an online identity (and build social capital around it) that other readers might recognize and/or seek out. Anonymity is not necessarily detrimental to online community, as Katelyn McKenna, Arnie Green and Marci Gleason (2002) suggest it reduces the social risks of intimate self-disclosure between individuals and may actually enable social connections to be made more quickly and deeply. However, their study presumes individuals use their online interactions as a space of personal disclosure about their "real" lives and selves, not as a social space to judge the behavior of a celebrity who is not personally known by the participants. On PerezHilton, even if commenters do respond to each other, it is typically to deride or mock an earlier comment in ways consistent with the tone of the blog rather than attempt to promote back-and-forth dialogue with another reader. The commenter can achieve a form of pleasure and sense of belonging by engaging in malicious and idle gossip talk like Perez, and runs little social risk in doing so because she remains anonymous and disconnected because of the technological affordances of the site. The high level of anonymity seems to embolden commenters, to put it bluntly, to post whatever they want without consequences as there are no technological moderation or social costs for engaging in such mean-spirited or idle gossip within this community.

For example, on a February 16, 2008, post reporting the latest on Britney Spears' recovery efforts (discussed in chapter two), the following exchange took place between three commenters:

#33 - *h* says – **reply to this**
Yeah the bad influences have gone in her life YET somehow, she still is a fat ugly worthless slut, who is shopping for herself, always thinking about herself this whore is NOT mentally ill she is just a spoiled whore and child neglecter.

#37 - *Lynn Spears* says – **reply to this**
Re: h – I agree, someone tell that little brat that when you have kids...you're not the baby anymore. She's the only one I ever heard in Hollywood lose their kids. That shows you just what a trashy selfish whore she is. Sorry folks, I wished I never had her, but the money is nice.

#42 - *LickMyNutz* says – **reply to this**
Re: Lynn Spears – THE ONLY TRASHY WHORE AROUND HERE IS YOU
AND YOUR PROSTITUTE MOTHER WHOSE ASSHOLE YOU FELL FROM ☺
(comments on Hilton, February 16, 2008)

This exchange is representative of what occurs in the comments sections of
PerezHilton for several reasons. First, the judgmental and derogatory gossip
talk reflects the tone established by Perez across the site. Though in this case
the initial post was actually supportive of Britney's improvements and said
positive things about her, the overall tone of his blog (and indeed towards
Britney prior to her mental breakdown) is usually nasty and judgmental,
particularly towards female celebrities who transgress dominant ideological
norms. The commenters' gossip talk reinforces this tone by criticizing Britney
in ways that uphold these norms of engagement through idle and malicious
gossip. The interaction between commenters is decidedly mean-spirited, using
the anonymity of the comments section to lob insults at celebrities and other
commenters as a means of reinforcing the tone that drew them to the site in the
first place. This has the effect of distancing commenters from each other, even
when, as in this case, they actually share similar ideas about Britney (and her
mother, Lynne Spears) as a bad mother and a failed woman who is therefore an
unworthy celebrity. Such behavior is generally tolerated on PerezHilton, as any
commenter who tries to intervene is met with similarly derogatory comments
or, more commonly, is simply ignored. The idle talk orientation that defines
participation and the weak technological affordances that structure the online
interactions makes this a weaker form of community overall, despite its
seemingly high levels of participation. Interestingly, many of my survey re-
spondents directly (explicitly naming PerezHilton's comments sections) and
indirectly cited these sorts of audience interactions as reasons why they do not
participate in or even read comments sections, indicating such weak forms hurt
the overall concept of online community amongst gossip blog audiences.

The open commenting structure and lack of moderation are technological
affordances that have social consequences for community building. This is not
simply a problem of technological controls, as the social protocols of participa-
tion evident on PerezHilton do not support a goal of dialogue or deeper gossip
talk. As will be demonstrated in the remaining blogs, combining stricter
technological protocols with clearly stated and enforced social goals for
participation creates the conditions for a much stronger sense of community
amongst commenters on celebrity gossip blogs. This is not to suggest readers
want the blogger to exert total control over the interactions in the comments
sections, as will be evident my discussion of the reactions to Jezebel's strict
community rules. Indeed, the presence of stricter technological controls does

not guarantee a robust community, but there is ample evidence that some level of technological control in the service of the social goals of the site works to create a stronger sense of community.

Popsugar

Popsugar.com provides an excellent example of how a closer connection between technological affordances and social practices promotes a stronger sense of community on celebrity gossip blogs. This blog has more interactive features than any of the other blog in my sample, suggesting it relies heavily on technological affordances to structure its reader communities. These protocols are not arbitrary features but aim to provide some sort of bounded community in the interest of maintaining the social goals of the site. By holding comment-ers accountable for their content, they are given the sense such creation of content is essential to the overall functioning of the blog and its community. This creates a stronger sense of community by promoting specific forms of communal practice within the technological spaces of engagement.

PS marries the social goals of the site to the interactive features through a unique rewards-based system that encourages readers to create content for the site as a way to connect with each other through gossip talk. Though anyone can read blog posts and comments sections, only registered users (those who have static user names attached to a verified user profile) may use these interactive features. Registered users are rewarded with "Sugar Points" when they participate in any of the interactive features, such as posting a comment, taking an online quiz or playing a game. By accruing points, users gain "Sugar Status," an indicator of social capital based on engagement with the site, creating a sort of hierarchy amongst the commenters in terms of frequent activity. Silver members have at least 100 points, Gold at least 1,000, Platinum at least 5,000 points, Diamond at least 10,000 points. A user's Sugar Status appears as part of her avatar when she participates on the site (Community Manager, August 24, 2009)[1]. Thus, while the technological affordances of the site work to limit the number of group members (user registration/account creation), they also visibly reward them with social capital for engaging with the community within prescribed spaces. While I am interested in only the use of comments sections as a way to create connection with other readers, PS explicitly defines a variety of interactive features as community spaces, making

[1] These reflect the list of activities that earn points at the time of my observation and the PS page cited lists many more that were added after my fieldwork as the site continued to intensify its community participation aspect, as will be discussed in the conclusion.

[2] As email addresses are not visible to the reader, I cannot know for sure that the same usernames

reader-generated content and the ability to form social connections through that content central characteristics of the site.

Instead of relying solely on a technologically-based form of moderation that automatically deletes comments featuring certain phrases or an outside link (typically used to avoid advertising spam in blog comments sections), comments sections on PS are moderated by Sugar Network staff who have the power to remove offending comments and/or ban users, something readers do not have the ability to do. This is a specific instance of a technological affordance (moderation) rooted in prescribed social practices (the commenting rules, the human enforcement) working together to promote the community-oriented goals of the site. Readers are reminded of the social goals of the site at the top of the comment field in a statement that reads "We like a happy community, therefore we moderate our comments. Vicious attacks on other users, extremely bad language, and other things that don't make for a happy place will not be allowed." The moderators are fairly tolerant and often do not remove entire comments, preferring instead to redact individual letters of offending words and let the commenters work out problems themselves (and some commenters appear to adopt this behavior in their own comments in order to avoid moderation). In contrast to the unrestricted free-for-all seen on PerezHilton, PS's community is much more cohesive in terms of tone, content and promotion of dialogue because the technological affordances exist to support social rules, creating a safe space for readers to comment without the risk of vicious ridicule from other commenters that encourages more participation. But commenters on PS do engage in dialogue with each other in ways that are not strictly related to the technological affordances that structure the site.

For example, as discussed in chapter two, PS frequently posts polls for readers to voice their opinion on a recent development in celebrity news. On February 14, 2008, a poll asking whether or not Britney Spears' father should retain his position as conservator of her estate as she continued to deal with mental health issues is a clear technological affordance that gives the audience an easy and specific way to engage with the site and each other (Pop Sugar, February 14, 2008). By February 23, 2008, the post had been viewed 4,906 times and 3,245 readers responded to the poll. Though clearly many users simply read the post and did not participate in the poll or the comments sections, an overwhelming majority of views resulted in the user participating in the poll. This may be because clicking a poll response is an easy and unobtrusive way for audiences to engage beyond reading and one that is rewarded with Sugar Points. Even in this basic mode of interactivity, the poll demonstrates a level of imagined moral community amongst PS audiences based on shared

perspectives as an overwhelming majority (91% of respondents) agreed that Britney's father should stay in control.

But this prescribed area of interactivity does not get at the deeper meaning-making processes behind this reading of this moment in Britney's celebrity. The way commenters discussed this story in the comments section of the poll post reveals the social goals of participation in this community are much broader than what is recognized by the limited interactive space of the poll. Though only 103 comments appeared on this post, a quite low number compared to the number of votes tallied, the dialogue that emerged points to the shared meanings and interest in connection that more clearly shape this community of commenters. Not only do several of the commenters make more than one comment, there is also evidence that they are reading and engaging with the ideas expressed by other readers. The comments include responses to the initial post and specifically engage other commenters in dialogue. The following series of comments to that post provide a representative example of how gossip talk occurs on the PS comments section and how it speaks to a notion of community between the commenters enabled by the interactive features but built on shared forms of gossip talk as a means to connect with others on a publicly visible level:

#1
pinkprincess1101 DUH
GOLD

#2
Briandiesel that pretty much sums it up for me too Pink!
GOLD

#3
DesignRchic Despite the fact that I think she's irresponsible and to-
DIAMOND tally incapable of caring for herself or others, she IS an
 adult. Let her be in control of her life. She should take
 responsibility for her actions and her life.

#4
Dbtabm She's not capable of being in control. That's the whole
SILVER point! She has an illness and until it's fully controlled
 with medication and therapy she needs help. She will
 thank her family once she is able to have contact with
 her boys again.

[...]
#6
pinkprincess1101 have you not noticed she IS NOT RESPONSIBLE AT
GOLD ALL!

#7
DesignRchic
PLATINUM

I guess I'd feel the same way as you ladies, but it seems like Brittney's been so defiant it's as if I want to give her a taste of her own medicine. Let her destroy what she has so that she realizes that she DOES need help and isn't so proud

[...]
#10
RosaDilia
PLATINUM

Yes, it seems things are much quieter now that her parents are in the picture.
Pink you're too much! 😈 (comments on ibid.)

Unlike the first ten comments of the PerezHilton post on Lindsay Lohan, these commenters are already engaging in dialogue and discussion, using the site and the celebrity content on it to connect with others. There is not necessarily absolute agreement, but the comments are made respectfully and work to negotiate a shared set of social and moral values. In some ways, these dialogic practices exist outside the boundaries of the technological affordances of the comments section, as there is, surprisingly, no "reply to this" feature on PS's comments sections. Instead, the commenters that want to speak to each other simply include names or references to earlier comments in the text of their posts. They create intimacy by talking with each other, not just assuming a shared perspective by virtue of reading the same blog, as in an imagined community.

The strength of the community in terms of interactions between commenters does not necessarily translate into the use of gossip as a form of resistance. In fact, on PS, much of the pleasure in celebrity culture comes from using a serious orientation towards celebrity culture to reinforce the status quo. Celebrities are role models, either of idealized identities and behaviors or cautionary tales of how fame can rob you of your true self. Commenters often take a strong stance against celebrities who in some way violate dominant norms of femininity, particularly in terms of sexuality and motherhood, a perspective still evident in the comments above. Britney may have gotten more respectful treatment in these PS comments because of the tragic turn her personal life had taken at that point, as in addition to first losing primary custody of her children and then all visitation rights, she was also placed under psychological care against her will after a series of bizarre public incidents, such as shaving her head in front of paparazzi cameras and being taken away in an ambulance after locking herself in a bathroom in her home while reportedly under the influence of unknown substances (Orloff, 2008). However, this represents a shift in the reading of her image on PS, as she certainly was criticized when rumors of her substance abuse first surfaced in the wake of her

divorce from Kevin Federline and when she repeatedly failed to appear in court regarding custody issues. They are not as mean in their comments as on Perez, but Britney still serves as a shared touchstone of how *not* to be a woman (and a mother) in contemporary culture for PS commenters.

Other celebrities, particularly other female celebrities, are not necessarily afforded the same kindness, even when they are believed to be experiencing similar problems. For example, a post titled "Lindsay Aims High With Leo and Adrian" published on February 15, 2008, chastised Lindsay Lohan, who has her own public history of substance abuse and family issues, for allegedly spending her Valentine's Day drinking and unsuccessfully flirting with actors Leonardo DiCaprio and Adrian Grenier. PopSugar writes:

> Her love for men wasn't the only thing in overdrive that night, apparently the starlet was drowning her sorrows in vodka and champagne. As expected, since we saw her take her first swing from the bottle on New Year's, LL may be **on another downward spiral that will only get worse** (PopSugar, February 15, 2008)

This gossip item was met with the sort of extreme derision and body snarking more common to PerezHilton but not without precedent on PS when discussing female celebrities. Frequent commenter "pinkprincess1101" says "what makes her think she looks good in these leggins there as nasty as her face" (comment on ibid.). Another commenter, "marybethrizalu," adds "Linsay Lohan! You are a disgrace to all women. Learn to love yourself and then maybe people will learn to love you, otherwise you will always behave and be looked at as a nasty wh*re" (comment on ibid.). "Jenny86" says, "What a slut! No wonder she's not getting offered any movie roles. Her stupid ass album is going to tank too" (comment on ibid.). In fact, most of the comments on this post follow this sort of mean-spirited judgment of Lohan's feminine shortcomings rather than attempting to empathize with Lohan as they did with Britney Spears. But even as the tone of the language changes, the overall serious reading of celebrity remains. The commenters combine this new information about Lohan with existing negative information to come to a moral consensus about her value as a celebrity and, more troublingly, as a woman. Continued rumors of her promiscuity led these commenters to reject her as a role model or a celebrity with whom they want to identify in everyday life. Unlike the PerezHilton comments that seem more interested in malicious gossip and promote imagined community of like-minded individuals, these dialogic comments are aimed at making meaning through publicly visible gossip talk with others as a means to define acceptable shared standards of female sexuality and beauty as markers of cultural value.

The Young, Black and Fabulous

Whereas PS offers a range of interactive features to expand the ways users can create content as a way to increase a sense of community, YBF's technological affordances aim at restricting this form of engagement and maintaining the blogger's position as the authority within this community. Entrance to the YBF community is fairly open, as commenters do not register for the site in order to participate, and, as on PerezHilton, could adopt a different username and email address (verified only to avoid spam) every time they comment. Some readers appear to adopt the same username,[2] and this may be related to their participation in other interactive features on the site, such as the chat rooms, where they do have to register. However, despite these loose technological protocols limiting who enters the community, stricter social rules are employed to control the type of content they can create once they are there.

YBF blogger Natasha does moderate the comments sections and will remove offending comments and ban individual email addresses if a commenter breaks the clearly defined commenting rules (Eubanks, personal interview, July 23, 2008). These rules are listed above the comment field to guide the reader as she creates her comment:

YOU WILL BE BANNED IF:
- You Disrespect The Owner Of This Site
- You Spell Out URL's In Name Or E-mail Fields
- You Mention and/or Link To Any Other Site Outside Of YBF In Your Comments
- You Advertise In The Comments
- You Hotlink Any Images

Instead of defining forms of social engagement allowed in the comments section, these rules mostly serve to limit user's technological interactivity within the social realm of the commenting community. These rules work to keep the community within YBF by prohibiting any links or advertisements in the comments section that would direct readers to other sites or outside images. This technological feature helps Natasha maintain authority as the primary producer of meaning on the site and protects the "brand" of YBF by controlling the audiences' content creation. That the only rule governing a social goal for the community relates to not disrespecting Natasha herself, rather than governing exchanges between commenters, further emphasizes her place at the top of the hierarchy of meaning-making. Commenters can disagree with her, and many frequently do, but it must be done in a respectful manner.

[2] As email addresses are not visible to the reader, I cannot know for sure that the same usernames are always attached to the same user.

Despite these rules, the acceptable social practices of commenting are mostly learned through participation on the site. One may be drawn to the imagined community of readers based on the blogger's particular perspective, but the commenter moves to a deeper sense of belonging by engaging in practices that reinforce that perspective as a shared one. On YBF, black celebrity culture is to be celebrated in the comments sections, as in Natasha's posts, though the ridiculous or "foolywang" nature of celebrity is also gently mocked. This gossip reflects a serious engagement with celebrity culture, but also challenges its whiteness and reframes it through a black cultural lens. In this way, the gossip "provides a resource for the subordinated...a crucial means of self-expression, a crucial form of solidarity" (Meyer Spacks, 1985, p. 5). In addition to using gossip to voice the value of black celebrity culture, the gossipers on this site frequently engage oppositional readings that challenge dominant definitions of racial and gender identity expressed within mainstream celebrity culture, reflecting the ideological perspective of Natasha's blog posts.

On February 25, 2008, Natasha posted an Oscars red carpet pictures of music mogul Quincy Jones and his "now 20 year old girlfriend he started dating when she was 19," sarcastically suggesting that we "can't hate our favorite septuagenarian for trying to stay young" (Eubanks, February 25, 2008). While many of the commenters take up her critique of the age difference, several focus instead on the fact that Jones, a black man, is dating a woman who is of a different race:

Jobell:
I'm not feeling it... where's all tha sistas?

Kiki68:
Seriously !! I could almost stomach it...if she were a sistah. Wait a minute strike that, UUUUHHHH !

Annie:
Quincy should be ashamed of himself. He has daughters older than this chick. Not a good look at all. A lot of people judge a man on who they pick as a girlfriend. It does say a lot about their character. Here are some examples:

1) ice-t and coco = Not Good
2) Reggie Bush and Kim. K[ardashian] = Not Good
3) Denzel and Paulette [Washington] = Good
4) Will [Smith] and Jada [Pinkett Smith] = Good

BlackNProud:
So... Has anyone EVERY asked Quincy Jones why he NEVER dates Black women.. but he has so much 'black pride'? Isn't that like an Oxy MORON.... What's the problem he has with Black women??? BASTARD!! (comments on ibid.)

The photos of the celebrity couple provide the commenters an anchor for discussion of questions of gender and race within the black community outside of celebrity culture. For these commenters, suggesting that black men should date black women is about having pride in one's racial identity and community. Black male celebrities, in particular, are criticized as "selling out" for dating white women or even light-skinned black women, a reading particularly evident in Annie's comment that chastises mixed-race couples as "not good" and black couples as "good." The gossip here serves to reinforce the commenters' own sense of cultural identity while also challenging values that may disparage such self-pride. By engaging in practices that reinforce this particular view of celebrity culture, YBF creates a stronger sense of community in the comments sections that connects their offline lives to their online meaning making.

What Would Tyler Durden Do?

What Would Tyler Durden Do? (WWTDD) defines who engages in the comments sections through technological affordances that require readers to register a username and verified email address before they are able to post comments, though as on all the blogs in my sample, all comments are publicly available to anyone who visits the site. Users also have the ability to upload an avatar image that will appear every time they comment from that account, a technological protocol seen on PS as well. The ability to choose unique usernames and upload unique avatar images is a technological space of engagement, but what images are uploaded and how they work to define a user's participation and place within the group reflects the larger social norms held by this community. For example, many of the avatar images on WWTDD are lewd photos of women's body parts, such as close-up photos of breasts, buttocks or other sexualized images, thus reflecting the tone and perspective of the blog itself. These types of avatar images would not be tolerated on other blogs and are a reflection of the specific audience drawn to WWTDD for celebrity gossip and the practices that unite this group.

WWTDD, as previously discussed, attracts a predominantly heterosexual white male audience (Alexa, 2009e), which expands the definition of traditional audiences of celebrity gossip blogs. As a result, this audience engages in forms of gossip talk that reflect a perspective not typically seen on the other blogs in my sample. WWTDD's blogger and commenters definitely do not share the serious gossip perspective exhibited on PS or YBF. Instead, they exhibit a particular sort of oppositional and ironic form of gossip that, as Hermes (1995) argues, mocks celebrity culture as a means of justifying one's engagement with it. Though the shared interest in the perspective of the blog draws them in, the robust community of commenters on WWTDD moves beyond the technologi-

cal and social parameters established by blogger Brendon to create and enforce their own culture of commenting. The blogger may control the technological affordances that shape the platform for community, but the users do more to define the social goals of this community through their communal practices.

WWTDD commenters are not particularly concerned with knowing the latest details of a celebrity's private life as a way to stay current or feel closer to the celebrity. Instead, the pleasure in celebrity gossip comes from rejecting a serious reading of celebrity culture and using humor to distance themselves from it. Humor, as Baym (2000) and Bury (2005) both argue, plays an important role in establishing and maintaining a sense of community within virtual settings. Though quips and one-liners can be seen across the blogs, the stronger communities, like WWTDD, PS and Jezebel, featured extended repartee and even "inside" jokes amongst the commenters. But the performance of humor is specific to each group, reflecting the way language is used to create a sense of group identity as well as establish one's status within that group. In her study of online female fan communities, Rhiannon Bury (2005) notes that humor was a strategy used by all members of the group, a few "star performers...received top accolades" and higher social status within the group evident in the number of responses to the comment. (p. 125). The initial humorous quip results in a string of responses from other members or the dialogue and exchange that strengthen the meaning-making and the sense of belonging on the site. This humor can be a source of pleasure for lurkers who enjoy reading witty comments, but may also ostracize those who lack the linguistic capital to effectively perform the "right" kind of humor that defines the communal practices of that group.

WWTDD engages with celebrity culture, but distinguishes itself from a serious gossip approach, even in its more malicious form on PerezHilton, through the use of jokes rooted in "ironic" humor. Hermes (1995) describes an ironic approach to reading gossip as embodying

> parody rather than outright subversion...It is a much more defensive stance on the part of those with enough cultural capital to feel sure that they will distinguish themselves as "cultured" by admitting that they feel critical about the system of taste and the exclusiveness of high culture...Irony is a means of detaching oneself from what one reads (or watches on television). (p. 134)

This ironic approach is similar to camp in its emphasis on subversion, but uses a stance of dis-identification to reject celebrity culture rather than "aggressively flaunt" their interest in it as a means of subverting "conventional morality and taste" more typical of camp readings of celebrity culture (ibid.). By sexualizing, objectifying and/or mocking celebrities, these commenters reframe what it means to gossip about celebrities, a defensive move to detach themselves from

"traditional" gossip audiences, namely women and gay men, in addition to detaching from celebrity culture as something that has cultural value.

All efforts at distancing themselves from typical celebrity-watching audiences aside, these commenters are still engaged in a form of gossip talk, mockingly called "brossip" by some other gossip bloggers, that aims at creating and policing the shared moral standards centered around the reification of hegemonic white masculinity. On WWTDD, commenters recognize celebrities are nothing *but* images, and, consequently, their social value exists only through the ways commenters talk or "joke" about them. Though there is no "reply to this" feature, the commenters do specifically address comments to each other (often using bold or italicized text to indicate they have pasted in an earlier comment as part of the new response), suggesting this community is rooted in dialogue between commenters. But this dialogue does not resemble the supportive negotiation seen on PS, and is typically a space for readers to mock each other, as well as celebrities, in the service of the overall ironic humor that shapes this community and defines one's status within it. That is, Brendon's mocking and ironic perspective does set the general tone for the commenter community, as they have come here to mock celebrities, but, as on PerezHilton's comments sections, commenters actually gain greater social capital within the community by going well beyond his original ironic and humorous framing. One's social status in the community is earned by being even more outrageous and "taboo" in the use of humor than Brendon's original post.

The importance of this ironic gossip orientation to defining this community is evident in the way the comments sections are policed by the commenters themselves. In a post from March 5, 2008, Brendon reports Britney Spears had been teaching dance classes to children at a Los Angeles dance studio, mocking her dancing skills and calling the kids who reportedly liked her "idiots" (Brendon, March 5, 2008). Frequent commenter "Mongro Jackson," rather uncharacteristically, attempts to defend Britney saying:

> There are a very few times that I'd just like to reach through the computer and break Brend()n's teeth, and this is one of those times. If she's flashing her cooter and beating cars with an umbrella, it's one thing. When she's doing something positive and constructive, and fuckfaced cockboys like you find a way to guffaw at it, I really question what the fuck I'm even looking at this assed-out site for. (comment on ibid)

Mongro's spelling of "Brend()n" is actually a move to avoid a technological protocol that deletes any comment that includes Brendon's name (a protocol set up by Brendon to, as previously discussed, help prevent the page from being "about him"). Tellingly, Mongro's participation in a more serious and thoughtful reading of the story is quickly mocked by the other commenters, who say things like, "I that suspect Mongro is that 'leave her alone' queer on YouTube,"

and "Haha Mongro loves Britney! Mongro and Britney sitting in a tree! K-I-S-S-I-N-G!" (comments on ibid.). Commenter "Observer" reinforces the proper practices of commenting on the site as a means to bring Mongro back to the fold, saying:

> Mongro.....I hope you've only temporarily lost your mind. Let us obeserve with "irony".........she's teaching kids to dance yet she has not seen her sons in weeks. That is enough to slam the formerly fatty. However....as soon as she is back in fucking trim.....I'm (mentally) in. (comment on ibid.)

Commenters uphold the community norms not only by posting "appropriate" comments, but also by calling out others who do not. A comment is appropriate if it upholds the ironic reading that rejects the value of celebrity culture by pointing out its moral flaws while simultaneously sexualizing and objectifying the female celebrity in a way that equates her social value with dominant standards of feminine attractiveness.

The ironic reading of celebrity on WWTDD seeks to diminish celebrity power, which could be a liberatory goal for a commenter community similar to YBF's challenge to racist standards of beauty forwarded by celebrity culture. For "Observer" and most commenters in this community, the idea that celebrities are more important or valuable than the average individual must be challenged, reflecting the use of gossip by subordinated groups as a way to speak back to power. However, by objectifying, sexualizing or dehumanizing the celebrity in a way that actually serves to reinforce many existing hegemonic norms, this community illustrates the role of gossip as a form of social control that reflects on the real-world standards of identity. On WWTDD, the use of humor tends to mask the exercise of dominant power behind the gossip talk. The tone of the comments reflects Brendon's ironic stance, but often goes beyond his "just jokes" framing of celebrity culture to use the ironic deconstruction of celebrity culture to more explicitly reinforce hegemonic norms. A post from February 29, 2008, provides an excellent representation of the typical types of dominant social meanings that shape this community and the role the commenters play in establishing and maintaining these meanings. The original post was brief, featuring several paparazzi photos of actress Gabrielle Union cavorting on the beach in a bikini during a magazine photo shoot. Brendon writes:

> I like to think **this** is exactly what Gabrielle Union would look like if I got on top of her to sling my ropes. Except she wouldn't have that content smile on her face. Despite a media brainwashing to the contrary, experience has taught me that the female orgasm is only a myth. (Brendon, February 29, 2008)

Here, Union is only worth talking about as a sexual object, with the "joke" being that men's pleasure is ultimately what matters. However, the comments section goes much further than Brendon in terms of sexualizing and, indeed, belittling Union as both a celebrity and as a woman as a means to reinforce community norms and strengthen their ties to each other. One notable comment thread of dialogue begins when commenter, "She Cums For the Jokes," alleged that Union, "got her start in a strange way," saying:

> she worked at Payless or something, was robbed and raped by a guy who apparently was on a robbing and/or raping Payless employees spree, sued Payless for negligence since they knew about the guy but didn't tell their employees or take precautions, and took acting lessons with her money. Funny how rape can change your life. (comment on ibid.)

Many commenters followed suit in making rape jokes, such as:

02/29/2008 13:57
Zack says
Yeah, **SCFTJ**, that's why I only rape people at their place of employment, and then afterwards point out that they could probably sue said employer for negligence. I like to think of it as my way of giving something back.

02/29/2008 14:02
She Cums For The Jokes says
Well Zack, do it at your own risk. He had a gun, she got a hold of it, pulled the trigger, and missed. Rape can be tricky; you have to find the right balance I guess

02/29/2008 14:07
Pennsylvania's Finest says
thats why i rape little kids....they don't fight back

02/29/2008 14:10
Miss Mabel says
Rape is such an ugly word. I prefer U.S.E. (Unplanned Sexual Event).

02/29/2008 14:42
Doctress Leisa says
Rape is such an ugly word. I prefer U.S.E. (Unplanned Sexual Event).
Miss Mabel, I'm partial to the term "surprise sex" myself. (comments on ibid.)

As evidenced by this exchange, one gains social capital within this community by participating in the accepted tone and style of conversation that uphold shared norms. This conversation continued throughout the comments section, bringing members together around through shared practices of meaning-making that draw from, but go beyond, the initial framing of the gossip item offered by Brendon.

As on the other celebrity gossip blogs, the commenter community on WWTDD uses celebrity gossip as a means to create shared meaning around issues of identity, particularly gender, race and sexuality. But here the emphasis is on using ironic humor to distance oneself not only from celebrity culture, but also from claims of racism, sexism and/or homophobia. Brendon maintains:

> I'm not trying to change the world here. I'm just trying to tell a joke. And, so the joke's in bad taste sometimes? Yeah, so what? It's a joke... Hopefully people know the difference between a joke and venom. (Brendon, personal interview, July 22, 2008)

On one hand, the use of jokes and ironic humor in gossip talk to break down celebrity culture is an oppositional stance that challenges the reification of celebrities and the moral and cultural values they embody. However, this community of commenters clearly upholds rigid standards of both what acceptable feminine beauty and sexuality looks like within the very culture they claim to mock. Even under the guise of humor, it seems this gossip community, whether Brendon intends it or not, aims at more than just making jokes. The gossip talk amongst commenters reinforces oppressive cultural ideologies that privilege male dominance and equate women's social value with their heterosexual desirability and adherence to hegemonic standards of beauty both within and outside of celebrity culture.

Jezebel

Jezebel's community has strong and clearly stated social goals, namely to read celebrity culture through a feminist lens, and engages strict and clearly defined technological protocols to support those goals. Jezebel, and indeed all of the blogs under parent-company Gawker Media, strongly encourage user-created content, but regulate it in both technological and social ways. Readers not only register a static username and verified email to create a Jezebel account, they must also "audition" before they are allowed to freely post comments. In order to audition, a new commenter simply writes a comment in the available comment field and then is prompted to create a username and password and, if they choose, upload an avatar image. But the new comment does not instantly appear on the site, as all comments from new accounts are first read and approved by a human moderator. After a new comment is approved, the new member is admitted into the community of commenters and is free to comment at will. According to the network's commenting FAQ, comments are approved if they are "interesting, substantial, or highly amusing" (gfutrelle, 2009). This definition is necessarily vague and allows moderators to easily approve a wide range of comments. But it certainly would weed out many of the comments made on PerezHilton or WWTDD, as they simply do not address the goals of

the blog. This vague definition also supports the blog's overall emphasis on sociability within the community, as users learn to be a part of the community through participation not by adhering to stricter prescriptive rules.

The audition process is a technological protocol that was established across the Gawker blogs as a means to control the number of commenters, which was rapidly expanding as the sites gained popularity, and to prevent "trolls," or individuals who post simply to start online fights or engage in what regular Internet users call "flaming."[3] But, as Jezebel editor Anna says, it also helps promote a certain level of discourse and to connect readers with each other:

> When we first started, it was different. We didn't have a lot of commenters, so if there were problems with the commenters, well there just weren't very many of them... But there has to be some sort of control, otherwise the comments would become much like what you would see on, say, a YouTube video. Which are bananas. Which are crazy! Or Perez Hilton...I mean, people already complain enough that we have too many comments. "You have too many commenters, I can't read through all these!" And if we were to have nothing in place in terms of keeping out some of the riffraff, it would be...no one would want to look at the comments. (Holmes, personal interview, August 9, 2008)

Jezebel is interested in creating a community where readers can participate in the creation of content and engage in dialogue with each other. Anna envisioned Jezebel as a safe space for feminist thought and one that encourages readers to translate those ideas into everyday life. Thus, the audition process uses technological means to limit the number of commenters through the enforcement of the social rules aimed at promoting "quality" contributions to the community. Other technological protocols are in place to support the sociability of the site, such as a "reply to this" feature that enables commenters to specifically quote and respond to an earlier comment and the placement of the comment field at the bottom of the comments section, thus forcing the reader to at least scroll past, and hopefully read, the existing comments.

The strength of this community comes less from these technological means than from the culture of commenting created and enforced by the bloggers/moderators and, more importantly, the commenters themselves within those technological boundaries. Both bloggers and commenters see themselves as having a stake in creating and maintaining the tone of the site and actively engage in policing the boundaries of the community in order to achieve their social goals. Instead of a top-down model seen on sites like YBF or a hands-off

[3] Though it is unclear who first coined the term "flaming" or "flame wars", its use reflects the need to give names to certain sorts of online behaviors. Ananda Mitra (1997) describes "flaming" as "the process where users resort to highly inflammable language exchanged between individuals for no apparent reason." (footnote 7, p. 77)

model like on WWTDD or PerezHilton, Jezebel promotes a shared community where bloggers and commenters have equal status. As Jezebel moderator Hortense puts it, "I think the attraction to the site comes from the fact that unlike many female-oriented sites, the Jezebel editors tend to talk TO women, and not AT them" (Hortense, personal communication, September 7, 2008, emphasis in original). While this explains why audiences read the site, I suggest the active commenter community is further attracted to Jezebel because the bloggers talk *with* them and leave space for them to talk *with* other women, thus refusing hierarchies of meaning and valuing multiple perspectives in shaping this community. Indeed, the fact that Hortense, who joined Jezebel first a member of the commenter community, became a moderator (shortly after my fieldwork period ended and as a result of the "commenter executions" which will be discussed below) demonstrates that the readers are as important to defining the sociability of the site as the bloggers.

As they are already, presumably, drawn to the blog because of its feminist approach to celebrity and popular culture, it is no surprise to see this perspective reflected in the comments sections. Commenters certainly find pleasure in mocking celebrities, but comments are generally snarky rather than outright mean. They do not identify with or show reverence for celebrities to the same degree as PS readers, nor do they seek to break down and deride celebrities as a site of false value as on WWTDD. Celebrity culture is pleasurable for Jezebel readers, but it is also a critical space of intervention into popular culture representations of identity that shape our experiences of women in everyday life. Most notably, as previously discussed, Jezebel commenters do not tolerate any form of body snarking. Commenters may critique a celebrity's clothing or style, but not in a way that overtly criticizes her physical body. The refusal to "body snark," or objectify, sexualize or negatively judge the female celebrity body is of primary importance to distinguishing the content and the community from that on other gossip blogs because it reframes the value of celebrity culture in feminist terms.

For example, when the nude photos of Lindsay Lohan recreating the Marilyn Monroe photo shoot appeared on Jezebel on February 18, 2008, the initial post jokingly stated that Jezebel is a place to "debate the *real* issues affecting women today…are Lindsay's considerable assets her own, or surgically-enhanced?" (Coen, February 18, 2008). On the surface, this appears to be a way of getting readers to scrutinize and judge Lohan's body. However, within the context of the Jezebel community, the post and the comments actually focus on discussing the range of shapes and sizes of "real" women's breasts as well as the unbelievable pressure in and from Hollywood for all women to have a "perfect" body by any means necessary. They also celebrate Lohan as beautiful, a perspec-

tive not commonly seen on other blogs in my sample when these photos were circulated. The comments on the post used the negotiation of shared knowledge characteristic of gossip talk to discuss the larger implications of these photos. Commenters drew on their knowledge of Lohan's celebrity image, their knowledge of women's bodies (largely based on personal experience) and knowledge of the pressures of celebrity culture to engage in a more thoughtful discussion of these photos.

Some representative comments from the 181 made on this post illustrate not only the way this community talks about (female) bodies but also how they engage with each other through their comments:

BY **LINKURA** AT 02/18/08 04:07 PM
Real. My boobs ended up suddenly ballooning when I was around 19 1/2 or so. Lindsay probably had a similar experience, and the dumbass media of course had to say she got implants.

BY **ELIN** AT 02/18/08 04:11 PM
Real. They change size like normal breasts. @linkura: Hah, mine still do. I outgrow bras about once a year. Going on a E-cup now :p Lucky I'm not in the spotlight.

BY **BADMUTHA** AT 02/18/08 04:14 PM
I think they are real b/c the one on the left (picture left)is slightly larger than the one on the right. Which is exactly how people look. Most docs can't deal with assymetry (sp?) so they don't look real. My left is bigger than my right too. Stars! Their boobs are just like ours!

BY **SIRSNARKSALOT** AT 02/18/08 04:19 PM
i say not only are they real, but there just about the last morsel of herself she has left that is actually attractive. She wrecked the rest of it with tanner, coke, LI makeup, leggings, and partay-ing. And soon enough, the nice ta-ta's will be gone too. Couldn't happen to a trashier girl.

BY **MSDIRECTOR** AT 02/18/08 04:22 PM
Can I ask why this is such a big deal? I don't care if they're real or fake. Frankly, I think if there's a question that people have this much trouble answering, who cares? If real, rock on. It's good to be you. If fake, then yay, you actually got a good boob job, so bully for you, go enjoy 'em.

She's quite young, so I hope they're not fake just because I hate to see anyone that young surgically altering their bodies for purely cosmetic purposes, but otherwise, why does everyone care so much? I'm not trying to be snarky - I really don't get it.

BY **BANGIEB** AT 02/18/08 04:24 PM
@sirsnarksalot: Please refrain from using the term "trashy girl". Thanks. (comments on ibid.)

As these comments illustrate, dialogue between commenters occurs frequently on Jezebel. While some conversations are simply echo chambers of people stating their agreement with a previous comment or praising the commenter for making a particularly witty or insightful comment, important strategies of support that bind this community, many are aimed at a more in-depth and shared analysis. The pleasure of engaging with celebrity culture comes from the critique of it but does not lose the fun and glamor that makes it pleasurable. Like YBF, Jezebel's community uses gossip as a form of solidarity to differentiate themselves from mainstream celebrity culture. They take their reading seriously, but as a way to recognize the constructedness of celebrity culture and its role in promoting hegemonic norms in everyday life.

An important facet of the social goal of solidarity is educating other commenters to the proper forms of participation on the site rather than relying solely on the technological features to limit the boundaries of acceptable community engagement. Though Jezebel eventually posted an explicit guide to commenting, these rules already existed on the site in a less formal way and were continually negotiated as part of the daily discussions amongst commenters. If a commenter makes an "inappropriate" comment that does not fit within the boundaries of the community, other readers tend to address the situation before the moderator has to act, as in the previous comment from BANGIEB to SIRSNARKSALOT on the Lindsay Lohan post. Even if the moderator or editor has to get involved, Anna points out that the author of the problematic comment is not only warned, but her history as a commenter is also taken into account. In other words, being a part of the community is learning about participation and about recognizing that mistakes can help improve someone's participation. She notes that:

> there are some commenters who are wonderful commenters and then they fuck up once and they're much less likely to get banned for one fuck up because of their history...And then some commenters come on and they've never commented and each comment they've ever made has just been, you know, "I hate this, I hate this." And we're like, you know what? They're not going to give them as much leeway because we can look at their comment history. I can go to the commenters' page and see all the comments that they've left, and if I see a history of them just being obnoxious, then it's like, well, forget it. (Holmes, personal interview, August 9, 2008)

If one earns social capital within the community by commenting regularly and productively, you may be allowed to stay, whereas a strict technological protocol (such as the removal of certain words or phrases or banning of email addresses) would police the offender out immediately. This promotes more thoughtful and engaged content in the comments section, but also lets commenters feel a sense of responsibility for their own community by giving them a

chance to improve the quality of their comments before being banned. Though Jezebel is far from a feminist utopia, this process helps promote a more feminist sensibility amongst the commenter community that reflects the overall goals of the site.

A particularly vivid example of this sort of shared responsibility emerged during my fieldwork during a period of community unrest stemming from the announcement of "commenter executions." The growing popularity of the blog in 2008 led to a massive influx of new commenters who were making it past the audition process but not upholding the ideals of the community, particularly in terms of "girl-on-girl crime" where women criticize other women's appearances and behaviors in misogynist and malicious ways that do not fit with Jezebel's culture of commenting. This includes individual comments made about female celebrities as well as inappropriate conversations between commenters. Though such rules about how to participate were implicit in the content of the posts on Jezebel, Anna first made them "official" in a post on January 2, 2008, in which she explicitly calls for an end to the practice:

> Maybe you don't notice, but, unlike the female-helmed celebrity rags, we take special care not to criticize the weight, wrinkles or cellulite of the women we feature. (Of course, their fashions, not to mention their actions, are fair game). Thing is, many of our readers don't notice this fact, or, more disturbingly, don't *care*, peppering many posts (particularly Snap Judgments) with their own offensive commentary about how women age, or gain weight....For those readers who want to rip into other women's appearances, consider yourselves notified: We will happily and quickly call you out on your bullshit if you continue with the superficial shitty comments. For those who don't like this, well, we can think of some **other sites** that would be happy to indulge you. (Holmes, January 2, 2008)

By explicitly stating a social rule, Anna attempts to better align commenter participation on the comments section with the overall social goals of the site.

Apparently, this was not sufficient, as on February 29, 2008, Anna announced that the problem had not been resolved and action would be taken in the form of removing offenders from the site by revoking their commenting privileges, a technological protocol that effectively "executed" these individuals by deleting their accounts and denying them further access to participation in the Jezebel community (though they could still read the site). In keeping with the sense of shared responsibility for the Jezebel community, these "commenter executions" were not performed by the editors/moderators behind the scenes, as on other blogs where those who are banned are simply removed without public comment. Instead, readers, as members of this community, were asked to nominate candidates for execution. Anna writes:

So, instead of simply announcing who *we* think the offenders are, we're going to let you weigh in too. If there's a commenter who is becoming a problem, send the screen name and reason to **tips@jezebel.com**. See you soon at the guillotine. (Holmes, February 29, 2008)

The response in the comments section on this post was largely supportive of the idea of removing routine offenders in order to keep the social goals of the community intact and most commenters were particularly pleased with the opportunity to be a part of a process that helped define their community.

On March 7, 2008, the list of those who were executed and an example of their offense was posted. For example, "Brainstorm" was banned with a comment on a photo of actress Sarah Jessica Parker, "I don't live in NY and think she is fugly and styleless" serving as one representative offense (Stewart, March 7, 2008). If this same comment appeared on PS or PerezHilton, it would not only remain on the site, it would likely not stir up debate as it did on Jezebel. It is important to recognize that commenters were not "executed" for simply disagreeing with the blogger and/or the dominant perspective on the blog. Jezebel is open to a wide range of perspectives and the best comments center on the respectful debate and dialogue between users, not just an echo chamber of "me toos." Unlike a blog like PerezHilton, Jezebel bloggers and commenters recognize that meanings made through gossip within this virtual space have real consequences for how audiences understand identity and culture in everyday life. In the end, only five commenters were executed (two of whom were the result of the user asking to be removed), but the overall effect of these removals helped clarify the social goals for the entire community.

This blog consciously structures its technological boundaries in ways that support the social goals. In fact, as the commenter executions show, the social side of community-building is more important, as the Jezebel bloggers explicitly involve community members in the definition and enforcement of these rules, rather than simply using technology to control it. The executions and warnings offered all commenters a way to actively define what they wanted from their community and the types of comments they believe support that goal. As the community grew in size, most commenters wanted to maintain the social goals of the site and recognized that some level of moderation would give more weight to the social rules of participation. They still self-moderate, but know that those who do not respond to social pressure have to face other consequences. At the same time, it also prompted some members (how many is unknown, as it is certainly not restricted to those who regularly comment) to participate less or leave the community entirely. The women who founded Buttercup Punch are examples of this, as they decided these rules and social practices did not fully reflect their pleasures in celebrity gossip, and moved their

engagement elsewhere (though several still continued to comment on Jezebel). This discussion of the standards of the community led directly to the creation of more explicit rules about acceptable commenting practices and the installation of active commenter Hortense as a moderator. This sort of direct engagement between bloggers and commenters around the question of community was not seen on any of the other blogs and is part of what makes the Jezebel community one of the strongest among them.

Understanding Online Community

The ability of audiences to interact with media content—to move from the solitary practice of consumption to a more engaged mode of shared production—is a key component of the shift from "old" to "new" media and one that explicitly opens the possibility of building community through media engagement. Yet these practices are not entirely "new," as in the case of celebrity gossip blogs, a range of meaning-making practices were already a part of consuming celebrity gossip. Though there is ample evidence that some sort of connection and community does emerge on celebrity gossip blogs, relying on a social perspective that suggests *any* collection of individuals online represents a community is equally problematic, as it is clear that technological features both enable and limit interaction in ways that are relevant to understanding online communities. No one definition of online community recognizes the range of social practices and technological protocols that shape each of the blog communities. Instead, I argue each offers unique insight into how gossip blog audiences become producers of content and the role celebrity gossip plays in larger practices of social meaning-making that ground the particular community and connect it to the everyday lives of its members.

Chapter 6

Rethinking Gossip and Celebrity Culture in the Digital Age

Gossip has historically played an important role in the circuit of celebrity production as a space where audiences navigate the tensions between the star's glamorous and extraordinary public persona and the private or "real" individual beneath that façade. Is the star all that she seems? Is she "just like us"? Yet celebrity gossip is more than a frivolous distraction; it is an important space of shared cultural production. The pleasures of gossip lie in the active practices of evaluation and judgment of the latest dish—from the mundane to the scandalous—using celebrity images to negotiate the anxieties and dreams of everyday life (Hermes, 1995; Turner, Bonner and Marshall, 2000). More importantly, as Turner (2004) argues, gossip about celebrities is "an important social process through which relationships, identity, and social and cultural norms are debated, evaluated, modified and shared," highlighting the importance of the connections (real or imagined) created between gossipers, not simply the knowledge itself, as a key part of gossip's social role (p. 24). A range of media sources, from tabloids to more "legitimate" celebrity and entertainment news sources, are key sources for the negotiation of the tensions between the private and public star that fuel audience gossip, positioning the celebrity image as an anchor for larger social ideologies about the individual in contemporary culture. Through the consumption of and engagement with of the celebrity image in gossip media, audiences are brought together into communities, both real and imagined, where they make sense of the self and the larger world through gossip talk.

Within the age of new media, celebrity gossip blogs have emerged as a textual form that emphasizes audience gossip about the private celebrity as the primary way that celebrity images are made meaningful in culture. Grounded in historical forms of gossip media that offer audiences purportedly uncontrolled access to the "authentic" celebrity, but extending and enhancing this surveillance of the private using the tools of digital media, gossip blogs have reshaped the production, circulation and consumption of celebrity images. As texts, blogs highlight the pleasures of gossip as a form of shared cultural production in several ways. Bloggers use existing stories as a springboard for their own commentary, creating a new form of celebrity media based on first on their

gossip talk, and then extending that space of cultural production to the audience through the blog's various interactive features. Such features, particularly the comments sections, give audience-generated meanings a public platform to both challenge and reinforce the ideologies embodied by the celebrity, a public space of community building and meaning-making not available in traditional print tabloids. The rapid ascendancy and cultural impact of celebrity gossip blogs offers insight into the technological and social changes central to broader shifts in contemporary celebrity and media cultures within the new digital and participatory age.

Technology and Participatory Media Culture

The technological features of blogs, particularly the emphasis on immediacy and interactivity/participation, offer new points of entry into celebrity culture that prioritize audiences' meaning-making practices as the center of cultural production. Such gossip-oriented practices of cultural production certainly existed prior to the advent of the Internet. But, as Jenkins (2006a) points out, online spaces like blogs that "enable communal, rather than individualistic, modes of reception" highlight how technological affordances work with social practices of media consumption to promote a new, participatory media culture (p. 26). Internet technologies enable audiences to quickly and easily engage with the latest celebrity gossip—and with each other—in ways simply not possible in earlier print forms. Rather than wait for a weekly tabloid to be published, audiences can read the latest developments in celebrity culture at the click of a mouse. Moreover, blogs' prodigious use of links also enables readers to define their own engagement with a story in new ways. Audiences can simply read what is posted by the blogger or they can follow as many links as they want in order to put a story in context, read background information or look at more photos of a particular celebrity. Finally, gossip blogs offer public space in the comments sections for audiences to become a part of the public construction of social meaning through shared talk, disrupting the industry producers' and entertainment media's control over the celebrity image.

The advent of digital technologies like the Internet has "enabled stars and celebrities to be endlessly circulated, replayed, downloaded, and copied," giving audiences near constant access to the star (Holmes and Redmond, 2006b, p. 4). This prioritizes the pursuit of the real individual through constant surveillance of the celebrity in her unguarded and uncontrolled moments as the key point of entry to celebrity culture. As Gamson (1994) suggests, "it does not matter for gossip how celebrities got there, or even how they manage to stay there, but how they behave once they're there" (p. 175). Though this question of who the star "really" is has historically been central to the circuit of celebrity production,

the primacy of the paparazzi photograph to the content of celebrity gossip blogs is part of larger project of deconstruction in which bloggers and audiences use gossip to tear down the manufactured and controlled surface of the celebrity image to reveal the "real" person beneath. The paparazzi photo and, more crucially, the audience's gossip about it, unmoors the celebrity from her public, talent-based performances and grounds the meaning of her image in the public performance of the private self.

Gossip blogs have also reshaped the celebrity media industry in unprecedented ways. The Internet has made the tools of professional production and distribution easily accessible to audiences, whose cultural production has historically been marginalized or invisible, enabling the rise of the blogger as a new "professional" celebrity media producer who exists outside the traditional circuit of production. These new practices of "produsage," while certainly not confined to celebrity culture, have, in the case of gossip blogs, disrupted the traditional role of the legitimate entertainment news media as well as the tabloids in circulating celebrity news and gossip. That is, bloggers enter the circuit of production first as audiences, and rely heavily on digital technologies to claim a place as a producer of celebrity media. They are not journalists nor do they work for any established print celebrity media outlet. In fact, most of the bloggers I interviewed had little or no previous media industry experience prior to starting their blogs. Instead, they simply utilized existing (free) blog software to start writing about celebrities and celebrity culture. Their production practices remain tied to these technologies, as they comb the Internet for existing content, use Photoshop and other programs to manipulate images and are able to quickly and easily update their sites though the use of blogging software. The availability of these technologies opened the category of celebrity media to allow individuals who began as audiences to participate in the public construction and circulation of celebrity images, a position simply not possible in print gossip media. Though not all audiences enter the realm of professional media producer and even fewer become successful bloggers, the success of these few blogs demands we rethink categories of audience and producer within contemporary digital media culture.

It is the centrality of audience engagement at multiple levels that further distinguishes the celebrity gossip blog from traditional forms of celebrity media. Whereas, as Hermes (1995) suggests, reading a gossip magazine is a largely solitary practice that may encourage a sense of imagined community with other readers, the technological spaces of the gossip blog, like the comments sections, reveal the presence of other readers and more explicitly connect the practice of reading to the shared cultural production and community participation of gossip. As evident across the blogs in my sample, the technological controls

imposed on the interactive features of the blog shape and define these spaces of engagement, yet can never fully define the emergent social practices of a blog or its community. In short, new media technologies are central to understanding the ways celebrity gossip blogs have reconfigured celebrity culture, but in ways that necessarily tie these technological spaces to social practices of gossip.

Celebrity Gossip Blogs as Social Spaces

Technological features define the format of the text, but the varied forms of content and the unique approach to celebrity culture across each of these blogs illustrates the critical role of the social practice of gossip in defining this media genre and its impact on celebrity culture. As I have argued, each blog in my sample defines itself not through the presence of technological features, but in terms of its particular gossip-oriented approach to celebrity culture. This entails a particular ideological reading of celebrity culture, emphasizing the celebrity's role as a social symbol and gossip about that celebrity as a means of (re)producing larger ideologies about identity and culture. This can be an important space of intervention, as gossip allows bloggers and readers to deconstruct the celebrity image and challenge the power of the media industry to define and circulate social ideologies through celebrity culture. Blogs like Jezebel and YBF have explicitly defined ideological stances that reject the negative and oppressive norms forwarded by celebrity culture while retaining the pleasurable community-building possibilities of celebrity gossip. YBF and its readers use celebrity gossip to challenge the mainstream reification of whiteness as the sole marker of success and social value. Similarly, those in the Jezebel community routinely call into question the oppressive standards of femininity and sexuality forwarded by celebrity culture by refusing to participate in body snarking or other overtly judgmental forms of gossip talk. In both these cases, gossip offers a mode of liberation from dominant ideologies and a site of alternative pleasure in celebrity culture.

At the same time, blogs and blog communities can also reinforce dominant ideologies under the guise of the humor and pleasure associated with gossip. The fun of gossip and celebrity culture can often mask more troubling readings of celebrities as markers of race, class, gender and sexuality. That is, challenging industry control of a celebrity image is not necessarily a socially resistant practice. For example, PerezHilton adopts a stance of dis-identification that takes pleasure in the deconstruction of the celebrity façade, yet often uses this stance to ridicule and shame celebrities who fall short of dominant social norms. The commenters' discussion of Lindsay Lohan's nude photos in *New York* magazine on PerezHilton provides a clear example of how deconstructing the celebrity façade simultaneously reinforces hegemonic norms about female

beauty and sexuality in everyday life. Similarly, the use of taboo and ironic humor on WWTDD to mock celebrity culture gives the appearance of an oppositional reading because of its deconstructive stance, but such deconstruction is based on the reification of racist, sexist and homophobic norms.

Understanding the social role of gossip in the production, circulation and consumption of celebrity images on celebrity gossip blogs reveals the ways women, as the predominant audience of and participants on gossip blogs may be implicated in the normative ideologies forwarded by mainstream celebrity culture. Even as gossip blogs offer their largely female audiences a form of public power through gossip, such practices do not necessarily imply resistance to the oppressive social ideologies that circulate within celebrity culture or, indeed, American culture more broadly. Celebrity gossip blogs often use gossip about the private celebrity to police acceptable standards of feminine behavior, values and appearances. For example, though PS takes a positive and serious approach to celebrity culture in its gossip, the blog tends to judge female celebrities according to narrow definitions of hegemonic femininity. This perspective is then reflected in the community of commenters, who often chastise female celebrities who do not uphold dominant norms of femininity, sexuality and/or motherhood, thereby consenting to these oppressive ideologies as a standard to which all women, including themselves, ought to adhere. That is, female celebrities become markers of what constitutes acceptable femininity or markers of feminine failure that serve as a warning to female readers.

This is not to suggest that the predominantly female audiences of celebrity gossip blogs are nothing but dupes seduced into their own oppression by the pleasures of celebrity culture and gossip blogs. Gossip blogs are but one cultural source where these gendered discourses are circulated, and, as with other forms of media consumption, there is ample evidence that audiences seek out blogs that speak to the ideals and values they already hold (Jenkins, 2006b). Celebrity culture socially and economically rewards women who adhere to these standards in ways that make such a lifestyle desirable to emulate without drawing attention to the narrow views and impossible standards it perpetuates. Given that contemporary American culture continues to conflate women's social value with physical beauty and sexual desirability, celebrity culture is an apt ideological marker for how to achieve such social rewards. At the same time, there is clear evidence that gossip about celebrities can be a site of resistance, and blogs that explicitly forward this sort of engagement with celebrity culture build communities of women who actively critique and demand more from celebrity culture. The outsider status of blogs as a genre helps open the possibility that oppositional readings may occur by shifting the balance of power away from the commercial interests of the traditional celebrity producers, who are politically

and economically invested in the perpetuation of such narrow definitions of femininity, and towards the audiences. Digital technologies make such alternative gossip communities visible and viable players that challenge the mainstream commercial media industry's control over celebrity culture and open the possibility, but does not guarantee, that audiences can use gossip as a site of resistance.

Technological and Social Changes to Gossip Blogs

Within digital culture, to remain static is to become obsolete. As a result, constant change is a necessary part of celebrity gossip blogs. What is visible one day may be gone, or at least changed, the next. New commentary from the blogger may be added without any indication the post has been updated.[1] New reader comments may be added (or in some cases, deleted) throughout the day. Visiting these blogs today would not precisely reproduce my experience of looking at them during the time of my fieldwork. Whether changing the physical design and layout or expanding (or constricting) the range of interactive features available to readers, gossip blogs are constantly adapting to new technological developments and, more crucially, to the social demands of their audiences for increased spaces of participation. Though all the blogs keep archives of past content, the completeness of those archives varies from site to site, and some, such as the archives on Jezebel and PS, reflect the site's design changes rather than show the posts as they first appeared. I made every effort to keep diligent field notes and created my own archive of blog posts in their original form, but I argue these technological updates and changes do not substantially alter the underlying social practices of gossip that shape each blog.

As the blogs gained popularity with audiences, they also became more sophisticated in their form and are, at this point, largely indistinguishable from many "professional" media sites, such as the online versions of print tabloids, in terms of the technological aspects and format of the site. This is a reciprocal shift, as many official entertainment media industry outlets have adopted blogs' writing style and highly interactive format in the online versions of their print publications. This includes reproducing the physical and technological layout of blogs: using visual images, typically paparazzi photos, as an anchors for short posts, inclusion of links to additional information about a story and, most importantly, a comments section for readers to add their own perspective on a

[1] This seems to be uncommon, as most bloggers either show redacted text (i.e., "celebrity X ~~is reportedly pregnant~~ has confirmed her pregnancy, according to *Us Weekly*") or explicitly include the word "update" before including new content. I have no way of knowing if content was changed if I did not see the original, but it seems that most gossip bloggers are upfront about the fact that they make changes to their content based on new information.

gossip item. The online outlets for popular print gossip magazines like *People* (www.people.com) and *Us Weekly* (www.usmagazine.com) use this frequently updated format to keep audiences current and draw them back to the print versions of the magazine, often by promising more details and information not available online. These online sites are intended to supplement, but not supplant, the print magazines and, thus, overwhelmingly reproduce the same approach to celebrity that structures the magazine and do not use any outside sources that may draw readers away from their sites. That is, they do not adopt the "outsider" or audience perspective typical of blogs, but do take advantage of the immediacy and interactivity of the Internet to keep readers engaged between print versions.

Though the key textual components—the post, the link and the visual image—remain central to current versions of the blogs examined here, all have made at least some sort of change to their layout and technological features. Most of these changes were made to update the blog's look but reflect little in the way of changes to the content or the approach to celebrity culture itself. Nevertheless, a brief examination of how these sites have changed reinforces several key points about how blogs have transformed celebrity culture and celebrity media, as even these new developments illustrate how the social and technological features work together to promote a particular type and strength of community on the blog.

There have been some notable changes to PerezHilton.com that go deeper than physical layout changes. In fact, PerezHilton remains largely the same in its layout, with short posts anchored by visual images and the use of MS Paint to write on those images. However, in October 2010, Perez publicly pledged to "stop bullying" on his site as a way to bring awareness to the rising problem of gay bullying and gay teen suicides. He said:

> I'm not going to call people nasty nicknames. I'm not going to go the mean route. I'm going to force myself to try and be funnier or smarter or just do things different, not doodle inappropriate things, not out people, which I have done all of those things in the past. (Dinh, 2010)

He still draws on photos and certainly still makes fun of celebrity foibles using a somewhat crude approach, reflecting the ideological brand that has always shaped this blog. For example, he still refers to pregnant celebrities as "sperminated," such as in the March 5, 2012, announcement of television personality Vanessa (Minnillo) Lachey's pregnancy. While the post itself is meant to be positive and celebratory, the headline "Vanessa Minnillo is Sperminated! Nick Lachey Announces Pregnancy on Air" retains traces of his mean-spirited snark in the use of the word "sperminated" and the policing of a pregnant woman's

body as the site of access to her private and "real" self (Hilton, March 5, 2012). This anti-bullying shift is even more apparent in posts about celebrities who were typically reviled and mocked in the original iteration of his blog. For example, in contrast to his mean-spirited mockery of Lindsay Lohan's nude photos in *New York* magazine in 2008, the 2011 post about the release of her nude *Playboy* pictorial, which again recreates some classic Marilyn Monroe photographs, was met with a much more positive tone. He says, "We'll hand it to her - regardless of who she thinks she's trying to emulate, she does look nice," though mockingly critiques the fact that she earned one million dollars to pose for the nude photos, yet did not show "her, ahem, 'lovebug,'" (Hilton, Dec 9, 2011). Though decidedly less mean-spirited than his body snarking of her *New York* magazine pictorial, he still polices the female celebrity body and equates Lohan's value to her private parts and willingness to put them on public display.

But Perez's move away from mean-spirited gossip has not necessarily carried over to his comments sections, as, despite a new user registration policy that will be discussed in more detail below, many of the comments remain highly judgmental and often reinforce the same racist, sexist and homophobic perspectives Perez is now allegedly fighting against. The comments section for the 2011 Lindsay Lohan *Playboy* photos post, like the 2008 *New York* magazine photos post, mocked Lohan for trying to emulate a much more worthy star and more viciously criticized her body for failing to live up to rigid standards of beauty as the true sign of that failing. Interestingly, there were far fewer comments overall on this post, just 116 compared to the thousands from the *New York* magazine post, which may be a result of the new registration process or may be tied to a waning interest in Lohan's star image. However, the post was retweeted 1,631 times and shared through Facebook 732 times, which indicates that current audiences are using other non-site-specific social media forms to build community with others (both known and unknown) through celebrity gossip. PerezHilton uses these social media platforms as well, often feeding Perez's personal tweets or Facebook updates directly into new posts on the blog, speaking to changing technological protocols of engagement on the site that nevertheless remain tied to the social practice of gossip.

As discussed in chapter three, PerezHilton has also expanded its brand to a range of popular culture blogs, indicating Perez's growing power as a commercial media producer. These sites share a similar format and also share content, as nearly every post is cross-linked to the appropriate sister-site as a way to reinforce the economic and social power of PerezHilton brand beyond celebrity gossip. Tellingly, all of the posts across these blogs lack a specific author attribution, giving the reader the impression that Perez is the author of all the

posts on all his branded blogs, which, given the frequency of updates and number of blogs, is an impossible task. Even before the expansion of the blog brand, Perez had been dogged by reports that he no longer writes any of the content on PerezHilton, limiting his actual contributions to occasional video blogs (Perl-Raver, 2009). In June 2009, Latino-focused celebrity gossip blog Guanabee.com claimed to have multiple "exclusive" sources that had ghostwritten for Perez as far back as 2006 (Cesares, 2009). Publicly, Perez maintains that he writes his own content, though admitted in a May 28, 2009 *Time* magazine video interview that he has "finally hired some help" without specifically addressing what these assistants do (Keegan, 2009). However, Gawker.com uncovered legal documents related to an ongoing lawsuit between Perez and gossip blogger Jonathan Lewandowski (who blogs under the name Jonathan Jaxson) that claims Perez violated a settlement by continuing to mention Lewandowski on PerezHilton. In these documents, Perez's attorney claims the posts in question were written by Perez's sister, Barbara Lavandiera, thus effectively disclosing the fact that Perez is not responsible for all content on the site (Tate, 2009). As his voice and persona are central to his approach to celebrity culture and indeed his brand as a blogger, it is not surprising that Perez maintains his position as the site's author even as the actual content is written by others.

In contrast, Trent Vanegas of PITNB, who has also made a number of technological and layout changes to his blog since the initial switch to the multipost format in 2008, openly integrated an additional writer to his blog in early 2012 (and a third in June of the same year) to help alleviate his workload and ensure that the quality—and the ideological framing—of the blog is maintained. Trent welcomed the new writer, Melissa, with a post introducing her and, more crucially, explicitly asking audiences to join him in welcoming her and her perspective into the PITNB community (Vanegas, Jan 10, 2012). He tells his readers he has "no plan to trick anyone or alienate anyone," but to expand "the fun" of the site by including a new writer who largely shares his perspective on celebrity culture (ibid.). His efforts to integrate her into the community, rather than hide it as Perez does, is consistent with his overall tone and positive approach to celebrity and to his online community. Each post is now attributed at the bottom to either Trent or Melissa (who has now been replaced by Shannon), but the overall tone of the blog remains consistent, and Trent still regularly posts updates on his personal life and social activities outside of the blog. In this way, PITNB has transitioned to a group blog, but retains the feel of an individual blog through its consistent tone and approach to celebrity culture. This is similar to the other group blogs, PS and Jezebel. While each writer may bring a particular nuanced style to a post, the overall

tone and ideological perspective remains consistent. Thus, although both PS and Jezebel have changed some of their writing staff since my initial observation, such personnel changes do not impact the overall approach to celebrity culture. Brandon and Natasha continue to be the sole writing voices on WWTDD and YBF, respectively. Despite technological, layout and even personnel changes, all of the blogs in my sample remain consistent in terms of approach and style, reinforcing the notion that it is each blog's particular approach to celebrity culture that draws audiences to it. As media audiences increasingly demand expanded forms of participation across media culture, the biggest changes on these blogs have been in the interactive spaces, working to encourage greater audience participation within the particular framework of a specific blog.

Technological Changes, Social Effects: Changes to Gossip Blog Communities

The ideological framing of gossip blogs has important implications for the emergence of community within these virtual spaces, highlighting the ways in which the social takes over from the technological in shaping an online community. Jenkins' (2006a) distinction between interactivity and participation suggests that while technological features may offer audiences a virtual space in which to interact, there is no guarantee that all audiences will actually use them or will use them in the same way. This supports my claim that the range of communities on celebrity gossip blogs are not captured by a technological analysis alone (e.g., observation of the visible reader comments), and also reiterates the need for a flexible notion of community when studying these online groups, as each group centers around distinct social practices of gossip.

The particular framing of each gossip blog draws a like-minded audience of readers who may or may not be interested in creating community as part of their engagements with celebrity gossip on the blog. My analysis indicates that readers are overwhelmingly drawn to a specific blog because of the blogger's commentary and approach to celebrity culture more so than any of the interactive features the blog may offer. This is similar to Hermes' (1995) work on the imagined communities that emerge amongst print gossip magazine readers, and suggests that while the technological features do play a role in how readers engage with blogs, any sense of community remains tied to the assumption of shared social values and negotiation of those values amongst commenters.

The technological features structure the community on the blogs, but the true character of the community is defined by the ways in which commenters engage with the blog and each other in these interactive spaces. The blogger, as the primary cultural producer, controls the implementation of technological

features and retains the authority to set the social boundaries of community on each blog. As a result, the participation in the comments section usually reinforces the blogger's preferred reading of celebrity culture. This is not to say that dialogue and dissent never occur, but they usually work to recuperate the meaning back to the preferred one or shun the wayward commenter from the community. Blog communities are always in process, negotiating the terms of engagement and using gossip about celebrities to create larger social meanings. Furthermore, the voluntary nature of the participation in the comments sections illustrates that the technological features of a blog cannot predict or confine the types of communities that emerge.

All the blogs have upgraded and redesigned their sites for aesthetics and functionality, and this generally extends to the comments sections as well. Yet such changes have not really impacted the social tone and quality of the commenter communities on each site. In other words, even if a technological change aims at limiting audience practices, making technological changes does not necessarily change social practices of participation. Some sites have not made any substantial changes, other than aesthetic, to the interactive features on their sites. As of March 2012, both WWTDD and YBF's comments sections look slightly different, but have the same registration requirements for users and rules (both official and unofficial) that governed their comments sections during my fieldwork. As a result, it is not surprising that that the commenter communities retain the same social forms of engagement that reflect, and often intensify, the approach to celebrity culture offered by the blogger. The specific focus of each site, black celebrity culture for YBF and "guy gossip" for WWTDD, means that a specific type of audience is already seeking out the blog and offering more or different technological spaces of engagement does not appear to be as relevant to each audience's decision to engage with that blog. Both communities remain active and have grown as the blog's popularity has increased, and seem to be satisfied with the existing forms of engagement.

The remaining blogs, however, have made technological changes to their interactive spaces that have had a more distinct impact on audience engagement. On PerezHilton, for example, the technological changes appear to be aimed at limiting audience engagement as a way to change the social tone of the community in accordance with Perez's new "positive" approach to celebrity culture. These comments sections, once a free-for-all space, were restructured in August 2008 to require users to register an account with the site or link to an existing Facebook account in order to post comments, thus effectively inhibiting completely anonymous commenting. Though this change pre-dates Perez's public decision to "stop bullying" on his blog, it does appear this feature was an attempt to regain some control over the comments sections on the site, which

were rife with spam, profanity and mean-spirited racist, sexist and homophobic sentiments. Furthermore, Perez (or whoever is moderating his site) often turns off the comments sections on individual posts without explanation or warning, which seems to indicate an effort to stop negative or inappropriate comments from appearing on the blog. As will be discussed below, the existence of such inappropriate comments does not necessarily cause a comments section to be disabled, as derogatory and mean-spirited comments not only appear but also continue to be the norm amongst comments in this established community.

This attempt to place limitations on how users engage with the comments section did have some impact on the community of commenters on this blog. The immediate effect of these technological changes was a drop in the total number of comments. According to a Jezebel report on the site changes on PerezHilton, a comparison of a randomly selected older post from PerezHilton with one just after the change showed the total number of comments dropped from 165 to 88 (Maria, 2008). Comparison of current posts to my fieldwork data reflects this finding, as the total number of comments across his site has definitely decreased. This is most telling on posts that normally would seem to attract huge numbers of comments, such as the December 2011 post on the Lindsay Lohan *Playboy* pictorial that generated just 116 comments compared to the over 2,000 comments generated within the first 24 hours of the posting of the *New York* magazine photos in February 2008.

I suggest the low number of comments is not a reflection of the public's lack of interest in these photos, as the issue of *Playboy* itself was quite successful, reportedly selling out at newsstands and prompting a swell in subscriptions to the magazine's online service, iPlayboy.com (Sacks, 2011). It could, however, be read as evidence of a shift in PerezHilton's popularity amongst online gossip readers. Though the blog still ranks in the top 100 celebrity and top 100 entertainment blogs according to Technorati, the site's overall popularity has fallen from its height in the mid-2000s. Data from web traffic tracking company Alexa (2012) indicates that since fall of 2011, PerezHilton's traffic ranking has been slightly, but steadily, declining. Though I do not suggest the changes in the interactive spaces are solely responsible for this change, the overall decrease in the number of comments across the site since the institution of the new registration policy is indicative of a larger decline in PerezHilton's audience that points to an alienated readership who are turning elsewhere for their celebrity gossip.

Interactivity, however, does not address the social rules and practices of commenting that shape audience participation in online spaces. Indeed, though the total number of comments on PerezHilton.com has certainly decreased, the tone of the comments sections remains largely the same. Despite having static

user names, more recent observation of the site shows little interaction or dialogue between commenters and the continuation of the isolated comments, consistent with my earlier observations. Interestingly, however, the race to be first, a hallmark of this community during my fieldwork, has largely disappeared. It is unclear whether such comments do not appear because they are moderated as part of the technological design of the new comments sections or if the practice has been effectively ended through social policing by other users. But the derogatory tone still dominates this community. The comments for Lindsay Lohan's *Playboy* pictorial reflect the same sort of body snarking and mean-spirited comments as those on her *New York* magazine photos, using a critique of her body as a means to police proper femininity and her worthiness as a celebrity:

> #3 bytchface says – **reply to this**
> Hef rejected the first ones because they were unairbrushable. I personally do NOT think she's good enough for Playboy, but smart move on Hef's part, everyone wants to see a trainwreck play the despiration card.

> #15 LizardKinG says – **reply to this**
> She looks like shit she's much sexier with the ankle bracelet…

> #21 Pam's Tijuana-Bought Silicone Implants says – **reply to this**
> The photos look GREAT; too bad she doesn't really look like that…

> #39 rayperson says – **reply to this**
> AIRBRUSH MUCH? kinda floppy, she is not now nor ever has been Marilyn Monroe. what a skank. (raypearson, comments on Hilton, Dec 9 2011)

Though a few commenters do express support for Lohan and offer kind remarks, the tone of this community continues to reflect the mean-spirited mode of dis-identification upon which Perez built his brand. He may have changed his own perspective somewhat, but much of his audience still prefers to use their gossip as a mode of social judgment. There seems to be little moderation or any clear rules for posting comments, thus it is not particularly surprising that the gossip style of the original site and commenter community continues to shape the current version. Many audiences who want this mean-spirited approach continue to turn to PerezHilton.com to get it, and use the comments sections to provide it if Perez's posts do not.

Other blogs more successfully integrated new interactive features by tying them to the social goals of the community rather than using them primarily to limit the audience's social engagement. As discussed in chapter three, PITNB did not have any comments sections during my fieldwork because Trent specifically chose to remove them after he perceived the tone of the comments

as detrimental to the social goals of his site. The comments sections were reinstated as part of the redesign of his blog in 2008 with a registration process that acts as a first level of control over how audiences may engage with the site. Importantly, unlike PerezHilton's comments sections, the comments are moderated, often by Trent himself, as a way to use social, not technological, means to encourage a particular form of participation in this interactive space. It is not uncommon to see Trent participate in the discussion in the comments sections, justifying his own perspective, answering questions from commenters or generally engaging in dialogue about the topic at hand. His involvement helps promote the positive tone of the blog within the commenter community, and these comments sections, while not always positive, are certainly distinct from those on PerezHilton. The static user names and "reply to this" button further help promote dialogue by structuring how users may engage, but the social protocols of participation reinforced by Trent's presence in the comments sections and the other users socially policing the comments reinforce the blog's perspective on celebrity culture and brings the audience into the process of meaning making through gossip talk.

Both PS and Jezebel have dramatically increased the number of interactive modes on their sites to offer more spaces for audience engagement and content creation. In a somewhat controversial redesign across the Gawker blog network in February 2011, Jezebel's already highly technologically and socially structured community was given more ways to engage with the site within protocols set up and maintained by the site's producers. Already identified by static user names and avatars, users now can post video clips and animated .gif files as part of their comments, extending their ability to contribute to the content of the site. The rules of auditioning and participating in the community remain intact, and continue to reinforce the feminist goals of the site within the comments sections. Comments are now threaded around audience discussions, with an initial comment at the top and a button to click to view all responses below it, making it easier to follow back and forth dialogues between commenters instead of putting them all in one long thread. Commenters seem pleased with these changes, as it allows them spaces of content creation and technological engagement, yet maintains the social goals of the group at the same time. These comments sections remain robust places of dialogue between users, and, despite some grumblings about layout changes and the move to a threaded commenting display structure, these technological affordances largely supported, or at least did not detract from, the social goals of the site.

The most radical expansion in interactive spaces is on PopSugar. Registered users are now responsible for a great deal of content on the site. They create and join groups, have extensive personal profiles, can privately message other

users through the site and redeem Sugar points to give virtual gifts to each other, among other features aimed at deepening the user's connection to the site and to other community members. Users are offered multiple technological spaces to create content and connect with each other, and this engagement is supported by social protocols including posting guidelines, moderation by Sugar staff and most importantly, self-policing by the community. The main posts, or what are now referred to as "editorial sites," are still written by Molly (now Vice President of Content for the site) and various staff members, though the PopSugar avatar and pseudonym has been discarded and all posts are attributed to a particular staff member. However, the blog has also hosts parallel "community sites" that are created and run by and for the members of the PS community. Groups devoted to a range of topics including fan sites for particular celebrities, general celebrity topics (such as "stars without makeup" or "celebrity style") or more specific celebrity gossip (such as groups devoted to particular celebrity couples). Once a PS user forms a group, any site member can join and post content, typically culled from either Sugar sites or across the web more broadly, as well as engage in conversation about that particular topic. The textual layout is similar to the PS editorial sites, with a photo and some text content at the top and comments sections beneath. These groups allow for smaller and more specialized "sub-communities" to emerge that intensify the user's engagement with the site by promoting closer connections with others around shared content-creation in these spaces as well as a general PopSugar community through the editorial sites. Though these user-generated groups fall outside of the scope of this project, they present a space for further research on how the amateur or audience is integrated into the circuit of celebrity production through new media technologies, yet still remains under the control of the blog producer.

The rising popularity of gossip blogs, and indeed of a range of social media platforms, is built upon audience participation. The technological evolutions across the blogs in my sample point to blog audiences' increasing demand to participate as part of their engagements with celebrity gossip blogs. Jenkins (2006a), drawing on the work of cultural anthropologist and industry consultant Grant McCracken, says "media producers must accommodate consumer demands to participate or they will run the risk of losing the most active and passionate consumers to some other media interest that is more tolerant" (p. 133). But these changes must always be tied back to social goals in order to address the social practices of participation. That is, technological bells and whistles are not what creates or maintains a community on celebrity gossip blogs. This is not to suggest that audiences do not want changes or that technological changes have no impact on the quality or social form of the

community. But even when changes are made, they are most effective when they deepen the existing social modes of participation on the site rather than attempt to restructure or control them.

Beyond Gossip Blogs

Celebrity gossip blogs reconfigure the circuit of celebrity production, giving audiences unprecedented power to shape the public meaning of the celebrity image. Audiences have always engaged with celebrity culture through gossip, using celebrity images as ideological anchors for shared negotiation of cultural norms. Thus, gossip provides a link between "old" audience engagements with celebrity culture and the new publicly visible spaces of audience participation on blogs. What is "new" about these practices, then, is not the gossip itself, but the public visibility of this audience practice within the interactive spaces of celebrity gossip blogs. Coming together around the shared desire to make meaning through the celebrity image, celebrity gossip bloggers and audiences have intervened into a previously closed system of celebrity production and, more importantly, have demonstrated the ways in which audiences use gossip and celebrity culture as part of their everyday lives. Such an intervention does not necessarily imply a resistance to the dominant ideologies embedded within celebrity culture, but it does recognize the power of audiences in the creation and reinforcement of cultural norms instead of assuming they are passive dupes who simply accept such norms. The pervasiveness of celebrity gossip in our culture is, then, far from a meaningless escape. Celebrity culture provides important narratives about identity that shape the way we see ourselves within contemporary American society.

These shifts are key to understanding changes in contemporary celebrity culture, but are indicative of broader transformations within media culture. Beyond gossip blogs, a range of new media platforms, such as digital photography and video, reality television and social networking sites, such as Facebook and Twitter, are also a part of this contemporary destabilization of the coherent celebrity image and an attendant emphasis on the role of the audience as part of the media system. These platforms offer immediate and interactive engagements with celebrity culture that not only originate outside of industry control but also specifically encourage the audience to see the industry manipulation and create their own meanings outside of it. However, this power is not given freely or without struggle, as the same digital technologies that open spaces for audience resistance have also been harnessed by industry producers to re-exert control over the meaning of the celebrity image under the guise of authenticity and unmediated disclosure. Media producers may have been pushed to develop new spaces of engagement to meet demands of audiences, but the visibility of a

newly powerful audience-producer in many ways masks the ever-increasing power of the media industry. Bird (2011) argues that far from being threatened by the rise of the active audience, traditional media industries "have simply found creative ways to harness the enthusiasm of active media audiences in order to sell them more effectively" (p. 507). Celebrity gossip blogs, which began as an amateur, grassroots intervention into celebrity culture, are being integrated into mainstream celebrity media practices, either by copying their textual form and interactive features or simply being absorbed into traditional media industries. The uneasy relationship between audiences and industry within the age of convergent and participatory media culture remains an area ripe for future research. Nevertheless, the rise of celebrity gossip blogs provides a look at the continued influence media and popular culture have over our everyday lives and the struggles that accompany the shift to a digital, interactive and participatory media culture.

Bibliography

Access Hollywood (2006, July 27). Did gossip blogger out Lance Bass? *MSNBC.com*. Retrieved September 29, 2007 from http://www.msnbc.msn.com/id/14065223/from/ET/

Alexa (2009a). Jezebel.com site info. Retrieved November 15, 2009 from http://alexa.com/siteinfo/jezebel.com

———— (2009b). Perezhilton.com site info. Retrieved November 15, 2009 from http://alexa.com/siteinfo/perezhilton.com

———— (2009c). Pinkisthenewblog.com site info. Retrieved November 15, 2009 from http://alexa.com/siteinfo/pinkisthenewblog.com

———— (2009d). Popsugar.com site info. Retrieved November 15, 2009 from http://alexa.com/siteinfo/popsugar.com

———— (2009e). Wwtdd.com site info. Retrieved November 15, 2009 from http://www.alexa.com/siteinfo/wwtdd.com

———— (2009f). Ybf.com site info. Retrieved November 15, 2009 from http://www.alexa.com/siteinfo/ybf.com

———— (2012) PerezHilton.com site info. Retrieved April 15, 2012 from http://alexa.com/siteinfo/perezhilton.com

Anderson, B. R. O. (1983). *Imagined communities: Reflections on the origin and spread of nationalism.* London: Verso.

Ang, E. (1985). *Watching Dallas*. London: Methueun.

Artz, L., & Kamalipour, Y. (2007). Introduction. In L. Artz, & Y. Kamalipour (Eds.), *The media globe: Trends in international mass media* (pp. 1-6). Lanham, MD: Rowman & Littlefield.

Barbas, S. (2001). *Movie crazy: Fans, stars, and the cult of celebrity* (1st ed.). New York: Palgrave.

Bausch, S. (2007, March 29) Popular celebrity news sites grow 40 percent year over year, according to Nielsen//NetRatings. *Nielsen//NetRatings, Inc.* Retrieved from http://www.nielsen-online.com/pr/pr_070329.pdf.

Baym, N. K. (1998). The emergence of online community. In S. G. Jones (Ed.), *Cybersociety 2.0: Revisiting computer-mediated communication and community* (pp. 35-68). Thousand Oaks, CA: Sage.

———— (2000). *Tune in, log on: Soaps, fandom, and online community*. Thousand Oaks, CA: Sage.

———— (2006). Interpersonal life online. In L. Lievrouw, & S. Livingstone (Eds.), *The Handbook of new media: Social shaping and social consequences of ICTs* (2nd ed., pp. 35-54). London and New York: Sage.

Bergmann, J. R. (1993). *Discreet indiscretions: The social organization of gossip*. New York: Aldine de Gruyter.

Biocca, F. A. (1988). Opposing conceptions of the audience: The active and passive hemispheres of mass communication theory. In J. A. Anderson (Ed.), *Communication Yearbook* Vol. 11 (pp. 51-80). Newbury Park, CA: Sage.

Bird, S. E. (1992). *For enquiring minds: A cultural study of supermarket tabloids* (1st ed.). Knoxville: University of Tennessee Press.

———— (2011). Are we all produsers now? Convergence and media audience practices. *Cultural Studies 25*(4-5), 502-516.

Brauer, L., & Shields, V. R. (1999). Princess Diana's celebrity in freeze-frame: Reading the constructed image of Diana through photographs. *European Journal of Cultural Studies, 2*(1), 5-25.

Brendon. (2008, February 29). Oh mama. *What Would Tyler Durden Do?* [Blog post]. Retrieved February 29 from http://www.wwtdd.com/2008/02/oh-mama/

———— (2008, March 5). Britney is a good teacher. *What Would Tyler Durden Do?* [Blog post]. Retrieved March 6 from http://www.wwtdd.com/2008/03/britney-is-a-good-teacher/

———— (2008, March 7). I think I'm in love. *What Would Tyler Durden Do?* [Blog post]. Retrieved March 7, 2008 from http://www.wwtdd.com/2008/03/i-think-im-in-love-8/

Brueur, H. (2008, February 14). Court may extend dad's control over Britney. *People*. Retrieved from http://www.people.com/people/article/0,,20178036,00.html

Bruns, A. (2008) *Blogs, Wikipedia, Second Life, and beyond: From production to produsage*. New York: Peter Lang.

Burnett, R., & Marshall, P. D. (2003). *Web theory: An introduction*. London; New York: Routledge.

Bury, R. (2005). *Cyberspaces of their own: Female fandoms online*. New York: Peter Lang.

Burkeman, O. (2009, June 24). The Brangelina industry. *The Guardian*. Retrieved from http://www.guardian.co.uk/lifeandstyle/2009/jun/24/magazines-media-aniston-jolie-pitt

Caplan, D. (2008, September 24). Clay Aiken: I'm a gay dad. *People*. Retrieved from http://www.people.com/people/article/0,,20228488,00.html

Cesares, C. (2009, June 1). Perez Hilton has ghostwriter says handwriting expert. *Guanabee*. [Blog post]. Retrieved July 20, 2009 from http://guanabee.com/2009/06/perez-hilton-ghostwriter

Chang, A., & Evans, M. (2009, June). Inside Twitter: An in-depth look inside the Twitter world. Retrieved from: http://www.sysomos.com/insidetwitter/

Chayko, M. (2002). *Connecting: How we form social bonds and communities in the internet age*. Albany: State University of New York Press.

Christian Bale rant: full transcript. (2009, February 4). *The Telegraph*. Retrieved from http://www.telegraph.co.uk/news/newstopics/celebritynews/4508022/Christian-Bale-rant-Full-transcript.html

Coen, J. (2008, February 18). Lindsay Lohan: Real or manmade? *Jezebel*. [Blog post]. Retrieved February 21, 2008 from http://jezebel.com/357739/lindsay-lohan-real-or-manmade

Community Manager (2009, August 24). What are PopSugar points? *Pop Sugar*. [Blog post]. Retrieved March 14, 2010 from http://community-help.geeksugar.com/What-PopSugar-Points-4343542

ComScore (2008, January 20). ComScore releases 2007 internet year in review. Retrieved from http://www.comscore.com/Press_Events/Press_Releases/2008/01/2007_US_Internet_Year_in_Review

———— (2009, July 1). More Americans reading entertainment news online, with much of it occurring during work hours. Retrieved from http://www.comscore.com/Press_Events/Press_Releases/2009/7/More_Americans_Reading_Entertainment_News_Online_With_Much_of_it_Occurring_during_Work_Hours

Day, E. (2007, September 30). Mr. gossip steps into the real world. *The Observer*. Retrieved from http://www.guardian.co.uk/media/2007/sep/30/digitalmedia.fashion

de Certeau, M. (1984). *The practice of everyday life*. Berkeley: University of California Press.

deCordova, R. (1990). *Picture personalities: The emergence of the star system in America*. Urbana: University of Illinois Press.

Denizet-Lewis, B. (2009, July 9). The real Perez Hilton. *The Advocate*. Retrieved from http://www.advocate.com/Arts_and_Entertainment/Internet/The_Real_Perez_Hilton/

Desjardins, M. (2001). Systematizing scandal: *Confidential* magazine, stardom, and the state of California. In A. L. McLean, & D. A. Cook (Eds.), *Headline Hollywood: A century of film scandal* (pp. 206-231). New Brunswick: Rutgers University Press.

Dinh, J. (2010). Perez Hilton vows to stop bullying celebs on "Ellen." *MTV News*. Retrieved from http://www.mtv.com/news/articles/1649894/perez-hilton-vows-stop-bullying-celebs -on-ellen.jhtml

Dyer, R. (1986). *Heavenly bodies: Film stars and society.* Basingstoke: Macmillan.

———— (1998). *Stars* (New ed). London: BFI Publishing.

Eubanks, N. (2008, February 25). Oscars 2008: So Quincy's keeping this one around? *The Young, Black and Fabulous.* [Blog post]. Retrieved May 17, 2008 from http://theybf.com/ index.php/2008/02/25/so-how-old-is-this-one-quincy/

Everett, A. (2001). *Returning the gaze: A geneology of black film criticism, 1909-1949.* Durham, NC: Duke University Press.

Fernback, J. (1997). The individual within the collective: Virtual ideology and the realization of collective principles. In S. G. Jones (Ed.), *Virtual culture: Identity and communication in cyberspace* (pp. 35-54). Thousand Oaks, CA: Sage.

Gabler, N. (1994). *Winchell: Gossip, power, and the culture of celebrity* (1st ed.). New York: Knopf: Distributed by Random House.

Gamson, J. (1994). *Claims to fame: Celebrity in contemporary America.* Berkeley: University of California Press.

gfutrelle. (2009, September 29). Comment FAQs [updated version]. *Gawker.* [Blog post]. Retrieved from http://gawker.com/commentfaq/

Goodson, M. (2008, February 19). Heidi, Seal, and all the kiddies are face-paint Disney fanatics. *Pop Sugar.* [Blog post]. Retrieved February 23, 2008 from http://www.popsugar.com/Heidi-Seal-All-Kiddies-Face-Paint-Disney-Fanatics-1054247

Grossman, L. (2006, December 25, 2006). You—yes you—are *Time*'s Person of the Year. *Time* Retrieved from http://www.time.com/time/magazine/article/0,9171,1570810,00.html

Hall, S. (1980) Encoding/decoding in television discourse. In S. Hall, D. Hobson, A. Lowe, & P. Willis (Eds.), *Culture, media, language* (pp. 128-139). London: Hutchinson.

Haughney, C. (2012, Aug 7). Women's magazines lead overall decline in newsstand sales. *The New York Times.* Retrieved from http://mediadecoder.blogs.nytimes.com/2012/08/07/womens-magazines-lead-overall-decline-in-newsstand-sales/

Hermes, J. (1995). *Reading women's magazines: An analysis of everyday media use.* Cambridge, UK; Cambridge, MA: Polity Press.

Hilton, P. (2008, February 16). The new & improved Britney Spears. *PerezHilton.* [Blog post]. Retrieved February 23, 2008 from http://perezhilton.com/2008-02-16-the-new-improved-britney-spears

———— (2008, February 18). Lindsay does Marilyn. *PerezHilton.* [Blog post]. Retrieved February 23, 2008 from http://perezhilton.com/2008-02-18-lindsay-does-marilyn

———— (2008, February 19). A process of healing. *PerezHilton.* [Blog post]. Retrieved February 23, 2008 from http://perezhilton.com/2008-02-19-a-process-of-healing

———— (2008, February 21). Headline of the ~~week~~ weak. *PerezHilton.* [Blog post]. Retrieved February 21, 2008 from http://perezhilton.com/2008-02-21-headline-of-the-week-weak-87

———— (2008, February 27). Pregnant and boozing!!!! *PerezHilton.* [Blog post]. Retrieved February 27, 2008 from http://perezhilton.com/2008-02-27-pregnant-and-boozing-2

———— (2008, February 28). The stripper strikes again. *PerezHilton.* [Blog post]. Retrieved February 28, 2008 from http://perezhilton.com/2008-02-28-the-stripper-strikes-again

———— (2008, March 2). Is this a publicity stunt??? *PerezHilton.* [Blog post]. Retrieved March 2, 2008 from http://perezhilton.com/2008-03-02-is-this-a-publicity-stunt

———— (2008, March 11). Separated by plastic. *PerezHilton* [Blog post]. Retrieved March 11, 2008 from http://perezhilton.com/2008-03-11-separated-at-birth-80

———— (2008, March 27). What's he smoking???? *PerezHilton*. [Blog post]. Retrieved April 6, 2008 from http://perezhilton.com/2008-03-27-whats-he-smoking-2

———— (2011, December 9). Lindsay Lohan's *Playboy* spread has arrived!!!! *PerezHilton* [Blog post]. Retrieved March 5, 2012 from http://perezhilton.com/2011-12-09-lindsay-lohan-playboy-spread

———— (2012, March 5). Vanessa Minnillo is sperminated! Nick Lachey announces pregnancy live on air. *PerezHilton/Perezitos* [Blog post]. Retrieved March 5, 2012 from http://perezitos.com/2012-03-05-vanessa-minnillo-is-pregnant-nick-lachey-announces-pregnancy-on-air

Holmes, A. (2008, January 2). This year, let's call it quits on the nasty nit-picking. *Jezebel*. [Blog post]. Retrieved February 16, 2008 from http://jezebel.com/339424/this-year-lets-call-it-quits-on-the-nasty-nit+picking

———— (2008, February 29). Commenter executions: Off with their heads. *Jezebel*. [Blog post]. Retrieved March 1, 2008 from http://jezebel.com/362532/commenter-executions-off-with-their-heads

———— (2008, March 10). Gwen & Gavin's special delivery. *Jezebel*. [Blog post]. Retrieved March 11, 2008 from http://jezebel.com/366115/gwen--gavins-special-delivery

Holmes, S. (2005). "Off-guard, unkempt, unready"?: Deconstructing contemporary celebrity in *heat* magazine. *Continuum: Journal of Media & Cultural Studies, 19*(1), 21-38.

Holmes, S., & Redmond, S. (2006a). Introduction: Fame simulation. In S. Holmes, & S. Redmond (Eds.), *Framing celebrity: New directions in celebrity culture* (pp. 209-214). London; New York: Routledge.

———— (2006b). Introduction: Understanding celebrity culture. In S. Holmes, & S. Redmond (Eds.), *Framing celebrity: New directions in celebrity culture* (pp. 2-16). London; New York: Routledge.

Huang, J. (2006, November 28). *Perez Hilton: Blogger extraordinaire*. Retrieved August 14, 2007, from http://www.snmag.com/INTERVIEWS/Celebrity-Interviews/Perez-Hilton-Blogger-Extraordinaire.html

Jaworski, A., & Coupland, J. (2005). Othering in gossip: "You go out you have a laugh and you can pull yeah okay but like...". *Language in Society, 34*, 667-694.

Jenkins, H. (1992). *Textual poachers: Television fans & participatory culture*. New York: Routledge.

———— (2006a). *Convergence culture: Where old and new media collide*. New York: New York University Press.

———— (2006b). *Fans, bloggers, and gamers: Exploring participatory culture*. New York: New York University Press.

———— (2007). Afterword: The future of fandom. In J. Gray, C. Sandvoss, & C. L. Harrington (Eds.), *Fandom: Identities and communities in a mediated world* (pp. 357-364). New York: New York University Press.

Johansson, S. (2006). "Sometimes you wanna hate celebrities": Tabloid readers and celebrity coverage. In S. Holmes, & S. Redmond (Eds.), *Framing celebrity: New directions in celebrity culture* (pp. 343-358). London; New York: Routledge.

Jones, D. (1980). Gossip: Notes on women's oral culture. *Women's Studies International Quarterly, 3*, 193-198.

Jordan, Edmiston Group. (2006) *Financial review of consumer magazines for 2005*. Retrieved from http://www.jegi.com/resource-center/industry-reports

Kadinsky. (2009, February 25). Calling all you commenters and lurkers. *Buttercup Punch*. [Blog post]. Retrieved February 25, 2009 from http://buttercuppunch.wordpress.com/2009/02/25/calling-all-you-posters-and-lurkers

Keegan, R. (2009, May 28). 10 questions for Perez Hilton. *Time*. [Video file]. Retrieved from http://www.time.com/time/video/?bcpid=1485842900&bctid=24546089001

King, B. (2003). Embodying an elastic self: The parametrics of contemporary stardom. In A. Thomas & M. Barker (Eds.), *Contemporary Hollywood stardom* (pp. 45-61). London and NewYork: Oxford University Press.

Labovitz, C. (2009, August 20). The Internet after dark (part I). [Blog post] *The Arbor Networks Security Blog*. Retrieved from http://ddos.arbornetworks.com/2009/08/the-internet-after-dark

Lenhart, A., Fallows, D., & Horrigan, J. (2004, February 29). *Content creation online*. The Pew Internet and American Life Project. Retrieved from http://www.pewinternet.org/Reports/2004/Content-Creation-Online.aspx

Lostracco, M. (2006, September 8). *Tall poppy interview: Perez Hilton, gossip king*. Retrieved from http://torontoist.com/2006/09/perez_dispenser.php

Magazine Publishers of America. (2006). *Average single copy circulation for top 100 ABC magazines*. Retrieved from http://www.magazine.org/CONSUMER_MARKETING/CIRC_TRENDS/22180.aspx

———— (2008). *Average single copy circulation for top 100 ABC magazines*. Retrieved from http://www.magazine.org/CONSUMER_MARKETING/CIRC_TRENDS/2008ABCsinglecopyrank.aspx

Maria. (2008, August 6). Registration required. *Jezebel*. [Blog post]. Retrieved from http://jezebel.com/comment-content/

Marshall, P. D. (1997). *Celebrity and power: Fame in contemporary culture*. Minneapolis: University of Minnesota Press.

———— (2006). New media—new self: The changing power of celebrity. In P. D. Marshall (Ed.), *The celebrity culture reader* (pp. 634-644). New York: Routledge.

McKelway, S. C. (1940). Gossip writer: Aspects of a non-layman. *The New Yorker*, 26-34.

McKenna, K. Y. A., Green, A. S., & Gleason, M. E. J. (2002). Relationship formation on the Internet: What's the big attraction? *Journal of Social Issues, 58*(1), 9.

Meyer Spacks, P. A. (1985). *Gossip*. New York: Knopf.

Mitra, A. (1997). Virtual commonality: Looking for India on the Internet. In S. G. Jones (Ed.), *Virtual culture: Identity & communication in cybersociety* (pp. 55-79). London and Thousand Oaks, CA: Sage.

Morley, D. (1980). *The Nationwide audience*. London: British Film Institute.

———— (1992). *Television, audiences and cultural studies*. London and New York: Routledge.

Navarro, M. (2007, July 29). Love him or (he prefers) hate him. *The New York Times*. Retrieved From http://www.nytimes.com/2007/07/29/fashion/29perez.html

Orloff, B. (2008, January 4). Britney's rocky year. *People*. Retrieved from http://www.people.com/people/gallery/0,,20100371,00.html#20371529

Perl-Raver, S. (2009, March 27). Exclusive: Perez Hilton pulls a Milli-Vanilli. *Gossip Sauce* [Blog post]. Retrieved April 11, 2009 from http://www.gossipsauce.com/perez-hilton/exclusive-perez-hilton-pulls-a-milli-vanilli

Petersen, A. H. (2007). Celebrity juice, not from concentrate: Perez Hilton, gossip blogs, and the new star production. *Jump Cut*. Spring. Retrieved from http://www.ejumpcut.org/archive/jc49.2007/PerezHilton/text.html

Pérez-Peña, R. (2008, February 12). Us Weekly's circulation rises 10% in soft year. *The New York Times*. Retrieved from http://www.nytimes.com/2008/02/12/business/media/12mag.html

PopSugar. (2008, February 14). Should Britney's dad get to stay in control?. *Pop Sugar*. [Blog post]. Retrieved February 23, 2008 from http://www.popsugar.com/Should-Britneys-Dad-Get-Stay-Control-1043905

———— (2008, February 15). Lindsay aims high with Leo & Adrian. *Pop Sugar*. [Blog post]. Retrieved February 23, 2008 from http://www.popsugar.com/1045794

Preece, J. (2000). *Online communities: Designing usability, supporting sociability*. Chichester, NY: John Wiley.

Prescott, L., & Hanchard, S. (2007). *Hitwise US consumer generated media report*. New York: Hitwise.

Quantcast (2010). Ybf.com. Retrieved March 25, 2010 from http://www.quantcast.com/ybf.com#demographics

———— (2011). usmagazine.com Retrieved March 20 , 2011 from hrrp://www.quantcast.com/usmagazine.com

Radway, J. (1984). *Reading the romance: Women, patriarchy, and popular literature*. Chapel Hill: University of North Carolina Press.

Raezler, C. (2009, September 29). Perez Hilton: Coarsening the culture one blog post at a time. *Culture and Media Institute*. Retrieved from http://www.cultureandmediainstitute.org/articles/2009/20090922100930.aspx

Rettberg, J. W. (2008). *Blogging*. Cambridge, UK; Malden, MA: Polity Press.

Rojek, C. (2001). *Celebrity*. London: Reaktion Books.

Sacks, E. (2011, December 18). Lindsay Lohan *Playboy* issue selling out at newsstands: report. *Daily News*. Retrieved from http://www.nydailynews.com/entertainment/gossip/lindsay-lohan-playboy-issue-selling-newsstands-report-article-1.993385

Schickel, R. (1985). *Intimate strangers: The culture of celebrity*. Garden City, NY: Doubleday.

Shafrir, D. (2007, July 10). The truth about Perez Hilton's traffic. *Gawker*. [Blog post] Retrieved July 20, 2007 from http://gawker.com/276369/the-truth-about-perez-hiltons-traffic

Stack, T. (2009, July 17). Perez Hilton won't shut up. *Entertainment Weekly*, 33-35.

Sternheimer, K. (2011). *Celebrity culture and the American Dream: Stardom and social mobility*. New York: Routledge.

Stewart, D. (2008, March 7). Commenter executions: The guillotine has fallen. *Jezebel*. [Blog post]. Retrieved March 7, 2008 from http://jezebel.com/365355/commenter-executions-the-guillotine-has-fallen

———— (2008, March 11). Madonna gave it to Justin Timberlake in the ass. *Jezebel*. [Blog post]. Retrieved March 11, 2008 from http://jezebel.com/366279/madonna-gave-it-to-justin-timberlake-in-the-ass

Story, L. (2005, June 13). Forget about milk and bread. Give me gossip! *The New York Times*, p. C1.

Tate, R. (2009, July 17). Perez Hilton: In my defense, I don't "actually" write that crap. *Gawker*. [Blog post]. Retrieved July 20, 2009 from http://gawker.com/5317104/perez-hilton-in-my-defense-i-dont-actually-write-that-crap

Tiffany, L. (2007, Dec 1). Gossip artist. *Entrepreneur*. Retrieved from http://www.entrepreneur.com/article/186508

Turner, G., Bonner, F., & Marshall, P. D. (2000). *Fame games: The production of celebrity in Australia*. Cambridge; New York: Cambridge University Press.

Turner, G. (2004). *Understanding celebrity*. London; Thousand Oaks: Sage.

———— (2006). The mass production of celebrity: "Celetoids," reality TV and the "demotic" turn. *International Journal of Cultural Studies, 9*(2), 153-165.

Ward, K. J. (1999). Cyber-ethnography and the emergence of the virtually new community. *Journal of Information Technology, 14*(1), 95-105.

Watson, N. (1999). Why we argue about virtual community: A case study of the phish.net community. In S. G. Jones (Ed.), *Virtual culture: Identity and communication in cyberspace* (pp. 102-132). Thousand Oaks, CA: Sage.

Wellman, B., & Gulia, M. (1999). Virtual communities as communities. In M. A. Smith, & P. Kollock (Eds.), *Communities in cyberspace* (pp. 167-194). New York: Routledge.

Vanegas, T. (2008, February 16). Steady, as she goes. *Pink Is The New Blog*. [Blog post]. Retrieved February 16, 2008 from http://trent.blogspot.com/2008/02/steady-as-she-goes.html

———— (2008, February 22). Baby, baby. *Pink Is The New Blog*. [Blog post]. Retrieved February 22, 2008 from http://trent.blogspot.com/2008/02/baby-baby.html

———— (2008, February 23). The Spears boys reunion tour. *Pink Is The New Blog*. [Blog post]. Retrieved February 23, 2008 from http://trent.blogspot.com/2008/02/spears-boys-reunion-tour.html

———— (2008, November 19). Les news, 111908. *Pink Is The New Blog*. [Blog post]. Retrieved November 19, 2008 from http://pinkisthenewblog.com/2008/11/les-news-111908/

———— (2012, January 10). Pink is the NEW blogger. *Pink Is The New Blog* [Blog post]. Retrieved January 10, 2012 from http://pinkisthenewblog.com/2012/01/pink-is-the-new-blogger/

Yuqing R., Kraut, R., & Kiesler, S. (2007). Applying common identity and bond theory to design of online communities. *Organization Studies, 28*(3), 377-408.

Index

Toby Miller
General Editor

Popular Culture and Everyday Life (PC&EL) is the new space for critical books in cultural studies. The series innovates by stressing multiple theoretical, political, and methodological approaches to commodity culture and lived experience, borrowing from sociological, anthropological, and textual disciplines. Each PC&EL volume develops a critical understanding of a key topic in the area through a combination of a thorough literature review, original research, and a student-reader orientation. The series includes three types of books: single-authored monographs, readers of existing classic essays, and new companion volumes of papers on central topics. Likely fields covered are: fashion; sport; shopping; therapy; religion; food and drink; youth; music; cultural policy; popular literature; performance; education; queer theory; race; gender; class.

For additional information about this series or for the submission of manuscripts, please contact:

Toby Miller
Department of Media & Cultural Studies
Interdisciplinary Studies Building
University of California, Riverside
Riverside, CA 92521

To order other books in this series, please contact our Customer Service Department:

(800) 770-LANG (within the U.S.)
(212) 647-7706 (outside the U.S.)
(212) 647-7707 FAX

Or browse online by series: www.peterlang.com